DREAMSCAPES
MYTH&MAGIC

Creating Legendary Creatures & Characters

Stephanie Pui-Mun Law

IMPACT
CINCINNATI, OHIO
www.impact-books.com

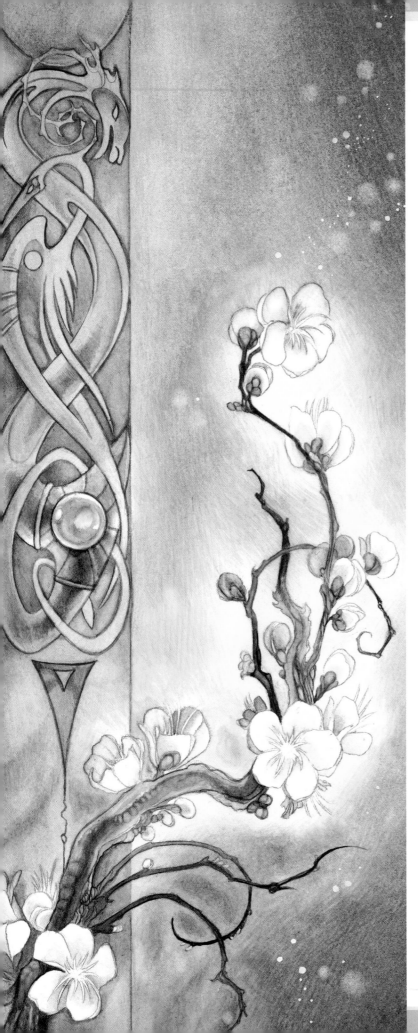

Metric Conversion Chart

To convert	to	multiply by
Inches	Centimeters	2.54
Centimeters	Inches	0.4
Feet	Centimeters	30.5
Centimeters	Feet	0.03
Yards	Meters	0.9
Meters	Yards	1.1

 Other fine IMPACT Books are available from your local bookstore, art supply store or online supplier. Visit our website at www.fwmedia.com.

17 16 15 14 13 8 7 6 5 4

DISTRIBUTED IN CANADA BY FRASER DIRECT
100 Armstrong Avenue
Georgetown, ON, Canada L7G 5S4
Tel: (905) 877-4411

DISTRIBUTED IN THE U.K. AND EUROPE BY DAVID & CHARLES
Brunel House, Newton Abbot, Devon, TQ12 4PU, England
Tel: (+44) 1626 323200, Fax: (+44) 1626 323319
Email: postmaster@davidandcharles.co.uk

DISTRIBUTED IN AUSTRALIA BY CAPRICORN LINK
P.O. Box 704, S. Windsor NSW, 2756 Australia
Tel: (02) 4577-3555

Library of Congress Cataloging in Publication Data is available from the publisher upon request.

Content edited by Layne Vanover
Production edited by Kelly Messerly
Designed by Wendy Dunning
Production coordinated by Mark Griffin

About the Author

Stephanie Pui-Mun Law has been painting fantastic otherworlds from early childhood, though her art career did not begin until 1998 when she graduated from a program of Computer Science. After three years of programming for a software company by day and rushing home to paint into the midnight hours, she left the world of typed logic and numbers for the painted worlds of dreams and the fae.

Her illustrations have been used for various game and publishing clients, including Wizards of the Coast, HarperCollins, LUNA Books, Tachyon Books, White Wolf, Alderac Entertainment, and Green Ronin. She has authored and illustrated *Dreamscapes, Creating Magical Angel, Faery & Mermaid Worlds with Watercolor* (2008, IMPACT Books), a book on watercolor technique for fantasy. She is also the creator of the Shadowscapes Tarot deck (Llewellyn Publishing).

In addition to the commissioned projects, she has spent a great deal of time working up a personal body of work whose inspiration stems from mythology, legend and folklore. She has also been greatly influenced by the art of the Impressionists, Pre-Raphaelites, Surrealists and the master hand of Nature. Swirling echoes of sinuous oak branches, watermarked leaf stains and the endless palette of the skies are her signature. Her background of over a decade as a flamenco dancer is also evident in the movement and composition of her paintings. Every aspect of her paintings moves in a choreographed flow, and the dancers are not only those with human limbs. What Stephanie tries to convey with her art is not simply fantasy, but the fantastic, the sense of wonder, that which is sacred.

While most of Stephanie's work is done with watercolors, she experiments with pen & ink, intaglio printing, acrylic and digital painting as well.

Acknowledgments

Thanks to Dana for always being patient with my moods when my head is buried in the "I'm working!" mode, while frantically typing away before the current idea evaporates; and for the impartial voice to talk some sense into me when I've been working sixteen hours straight on a painting and green and purple all blend together into one muddy mess in my head! Thanks to both Moms for being so supportive—with the two of you I've got publicity covered for both the East and West coasts!

\mathcal{T}able of Contents

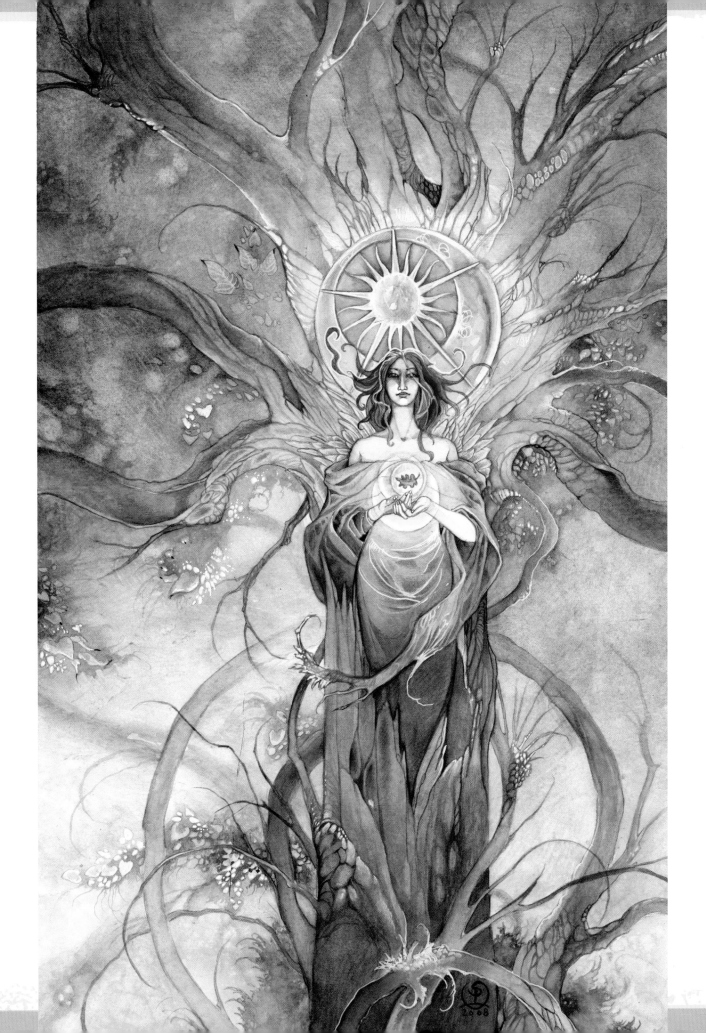

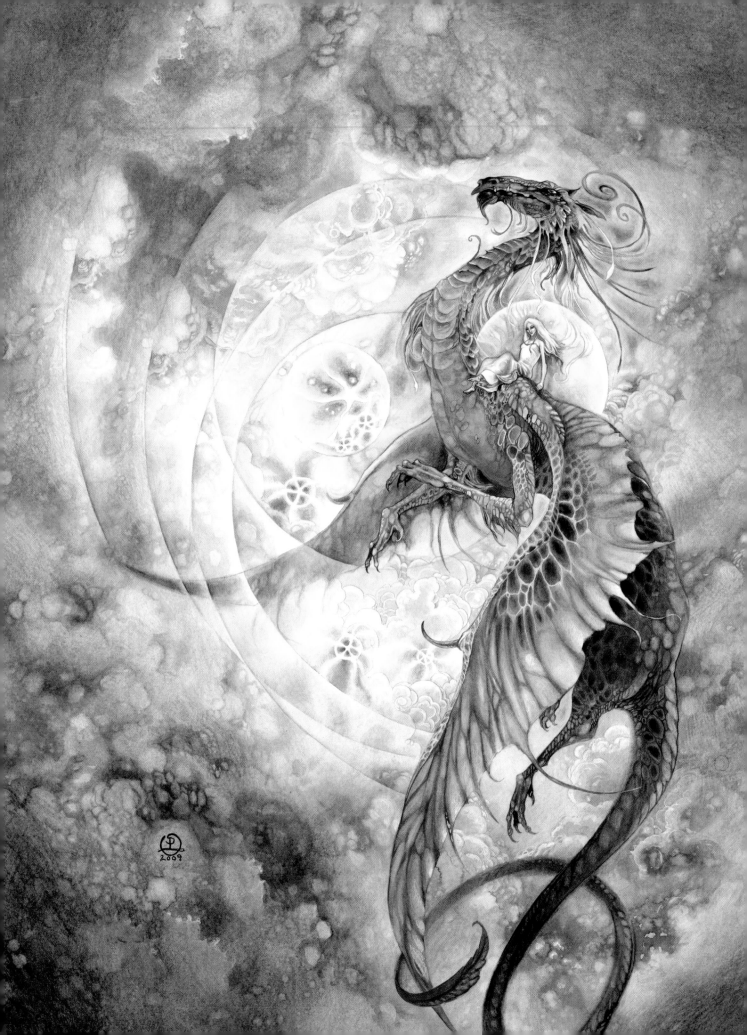

Introduction

Much of the fantasy genre is built upon a grand history of archetypal imagery. Tolkien understood this when he wrote his Lord of the Rings, drawing much of his inspiration from ancient tales that spanned across the mythologies of European cultures. He reinterpreted the lost bits of folklore and tales into his own Middle Earth.

Tolkien was not the first nor only one to draw from the vast array of mythos for his fantasy world. Shakespeare took the king and queen of faery, Oberon and Titania, into his *Midsummer Night's Dream*, and wove his play around that bright thread. Acknowledging the importance of such figures to the subconscious workings of the human mind, a tarot deck's twenty-two trump cards wend a path through a cast of archetypal characters: Emperor, Empress, Death and the celestial bodies of Sun and Moon and Stars.

Even into our modern popular culture, unicorns and dragons are commonplace on T-shirts and posters, kitsune run rampant through Japanese manga and anime, and tanuki even peek their wide eyes from video games like Super Mario Bros.

What are the origins of these images? Why does the Snow Queen in Hans Christian Andersen's story evoke chills that go beyond her introduction from his tale? Is it because there are a long line of witches before her, who provide a backdrop for our understanding of that type of character? Thomas the Rhymer is a bard in good company with Taliesin, Orpheus and Diarmuid. Even a simple tree can have impact across the world and across the divide of cultures for its significance in religions, stories, and mythologies.

A great deal of fantasy has evolved from the traditions of what was once word of mouth folklore, and much of what modern writers and artists depict follow in the footsteps of tales and images that are much more ancient. This book will be an exploration of some of those ancient origins. Come sit at this fireside that has burned from the first brand and spark of life and knowledge, listen to some tales, and let mind and hand bring them to life. Then, perhaps, you'll come and share your own tales—the ones that have grown from the seedlings of the old.

MATERIALS & TECHNIQUES

IT CAN BE A DAUNTING TASK, INDEED, TO SIT IN front of a blank sheet of paper with the expectation of creating something magical. Yet possibilities and inspiration lie all around you. From the myriad of legends and stories of the past, to the works of other artists, to the inherent beauty that exists in nature: There is no shortage of places to look for ideas. Even the *mistakes* you make when painting—those unplanned, and at times, highly frustrating marks or spills—can be utilized to create unexpected and unique results. So, while it certainly can be intimidating to stare at a stark white piece of paper and wonder how your composition will turn out in the end, don't let fear hold you back!

The good news is this: By obtaining knowledge about the tools of the trade and being familiar with the basic watercolor techniques at your disposal, you can help ease the transition from nebulous imagination to successful painting. With time and experience, the medium will simply become an extension of your imagination. After all, practice is the only way to turn a once blank sheet of paper into a colorful, whimsical and magical world filled with iconic figures of fantasy.

Selecting Pencils

IN THIS BOOK YOU'LL USE PENCILS IN YOUR studies of drawing ethereal fantasy creatures with the goal of a painted end result. Even though the focus here is on painting with watercolors, pencils are a viable tool for completed works of art.

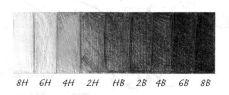

8H 6H 4H 2H HB 2B 4B 6B 8B

Lead Hardness

You can get leads in varying degrees of softness; 8B is the softest, while 8H is the hardest. HB is a medium hardness. The softer the pencil lead, the darker your mark. If you use too soft a lead, the pencil will easily smear and make your painted colors look dirty. If the pencil lead is too hard, you will have to press harder to draw your lines, creating indentations on your watercolor paper with the point. For this reason, HB and 2B pencils are good choices for sketches that are going to be painted over.

Selecting a Pencil

A traditional wood pencil is a good all-around choice. Mechanical pencils are consistent and convenient because you do not have to stop to sharpen them, and they can be purchased in a variety of lead thicknesses, from a very fine .3mm (for small details) to thicker .5mm and .7mm. The downside of a mechanical pencil is that you lose the organic flow that a uniform thickness of line cannot accommodate. A regular wooden pencil has an expressiveness that tends to get lost with mechanical pencils. An alternative is a lead holder. Lead holders can hold leads 2mm in thickness. They are similar to mechanical pencils, but can hold a much thicker lead that you can sharpen to a point or draw with its edge.

If you are planning to paint on the surface afterward, do not use much shading if you wish to keep the colors pure. If you are just sketching for ideas or doing a pencil drawing, however, go all out. A lead holder is a particular joy to use in that case.

Traditional no. 2

Mechanical (.3 thickness)

Lead holder

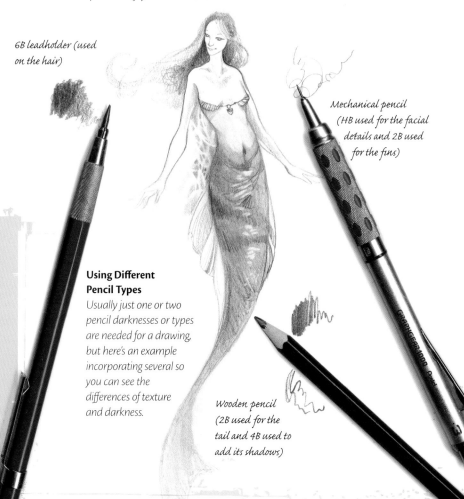

6B leadholder (used on the hair)

Mechanical pencil (HB used for the facial details and 2B used for the fins)

Wooden pencil (2B used for the tail and 4B used to add its shadows)

Selecting an Eraser

Vinyl erasers work fine for sketches, to clean up a piece after all the painting is completed or for removing bits of dried masking fluid. Kneaded erasers are only needed if your intent is to create finished pencil drawings because you don't want to be laying in heavy graphite under your watercolors—it will muddy the colors.

Using Different Pencil Types

Usually just one or two pencil darknesses or types are needed for a drawing, but here's an example incorporating several so you can see the differences of texture and darkness.

Choosing Brushes and Other Painting Tools

THE TWO MOST COMMON TYPES OF BRUSHES are flats and rounds. Flats are useful for creating large areas of even color. Rounds are great for shaping certain areas and adding details.

Items like salt and rubbing alcohol are great for adding unique textures to your painting.

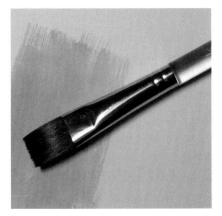

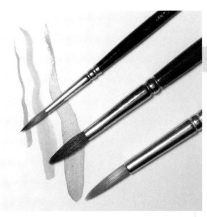

Flats

A ½-inch (12mm) flat is a good brush for doing washes in large areas. If you decide to work with bigger paintings in the future, you should eventually acquire bigger flat brushes that can cover more areas with one stroke. A ½-inch (12mm) flat is suitable for working in areas up to 11" × 14" (28cm × 36cm). But for surfaces larger than this, you'll need a larger flat to hold the necessary water and pigment.

Rounds

Having an assortment of brush sizes gives you a nice base of tools to work from. Rounds in nos. 0, 2, 4 and 8 are a good starter set. You can add to your collection as you gain more experience with painting and find yourself in need of a better selection. Sometimes you can purchase a starter brush set that includes three to five brushes of different sizes for a reasonable price.

Very fine work and details like leaves, eyes and scales require a small brush with a good point such as a no. 0 round, while a large round such as a no. 10 or bigger is useful for irregularly shaped washes.

Sable or Synthetic?

Brushes can range in quality (and price) from synthetic fibers to top of the line kolinsky sable hairs. If you are just getting started, you might not want to splurge on the most expensive brushes. There are many reasonably priced mixed synthetic and sable, or pure sable options that are of good quality. What you want to look for in a brush is the ability of the hairs to hold a point when wet (if the hairs all splay outward or don't stick together, the brush isn't good), and the resilience and bounce of the hairs (when bent, they should spring back to shape).

Cheaper brushes eventually lose their point as the hairs get splayed or bent, but do not just toss these old brushes out. They are good utility brushes to use when you need to lift paint or to apply masking fluid. When you don't want to spoil your nicer brushes with rough treatment, grab an older one.

Salt

Sprinkle salt into wet paint and the crystals pull the pigment as the liquid dries, leaving a random starlike mottled effect. Brush away the salt crystals after the painting has dried.

Rubbing Alcohol

Sprinkling rubbing alcohol onto wet paint causes the pigment to push away, leaving an interesting splotched effect.

Finding Paints

WATERCOLOR PAINTS COME IN TUBE AND CAKE form. Don't feel like you are limited to pans or tubes however. You can always mix and match— get a pan set for a basic starter set, and then, when you need additional colors that are not included, purchase tubes.

Scarlet Lake

Ultramarine Blue

Cadmium Yellow

Tubes or Cakes?

Advantages of tubes:

- *Offer more control over the intensity of color.*
- *Easy to acquire in a variety of pigments so you can custom select the array of colors.*
- *Easy to get the amount of pigment you need by squeezing a tube, rather than trying to work it up from a dried cake.*

Advantages of cakes:

- *Starter sets offer a good selection of pre-selected colors.*
- *Less cleanup is needed because a cake is more self-contained.*
- *Easy to take with you when traveling or painting on site—perhaps to a forest or garden for inspiration.*

Primary Colors

The primary colors (red, yellow and blue) are three basic colors to get you started. In theory, the entire spectrum of colors can be mixed from them.

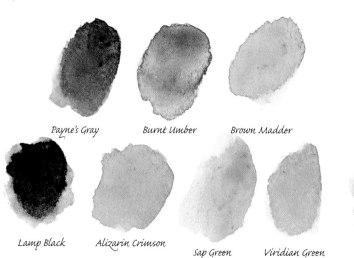

Payne's Gray Burnt Umber Brown Madder

Lamp Black Alizarin Crimson Sap Green Viridian Green Cerulean Blue

Cadmium Yellow Naples Yellow

White Gouache

Gouache is an opaque watercolor paint. When used sparingly, White gouache can be an effective way to go back over a finished area and paint in some white. However, the transparent quality of watercolor really makes a painting glow, and, when you apply opaque colors, you are stepping away from that look. The white of untouched paper will always be brighter and more pure than the added opaqueness of White gouache.

Expanded Palette

Having more colors gives you a brighter palette to choose from. You can mix a lot of shades from a limited set, but if you want a very bright and light color like pale pink, or a light shade of a primary color, you should purchase a tube or cake of that color.

In addition to red, yellow and blue, some additional recommended colors are shown above. Starter sets of cake paints usually will include most of these colors, though if you go with tubes you can individually select them yourself. As you gain more experience, you can add to your selection of colors.

Gathering Extras

Water Container

A bowl or cup of water is needed for washing off your brushes. Don't be lazy and let your water get too dirty and cloudy! Doing so will make your colors look muddy, so take the time to freshen the water every once in a while.

Palette

A lot of cake paint sets have a built-in palette for mixing colors; therefore it may not be necessary to purchase a separate one. However, if you are using only tubes you will need a palette to set out and mix your colors.

Absorbent Paper Towels

Keep a supply of paper towels on hand for mopping up excess moisture from a painting.

Masking Fluid and Old Brushes

Also called liquid frisket, masking fluid is a liquid latex that you paint directly on your surface to retain white areas before applying paint. Never use a good painting brush for applying masking fluid. Save up old brushes for this purpose, and clean them with soap and water quickly after you finish. Once the frisket has dried on the paper, you can apply washes of color over it. When the paint is fully dry remove the masking by rubbing gently with your fingertip or eraser. The areas underneath will be white and unpainted.

Colour Shaper

These are rubber-tipped tools with either a chisel or pointed tip that are often used for sculpting or acrylic painting. Because a Colour Shaper has no individual bristles, dried liquid frisket will not harm it, and it can be used just like a brush to apply the masking fluid. When finished, simply wipe off the tip with a paper towel.

> ### Mixed Neutrals on Your Palette
>
> *Although it is important to keep colors clean and separate (especially for pale colors like yellows, oranges, pinks and light greens), sometimes letting colors run together on your palette can create mixed neutral tones. Use them to paint subtle shadows and in-between shades, instead of a flat pure color. The less vibrant hues and neutral shifts lend a subtle realism to your painting.*

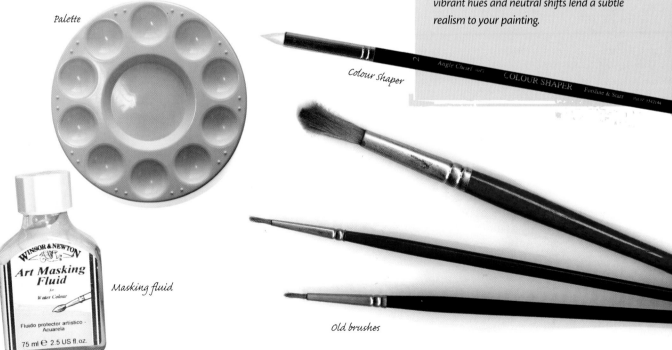

Palette

Colour shaper

Masking fluid

Old brushes

Selecting Paper

The type of paper you choose to paint on is as important as your brushes and paints. Papers are usually categorized according to the surface texture (which is commonly referred to as a paper's tooth): rough, cold press or hot press.

Watercolors are usually most suited to rough or cold-pressed paper because they absorb the pigment quickly. Hot-pressed paper is better for more opaque techniques such as working in acrylics or gouache paints and drawing with inks and pencils.

Selecting a paper is also a matter of personal preference—whether you like a rough texture or a smooth, unbroken surface. I prefer to work on lightweight illustration board, but you should try out different textures and types of surfaces to see for yourself how the paints behave.

Rough watercolor paper

Cold-pressed watercolor paper

Cold-pressed illustration board

Hot-pressed bristol board

Selecting a Surface

- **Rough surface**. *This finish has the most pronounced peaks and valleys. It is not recommended for a beginner watercolorist, as mistakes are hard to hide and paint can pool into the valleys.*

- **Cold-pressed surface**. *This surface has a medium tooth and allows the water and pigment to be absorbed quickly. The surface is also resilient to rough treatment and can handle lots of layering and lifting. Cold-pressed paper is a good type of paper to start out with.*

- **Hot-pressed surface**. *This surface is extremely smooth and nonporous. Watercolors tend to pool and bleed a bit more since the liquid isn't rapidly absorbed into the paper. However, this does make blending easier.*

Use Paper With a Slight Texture

One of the charms of watercolor is the randomness that can be achieved with the flow of water and the spreading and pooling of pigments. Textured paper can facilitate this look and keep the art from looking too tight and overworked.

An Alternative to Watercolor Paper

Illustration board serves as a good alternative to watercolor paper. It can be found in cold- or hot-pressed finishes, though even the cold-pressed tends to be on the smoother end of the spectrum. Illustration board does not get as warped from repeated washes as watercolor paper does, and it does not need to be stretched. Tape it down to a Masonite board for easy transportation and to prevent damage to the corners.

You can also use bristol board, but it does not take water very well and will easily warp. Bristol board, however, is better suited for pencil or ink drawings with very little color.

Basic Watercolor Technique
STRETCHING WATERCOLOR PAPER

Unless you use prestretched watercolor paper or illustration board, you must stretch your watercolor paper to prevent it from becoming swollen with water and warped.

MATERIALS LIST

Other ∼ 4 pieces of acid-free masking tape cut to the width and height of your paper, bowl of water, drawing board, paper towels, watercolor paper cut to size

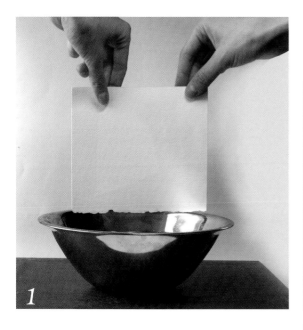

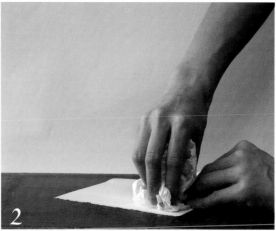

1 Wet the Paper
Take the sheet of paper and soak it thoroughly in water.

2 Remove Excess Water
Wipe away excess moisture with a paper towel.

3 Let the Paper Dry
Take the paper by the corners and lay it flat on the drawing board. Tape down all four sides with acid-free masking tape. Let the paper dry completely. When it is dry, the paper is ready to be painted. Do not remove the paper from the board until you have finished your painting.

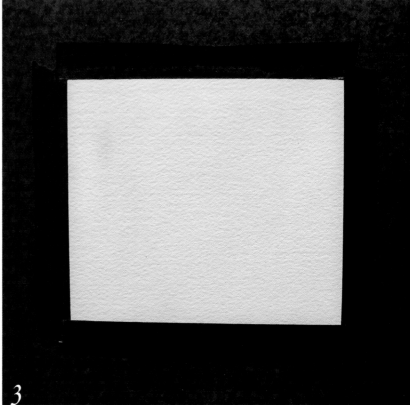

Understanding Color

The basic color wheel consists of the primary colors red, yellow and blue. From these three basic colors, the rest of the spectrum can be created. The secondary colors are orange (mixed from red and yellow), green (mixed from yellow and blue) and violet (mixed from blue and red). The six tertiary colors result from mixing a primary with a secondary color.

Generally, reds, oranges and yellows are considered warm colors while purples, blues and greens are considered cool. Being aware of a color's temperature can help you manipulate the mood of your paintings.

Mixing Lively Grays and Blacks

Grays and blacks (but especially blacks) straight from the tube are sometimes referred to as dead colors. *This is particularly true of black, as it is completely neutral (neither warm nor cold) and often results in a flat finish that draws the viewer's eye toward it. As such, it's best to use black paint from the tube sparingly.*

A nice alternative to pure black is to create a black mixture. After all, few things in the world are truly black; even a black object has light and shadows and is affected by the surrounding colors. Burnt Umber and Ultramarine Blue make a great combination for an artificial black. Add more Ultramarine Blue to the mixture for a cooler black or more Burnt Umber for a warmer cast.

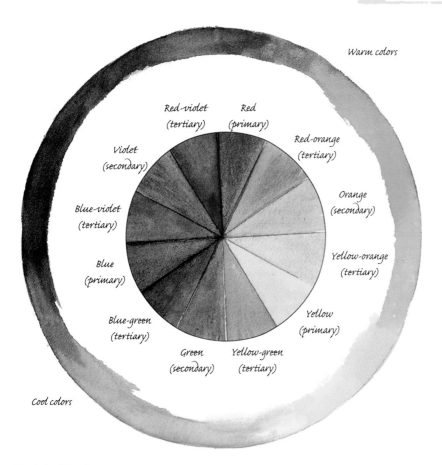

Warm colors

Red-violet (tertiary)

Red (primary)

Red-orange (tertiary)

Violet (secondary)

Orange (secondary)

Blue-violet (tertiary)

Yellow-orange (tertiary)

Blue (primary)

Yellow (primary)

Blue-green (tertiary)

Green (secondary)

Yellow-green (tertiary)

Cool colors

Complements and Color Mixing
Complementary colors sit opposite each other on the color wheel. Complementary pairs are red/green, blue/orange and purple/yellow. Mixing complementary colors together results in a muddy brownish gray tone. The more colors you mix, the muddier the mixture becomes. Try to mix only two or three colors at most to get the color mixture you need.

The Color Wheel
Being familiar with the color wheel will help you when it comes to mixing your watercolors and determining the color scheme of a painting.

16

Suggesting Edges and Incorporating Spills

THE BEST PAINTINGS ARE A MIXTURE OF control and random accidents. Most artists evolve beyond the frustration of not being able to control the paint, to using an iron fist and killing all the spontaneity of watercolors, to finding a happy medium that uses the natural tendencies of watercolors, while maintaining knowledge and control over the results.

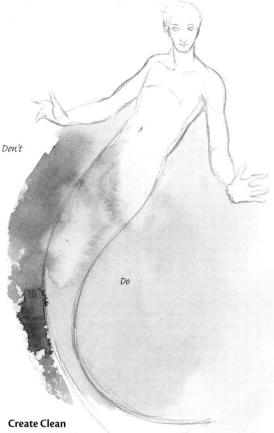

Don't

Do

Create Clean Edges by Working Wet-On-Dry
When not enough time is left for a surrounding color to dry, it will bleed into the newly applied color next to it. On one side, the blue wasn't dry before the green was applied, so the blue spilled over into his tail. Be patient—a minute spent waiting now will save you much hair-tearing and regret later when trying to correct an error. This technique of working wet-on-dry can help you create crisp edges.

Making Crisp Edges
To create details or a crisp edge, do not paint an adjacent layer of color near another wet color or it will bleed from one section to another. You can only create fine-edged details with dry adjacent colors. When in doubt and something is wet, wait.

Take Advantage of Spills
Sometimes spilling color can be a good thing. You can use the effect purposely as a technique. Her hair blends right into the background in a cloudy haze that works quite well in this instance.

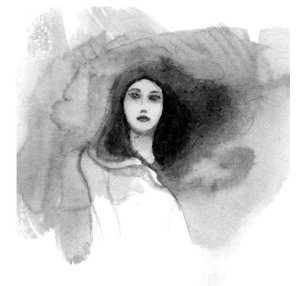

17

Basic Watercolor Technique
LAYING A FLAT WASH

Washes are the most basic watercolor technique, and can be used to cover large, flat background areas, or for laying in basic colors on smaller elements of a painting.

MATERIALS LIST

Watercolors ～ Ultramarine Blue

Brushes ～ ½-inch (12mm) flat

Other ～ Acid-free masking tape, cold-pressed watercolor paper or illustration board, drawing board

1 **Wet the Paper**
Secure your surface to a drawing board. Position your paper at a slight angle toward you (prop some books underneath the top if you don't have a slanted drawing table). Use a ½-inch (12mm) flat to wet the entire area of the wash.

2 **Add Pigment**
Load a ½-inch (12mm) flat with Ultramarine Blue. Drag the brush horizontally across the top of the paper. Since the surface is at an angle, the paint will drip toward the bottom of the page.

3 **Add More Pigment**
Before the previous stroke dries, drag a second stroke right below and slightly overlapping the first stroke. Make sure you catch the drips from the first stroke for an even wash.

4 **Create the Final Layers**
Keep layering pigments, following steps 2 and 3 until you get to the bottom. If too much paint runs to the bottom edge, reduce the angle of your work surface. Avoid going back and retouching areas that you have already painted until the surface is dry, since small variations and inconsistencies will smooth themselves out as the paint dries and the water flows.

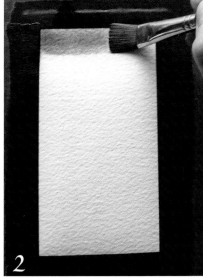

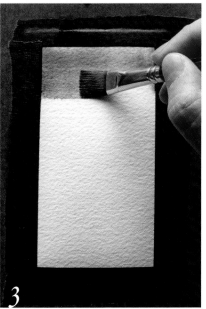

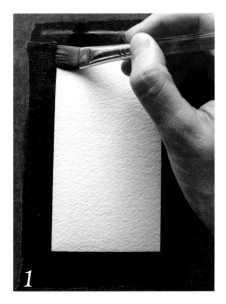

Basic Watercolor Technique
LAYING A GRADED WASH

For a graded wash, dilute the paint with each consecutive stroke so that the pigment eventually fades into clear water and the white of the paper. Remember, it's important to let the paint dry on its own. Do not fuss with it too much or you may make inconsistencies more obvious.

Use graded washes for the changing colors of the sky's horizon or to create the vibrant edge of a rose petal fading to the pale pink heart.

MATERIALS LIST

Watercolors ~ Ultramarine Violet

Brushes ~ ½-inch (12mm) flat

Other ~ Acid-free masking tape, cold-pressed watercolor paper or illustration board, drawing board

1 **Wet the Paper and Add Pigment**
Secure your surface to the drawing board. Prop the surface up, angling it toward you. Wet the area with a ½-inch (12mm) flat, then load it with fairly concentrated Ultramarine Violet. Drag the brush across the paper's top with a horizontal stroke.

2 **Add Lighter Pigment**
For the next stroke, dilute the paint a little bit so that it is slightly lighter than the first stroke. Drag the brush across the surface, overlapping the first stroke.

3 **Continue to Add Layers**
Keep layering pigments, following step 2 until you get to the bottom. Remember, dilute the paint for each row.

4 **Let the Surface Dry**
After you've covered the whole area, don't fiddle with it because this will only mar the smoothness of the wash. Minor inconsistencies will smooth themselves out as the surface dries. Practice this a few times until you can create an even wash.

Applying a Graded Wash in a Curvy Area

Create graded washes in areas with curves and edges by slowly building a series of washes in the area. Start with a very pale wash; let it dry then keep building layers. Building layers with this method gives you much more control.

Glazing

To give your colors a glowing gemlike quality, consider using the glazing technique. A glaze is a translucent wash applied directly on top of an existing layer of color. This technique not only adds an essence of shimmer to your paintings, but it also results in a subtlety of shifting colors that direct mixing can't accomplish. Each time you add an additional color on top of another color, it changes the tone in a way that is distinctly different from mixing the wet colors directly before painting. And, of course, you aren't limited to just two layers—you can add as many layers as necessary to build up the colors and create the tones you desire.

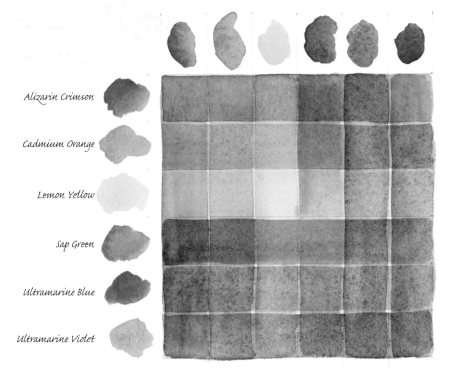

Alizarin Crimson

Cadmium Orange

Lemon Yellow

Sap Green

Ultramarine Blue

Ultramarine Violet

Creating Dazzling Results With Glazing
This chart provides an example of what happens when you use the glazing technique. Notice how a color's intensity is increased when another layer of color is added to it. Layering complementary colors results in muted brown and neutral tones.

Creating a chart like this with your pigments is a starting point to help you determine which colors to glaze, as you'll be able to see in advance how the colors look when one pigment is layered over another.

Glazing in Action
Glazing was used here to create a transparent quality to the skin. The shadows were laid in first using Indigo, then a very pale glaze of Naples Yellow and Alizarin Crimson was added to suggest the main fleshtones. I also glazed small nimbuses of Lemon Yellow around the bits of jewelry to add even more intensity. This gradual buildup of colors makes the composition much richer than if it were done in one pass and the colors were premixed on the palette.

Basic Watercolor Technique
LAYERING GLAZES

A dryad reaches up, stretching her leafy fingertips toward the light, so a graded wash makes the perfect background. Using a rich, verdant green for the base best complements the nature of the subject, and each added layer of color helps to define even the subtlest of details.

MATERIALS LIST

Watercolors ~ Burnt Umber, Indigo, Viridian Green

Brushes ~ ½-inch (12mm) flat, nos. 0, 1 and 4 rounds

Other ~ HB pencil, illustration board

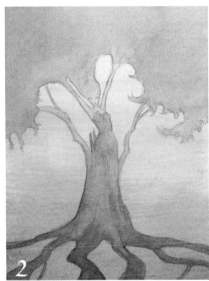

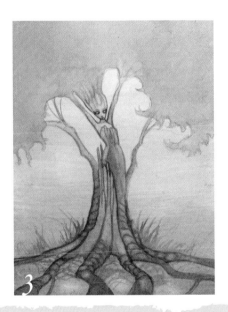

1 Finish Sketch and Lay a Graded Wash
Sketch the dryad with a pencil. Turn the paper upside down and use a ½-inch (12mm) flat to apply a graded wash of Viridian Green so that the darkest area is at the bottom of your sketch.

2 Glaze the Dryad
Apply a layer of Burnt Umber with a no. 4 round to the tree trunk and roots. Since the previous layer is darker toward the bottom, the roots will seem to darken toward the shadows in the foreground. Apply a layer of Indigo to the upper leaves and very lightly to her face.

3 Add the Final Details
With a no. 0 round, paint the details along the trunk, and her features with Burnt Umber. Paint some grass with Viridian Green. Lift out some highlights on the trunk with a no. 1 round. Notice that since Burnt Umber lifts more easily than Viridian Green, the lifted highlights show the tints of green peeking through.

Glazing Creates a Subtle Color Change

Here are the colors used in this demonstration in their pure form, that is, straight from the tube. However, when they are layered on top of each other, they interact and mix differently, creating a much more subtle effect and more interesting shades and variations of tone than could otherwise be achieved by straight mixing.

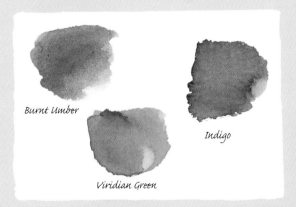

Burnt Umber

Indigo

Viridian Green

lending

When it's time to blend tones or colors in your painting, you can choose one of two approaches.

Blending Wet

When dealing with large areas, graded washes work well for blending from one tone to another, or from color to the white of the paper. For smaller areas, though it can be a bit unwieldy. Blending with your brush while the paint is wet can give you more control.

Blending Dry

Blending dry works well for softening edges, blurring for distance, or for shading; however, transitions will not appear as smooth as they do when blending wet. Results can vary greatly depending on how amenable the particular color is to lifting, as well as the type of paper you are working on.

Start in the Corners
Sometimes it can be tricky to blend a background around the tight corners of a foreground element. Depending on the size of the details, select a round brush that is big enough to hold a lot of water, and yet get into the tight corners you are navigating. Charge the brush with moderately diluted pigment, using just enough water to flow but not so much that the tones become too pale.

Blend Outward
As you move out from the foreground element you are painting around, start diluting the paint on your brush with water. Paint fairly quickly to keep the forward edge that you are working along wet. If it dries, there will be a noticeable seam of pigment.

Blend Until Clear
As you pull the forward line outward, keep diluting the paint on your brush until it runs clear.

Establish Basic Forms
Lay in the basic forms for the area you are painting.

Lift Along the Edges
A brush with stiffer bristles works better for this. After the initial layer has dried, load the brush with water and scrub along the edges of the paint to lift and soften the transition.

Using Salt

SALT IS AN EXCELLENT ADDITIVE TO HELP indicate texture in your paintings. It works especially well in creating a nice base for organic backgrounds like leaves and foliage, as shown on this page. However, it can sometimes be tricky to achieve a controlled result. By its nature, salt creates a randomizing effect, so be prepared to relinquish some control when using it. You can control the *type* of effect created to a certain extent, though, by choosing the appropriate grain of salt. Sea salt, for example, which is coarser and more irregularly shaped, generates large splotches of differing shapes and sizes. Table salt, on the other hand, which is very fine and more uniformly shaped, yields a fairly consistent splotched texture.

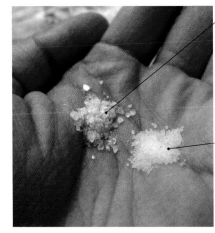

Sea salt—the rough, irregularly sized grains result in splotches of varying shapes and sizes.

Table salt—the standardized texture of these fine crystals produces a more regular texture.

Sea Salt Versus Table Salt

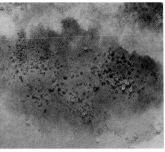

Getting Started
Start by laying in some wet paint, then sprinkle salt into the area you wish to texture.

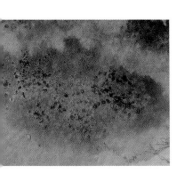

Watching Texture Form
As the salt dries, the grains suck in moisture, creating a distinctive starry texture on the paper.

If you wait until the paint is completely dry before removing the salt, little outlines of pigment may remain. This is because as the water was sucked into the salt, some of the pigment was also pulled in and dried around the grain. If you don't mind these residual blobs around the salt, waiting until the paint is completely dry will yield a very feathery, delicate starry texture.

If you very lightly brush the salt away (using a paper towel) when the paint is almost completely dry, you can avoid the dark grain outlines. However, this also blurs the starry texture a bit, resulting in a more nebulous blob shape.

Removing the Salt
When the paint is nearly dry, you can begin removing the salt by lightly brushing it with a paper towel. The timing of when to do this is something you have to experiment with as it varies depending on how wet your initial wash was, how much salt you sprinkle, how absorbent your paper is, and what effect you are attempting to achieve. Try it out on scrap paper first if you're uncertain how it will work out. Wiping the salt off too early (when the paint is still too wet) will obliterate all the texture you are attempting to create, while waiting until it is completely dry might leave dark unexpected splotches around the salt grains.

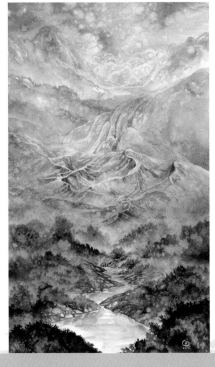

The Randomizing Effects of Salt

ℳore Watercolor Techniques

1

2

3

1 Layered Graded Wash

By combining graded washes and glazing, you can create a multicolored melding of tones. Use a ½-inch (12mm) flat to apply a graded wash with one color. When that has dried completely, paint a second graded wash with a different color (or use the same color to intensify its appearance). Repeat this until you get the appearance you desire. Use this technique for complex backgrounds.

Flow With the Medium, Don't Fight It

If you find yourself struggling too hard to accomplish a certain effect, it might be time to take a step back and reconsider your approach. Sure, there are some unpredictable elements to painting with watercolors, but this can be controlled—to some extent—by your choice of materials and technique. For example, wet-on-dry usually stays where your brush paints it. If you use more liquid, the stroke will be smooth, but less liquid will create a broken line, dry-brush effect.

Wet-into-wet, on the other hand, will cause colors to bleed and bloom across the wet zones. If you find details are hard to paint because everything is becoming blurry, think about the surface you are painting on. Is it wet? Is it too wet? Is the paper too rough? Are your brushes too big?

By familiarizing yourself with the characteristics of watercolor materials and techniques, and applying this knowledge to your paintings, you can avoid frustrating mistakes and enhance your watercolor experience.

2 Drybrush

Like the name suggests, this technique employs a dry brush (a brush with little to no water). Just load some paint on the brush, then dab it in a paper towel to get rid of excess moisture. Experiment with varying amounts and notice the results. With less moisture, the brush will skip over the texture of the paper and you will start to see the individual hairs of the brush in the strokes. With more water, you will get a very smooth, unbroken line similar to a wash. Drybrushing can be used to paint fine details in foliage, grass and hair.

3 Dry-Into-Wet

When using this technique, wet only the areas you will be working with using clear water. Then, with a brush loaded with relatively dry paint, work through those wet areas. The wet parts will dilute the pigment, while the dry areas hold the paint still. This technique can be used for surface ripples of water.

4 Wet-Into-Wet

If you want to achieve an organic look in your painting or blend your colors in a looser fashion, simply use the wet-into-wet technique. To begin, wet the entire surface of the area you will be working in with clear water, then take a brush loaded with color and paint into the wet areas. The water will dilute the edges of the painted areas and pull the pigment away from the center, creating a softer, more natural look.

5 Lifting From a Wet Surface

Lifting is when you remove pigment from the paper after it has been applied. You can lift from a wash that is still wet by taking a paper towel, tissue or sponge and dabbing at the paint. The drier the paint gets, the less color you can remove.

6 Lifting From a Dry Surface

To lift color from paint that has already dried, you must apply water. You can do this by dropping water onto the dried surface and letting it sit for a moment before lightly scrubbing it with a paper towel. You can also take a brush charged with water and use it to lightly scrub the surface. Using a smaller brush gives you more control over what is lifted. This technique is very useful for distant foliage, tree bark, stars, mermaid scales or for creating highlights.

7 Plastic Wrap Texturing

If you want to add extra texture to your painting, lay a wash, then, while it is still wet, lay a piece of plastic wrap on top. After the paint has dried, remove the plastic wrap. This technique works well for rock textures or stained glass.

8 Rubbing Alcohol Texturing

You can also create texture using rubbing alcohol. Again, start by laying a wash, and while it is still wet, sprinkle it with rubbing alcohol. The pigment will push away from the rubbing alcohol and leave interesting speckled patterns. Rubbing alcohol is great for suggesting distant foliage or bubbles in an underwater scene.

Secrets to Successful Lifting

Certain colors respond very differently to lifting. Blues lift very easily (for this same reason, blues are sometimes difficult to glaze because the color insists on lifting as you apply a second wet layer). Reds, on the other hand, can be extremely stubborn and require much more force to lift. The paper also affects your ability to lift a pigment. Pigments on hot-pressed paper lift easily since the paint mostly sits on the surface. A very rough cold-pressed paper might be more resistant to lifting. Cheaper papers also have a tendency to suck up the pigment and very reluctantly release any of it.

Drawing on Inspiration

FOR CENTURIES NOW, MYTHOLOGICAL SUBJECT matter has been a source of inspiration to many artists, whether gleaned from the living stories and tales of one's time, or from long ago legends cloaked in magic and mystery. The faery tales that have inspired so many can also help spark your artistic imagination. Your local library and bookstores have shelves filled with mythologies of the world. Browsing through a sample of these texts will certainly arm you with the concepts necessary to create innumerable creatures, heroes and goddesses. After all, studying the past is a good way to learn.

Once you've found the perfect piece of inspiration for a painting—whether it's a piece of existing art, a photo you have taken or a sketch you've done on flimsy scrap paper—you'll need to copy the image to an appropriate painting surface. Employing a grid method will help you transfer your reference and maintain proper proportion and balance.

Alternate Methods for Transferring Your Image

Artist transfer paper (a product similar to carbon paper) can be purchased at most art supply stores. Just lay the transfer paper on your painting surface, dark side down, place your drawing on top, and secure both to your painting surface. Then simply trace over the lines of your drawing, being careful not to press too hard or else you will leave indented grooves on the painting surface where liquid and pigment will pool when you start to paint. If you can't find transfer paper, just use this trick. Make sure all the lines on your sketch are dark, then turn it pencil-side down on your painting surface and tape it in place. With a dull pencil (or anything that can serve to burnish) scribble on the back side of your sketch wherever your sketch lines were. This will transfer your original drawing in reverse onto your painting surface.

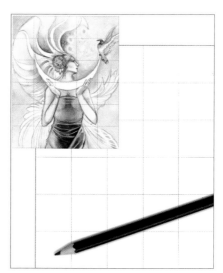

Lay Out a Grid on the Image and Your Surface

Select a picture or study. Mark off a grid on the image with either a pencil or pen and a ruler. If you have a computer, you can scan and digitally mark off a grid.

Mark off your blank drawing paper lightly in pencil with the same number of gridded subdivisions. It does not need to be the same size as your gridded photo. Just be sure it is the same proportions of width and height.

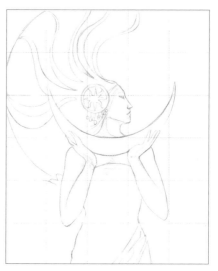

Begin to Map Out the Image

Using the gridded photo or study as a reference, draw small sections of the image one at a time. If you have never done this exercise, concentrate on one square at a time and try not to think of the picture as a whole figure, but just lines and shadows. Look at where the lines are in each square of your grid, how the eye is three-quarters of the way across one square and at the very top, how far the space is between the hands. Relying on the preconceptions your brain has of the figure and what things should look like can lead to an inaccurate drawing.

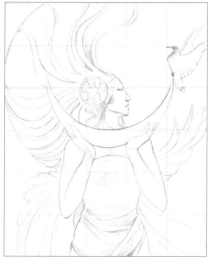

Complete the Sketch

Continue fleshing out the details and light shading. It's important to keep any shading light if you plan to paint over the sketch. If the pencil lines are too dark, they will make the paint's colors seem dirty. After you finish sketching, erase the grid lines.

Using Ideas Around You

IT'S EASY TO START A COLLECTION OF REFERENCE images for your paintings—anyone can do it! Just take a camera along to any interesting outdoor location and capture those scenes or elements you might find useful. Here are a few suggestions for places you can go to help you get started on your photo collection.

A Nearby Botanical Garden
It's always inspiring to stroll through the flower-beds or to take a hike at a reserve.

Your Own Backyard
Step outside in the springtime when all the flowers are in bloom and take snapshots of your own garden blooms and trees!

Keeping a Sketchbook

It's hard to have a camera on hand at all times, but a thin pocket-sized sketchbook can be useful for a mental recording of what is around you, or for when sudden inspiration strikes! Try to keep a sketchbook with you at all times because the best ideas can some-times come on you unexpectedly. But it's good practice for idle moments sitting in a café, at a park, waiting for the bus. Training yourself to draw quickly and to sketch people in motion is a valuable skill that will enhance your more polished pieces as well.

Aquariums
Even a nearby tropical fish pet shop will do for ideas. Look at the colors and markings on the fish, and the shape of the fins.

Your Local Zoo
Ideas and references are all over the place at any zoo. Horns and antlers can be used for fantastical creatures. A snake's body for a dragon. An antelope for the grace of a unicorn. The avian creatures for angels and faeries. Snap some shots of creatures in action—walking, resting and stretching—for a full spectrum of poses.

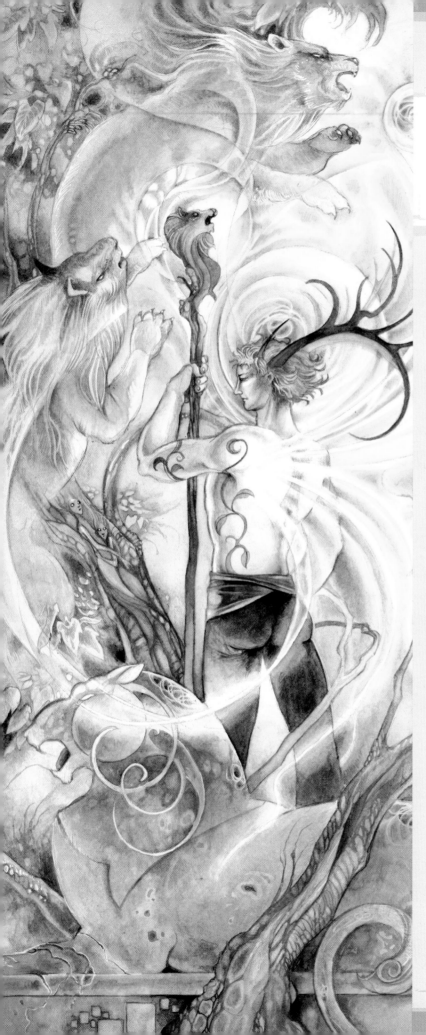

the SUN

THE SUN IS A MOST POWERFUL EMBLEM. WITHOUT its warmth, the earth would lie barren and cold. From the first sparkling rays of dawn until it sleeps in the western horizon embraced by fiery-colored clouds, it rides its arc across the skies, as if carried by a chariot.

In fact, there are many tales that attribute a god riding at the head of a blazing chariot to bear the sun across the skies. Two such examples are the ancient Greek Helios, who rides his fire-breathing chargers across the daytime sky, and the Norse goddess Sol, who rides her horse and chariot through the heavens while being chased by the wolf brothers Skoll and Hati. The sun Sol bore gave off heat, but it was the streaming manes of her mounts that were the source of light. It was said that solar eclipses were the result of those wolves almost catching her.

With its celestial rays possessing such grand dominion, it is no surprise that authoritative figures throughout history have sought to link themselves to the sun, as if to elevate themselves to a more heavenly realm. In ancient Egypt, the pharaohs took on the title *Son of Ra* to liken themselves to that heavenly force of life and power. Likewise, King Louis XIV of France was dubbed *The Sun King,* as if to imply that his kingship was akin to that of the sun.

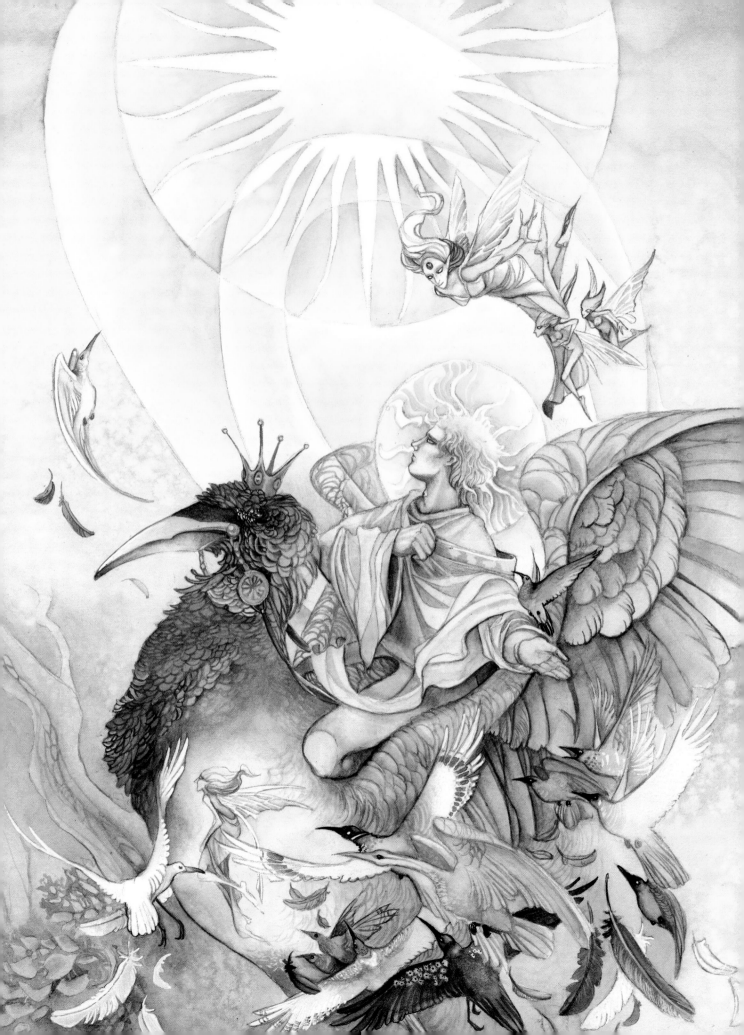

Sketching Ideas for the Sun

THE SUN IS INTRINSICALLY ASSOCIATED WITH life. In fact, no matter what incarnation the sun takes, this attribute is always made apparent. Whether symbolized in the lively flow of a creature's mane, the physical strength and attributes of a man's body, or the brilliant colors that cloak man and beast alike, the vibrant, pulsating power of light in the daytime sky forever shines through, evoking life itself.

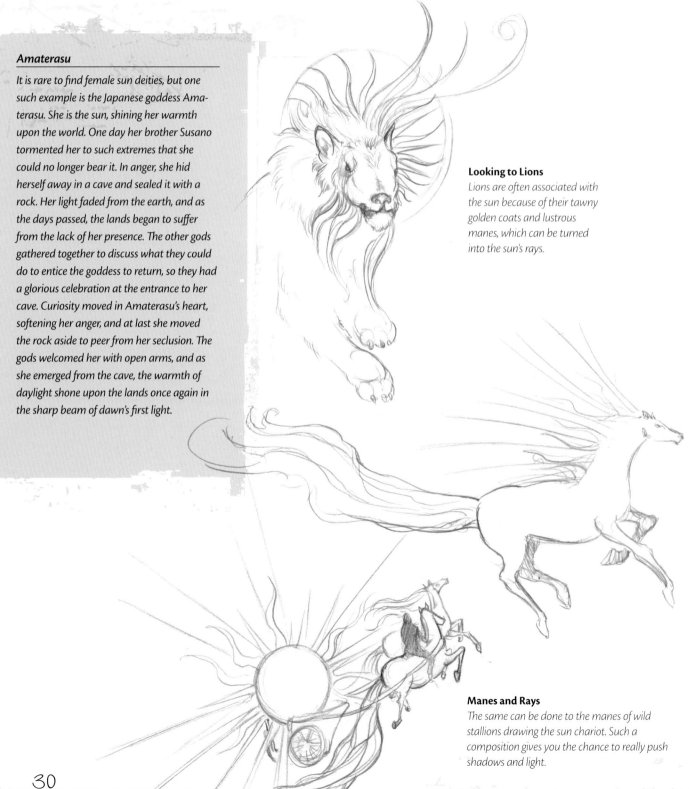

Amaterasu

It is rare to find female sun deities, but one such example is the Japanese goddess Amaterasu. She is the sun, shining her warmth upon the world. One day her brother Susano tormented her to such extremes that she could no longer bear it. In anger, she hid herself away in a cave and sealed it with a rock. Her light faded from the earth, and as the days passed, the lands began to suffer from the lack of her presence. The other gods gathered together to discuss what they could do to entice the goddess to return, so they had a glorious celebration at the entrance to her cave. Curiosity moved in Amaterasu's heart, softening her anger, and at last she moved the rock aside to peer from her seclusion. The gods welcomed her with open arms, and as she emerged from the cave, the warmth of daylight shone upon the lands once again in the sharp beam of dawn's first light.

Looking to Lions
Lions are often associated with the sun because of their tawny golden coats and lustrous manes, which can be turned into the sun's rays.

Manes and Rays
The same can be done to the manes of wild stallions drawing the sun chariot. Such a composition gives you the chance to really push shadows and light.

30

Apollo, the Sun God

You can also turn to classical mythology for sketch ideas. To the ancient Greeks, Apollo was the patron god of music, poetry, archery and lord of the sun.

Even if you are not completely sure of the finished pose you want to use, it's sometimes helpful to draw a quick little thumbnail of the general concept. If you don't feel comfortable enough to do thumbnails with fleshed out forms, simplify your concept to more basic lines.

The shoulders and hips are at a tilt that creates the tension of this pose.

Notice the whole body is aligned along an arc that mirrors the taut bow and gives tension to his pose.

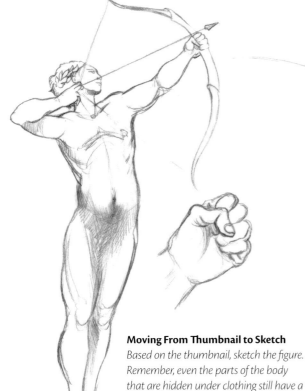

Moving From Thumbnail to Sketch

Based on the thumbnail, sketch the figure. Remember, even the parts of the body that are hidden under clothing still have a volume that you can't ignore.

Keep the Underlying Form in Mind

An easy mistake to make is to create a clothed figure without thinking about the muscles that fill out the clothing. The clothing doesn't just fit over an empty space—it clothes a human body. If you focus only on the portions of the body that you can see and ignore the rest, it will be obvious to the viewer.

This might look OK at first glance, but to have his left arm and shoulder so low would mean that his body must be twisted or contorted into a different position to allow for it. The sketch loses its believability.

Finishing the Sketch

Once you have a firm grasp of how the body is posed, you can add the clothing, erasing hidden portions as you go. As you become more adept, you will find that you don't need to actually draw out the underlying form as often because you can envision it in your mind and learn to see the hidden portions.

31

The Sun
PAINTING THE DAYTIME SKY

Sun is pure light and a lack of shadow in the sky. Be sure to take advantage of the white of the paper to create highlights and to let the sunlight glow on the page.

Splatter rubbing alcohol on the surface to create a nebulous base for the clouds that you can refine into wispy drifts. You could also lift out the white areas with a wet paper towel.

MATERIALS LIST

Watercolors ～ Cerulean Blue, Naples Yellow

Brushes ～ ½-inch (12mm) flat, no. 2 round

Other ～ Paper towels, rubbing alcohol

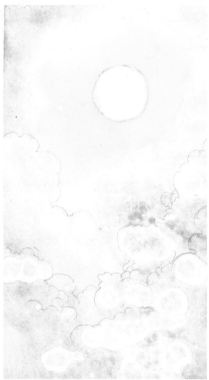

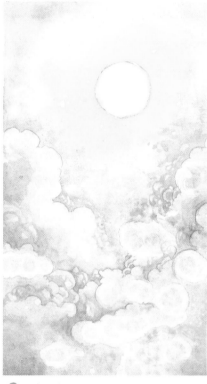

1 Lay In Color and Add Texture
The sun itself is the brightest, so be sure to leave it white. With a ½-inch (12mm) flat, wet everything except for the sun, and then paint wet-into-wet Naples Yellow around the sun, fading to Cerulean Blue. Splatter with rubbing alcohol to create texture.

2 Sketch In the Clouds
Using the irregularities created by the rubbing alcohol, sketch in rough towering cumulus cloud shapes.

3 Define the Clouds
With a no. 2 round and Cerulean Blue, paint in shadows to define the cloud shapes, enhancing the irregularities created by the rubbing alcohol.

Creating Cloud Formations

When you're ready to branch out from simple cumulus cloud formations, you can create other types of clouds by applying the following technique to different base textures. If you play around with different ways of lifting the color—whether it be by splattering rubbing alcohol or salt, dabbing or dragging a paper towel across your surface, or any other method you can think of—you can create an impressive variety of cloud formations.

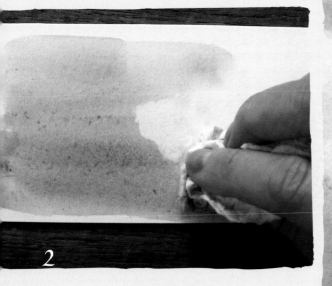

1

2

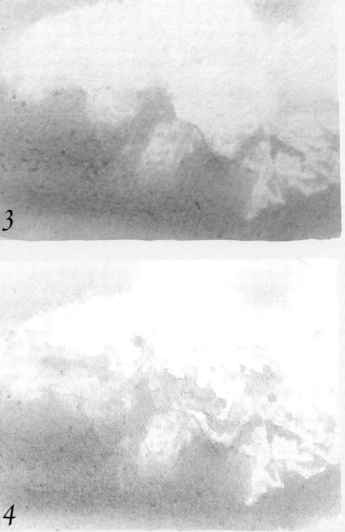

3

4

1 Lay In Base Color
Start by applying a wet-into-wet base of Cobalt Blue to your paper.

2 Lift Color
While the paint is still wet, take a paper towel and dab to lift color and create soft-edged white areas.

3 Allow Paper to Dry
Wait for your surface to dry completely before moving on to add the finishing touches.

4 Add Details
To suggest depth and shape, add shadows to the larger cloud masses with a light glaze of Ultramarine Violet.

The Sun
SUN WORSHIP

In the burn of morning light, the mists peel back from the ground. The last stray tendrils evaporate in the golden haze of sunlight as if physical fingers reach out to brush away the clinging, tenacious cobwebs. The sun beckons from beyond the window-panes with the many voices of the birds, in a dozen notes, in a hundred singing dust motes. Let illusions fall away beneath this brilliance!

MATERIALS LIST

Watercolors ～ Alizarin Crimson, Brown Madder, Burnt Sienna, Burnt Umber, Cadmium Orange, Cadmium Yellow, Lemon Yellow, Naples Yellow, Payne's Gray, Prussian Blue, Sap Green, Ultramarine Violet, Viridian Green, Yellow Ochre

Brushes ～ 1-inch (25mm) flat, nos. 0, 1, 2, 4 and 6 rounds

Other ～ Rubbing alcohol

1 *Finish Sketch and Add Golden Halo*
Sketch the picture. Then using a no. 2 round and Lemon Yellow, add color around the figure's sun halo.

2 *Lay Background Base*
Using Naples Yellow, paint in the background. In the open areas use a 1-inch (25mm) flat, but as you come to the tight corners, switch to a no. 6 round. Don't worry about avoiding the smaller twigs, but avoid the main foreground elements. Let the color fade toward the top. Splatter the wet paint with large drops of rubbing alcohol.

3 *Deepen the Background Tones*
Add more depth to the background by darkening the tones in the lower half. Use Burnt Sienna with a no. 6 round in the lower half, blending toward the upper half. Sprinkle with more rubbing alcohol. Don't worry about keeping these background layers smooth. They will become cloud layers later.

4 *Paint In Clouds*
Mix a little bit of Sap Green with Burnt Sienna, and with variations of that mixture, paint in the lower clouds. As you move up the page, change the mixture to Lemon Yellow and Burnt Sienna. Use nos. 0 to 2 rounds. Explore the irregularities of the initial washes and textures made by the rubbing alcohol by enhancing the bubbly textures already there.

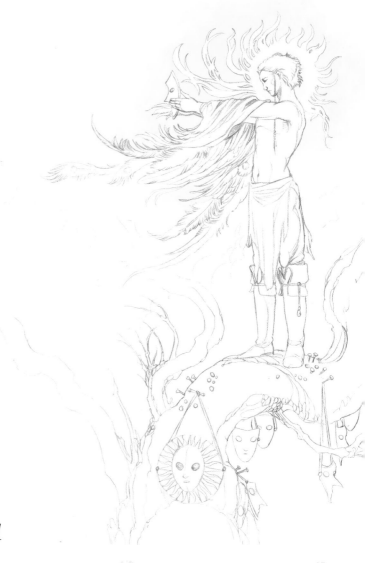

1

2

3

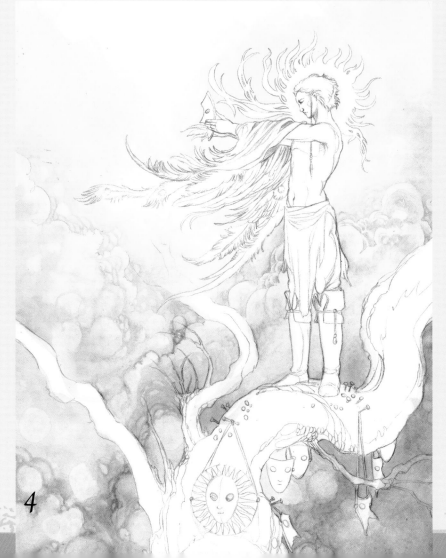

4

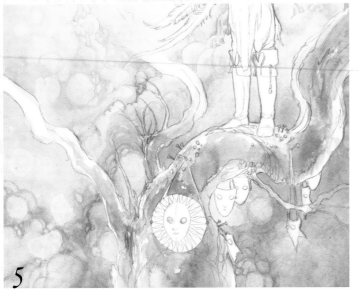

5

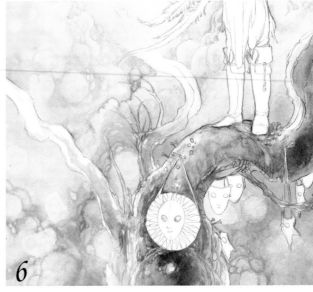

6

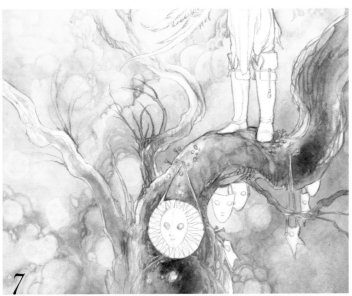

7

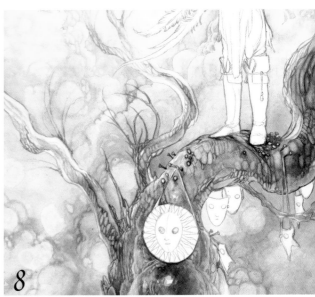

8

5 Lay In Tree Base
With a mixture of Brown Madder and Burnt Sienna, use a no. 4 round and the dry-brush technique to paint a textured base layer for the tree.

6 Suggest Tree Shadows
The strongest light will be coming from the upper left side. Thus, when working in the shadows, focus these toward the front, right and lower limbs of the tree. Mix Ultramarine Violet and Viridian Green, and with a no. 2 round, add shadowy washes along the lower right side of the branches. With smaller nos. 0 and 1 rounds, paint in basic bits of bark texture as well.

7 Finish Lighter Branches
For the arms of the branches that stretch out toward the upper left, let them fade with the background colors. For the distant branches, paint light layers of Yellow Ochre using a no. 2 round. Be sure to leave some bits of white paper showing through along the edges. With a no. 0 round, trail out the little twigs. Smooth and blend them, lightly brushing clear water over the strokes.

8 Create Bark Texture and Details
Add more definitive texture to the bark using a no. 0 round and a mixture of Burnt Umber and Ultramarine Violet. Lift out highlights with a no. 1 round and some clean water, scrubbing lightly then dabbing the liquid with a paper towel.

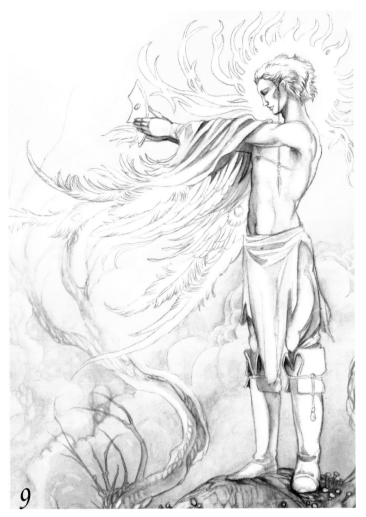

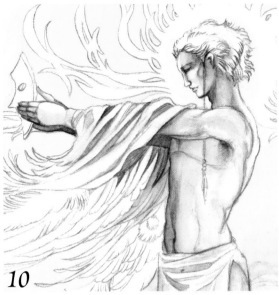

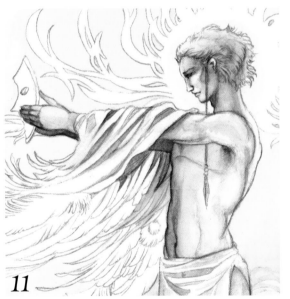

9 Paint Shadows on the Figure
Mix Ultramarine Violet and Burnt Umber, and paint shadows on the clothing with a no. 0 round. Then, using just Burnt Umber, paint the shadows on his skin.

10 Refine Skin Tones
Mix Naples Yellow and a tiny bit of Alizarin Crimson, and dilute the tones. With a no. 2 round, paint a wash over his skin, leaving an edge of white along the back of his neck and back, and the top side of his hands.

11 Add Details
Using a no. 0 round, paint an edge of Sap Green along the shadows on the right side of his body to reflect the surroundings. Do the same for the shadows on his face, around the eyebrows and his jawline. Be sure to leave white edges, especially along his back and the top of his arms, where the light is coming from.

Use a little bit of Payne's Gray for nostrils, eyes and lips. For the hair, wet the area, then drop in some Cadmium Orange wet-into-wet, concentrating the color in the center near his ear and leaving white around the edges.

12 Darken the Halo
With Cadmium Yellow, use a no. 1 round to darken the halo around his head. Contrast the white edges of his hair and the sun's rays with darker yellow to make them stand out. Then with a no. 0 round, add a little bit of Sap Green at the halo in back of his head to create more contrast.

13 Fill in Clothing
Use a no. 1 round and a mixture of Burnt Umber and Payne's Gray to paint a glaze over the shadows of his boots. For his pants, paint a glaze of Yellow Ochre.

14 Color Cloak and Loincloth
With a mixture of Cadmium Orange and Alizarin Crimson, use a no. 2 round to glaze over the shadows of the cloak and loincloth. Use a no. 0 round and a mixture of Burnt Umber and Payne's Gray to paint the shadows on the feathers. For the textured bits, use short parallel strokes along the grain of the feather.

15 Begin Painting Feathers
Use a variety of colors for the feathered fringe of the cloak. Starting with a no. 0 round, paint in some long trailing peacock feathers with a glaze of Viridian Green, fading to Prussian Blue closer in the shadows. Trail off the ends of feathers with clean water to blend more softly into the surroundings. Keep the glazes light enough to see the shadow textures painted in the previous step.

16 Continue Developing Feathers
Alternating between Alizarin Crimson, Cadmium Orange and Cadmium Yellow, glaze some more fiery colored plumes. Again, soften the tips with clear water. Add some contrast with some Sap Green pinions as well.

17 Finish Feathery Details
Retain a few white feathers in your composition, but add some shadows to them with an Ultramarine Violet glaze over the areas closer to his body. Add some Burnt Umber stripes and patterns to a few of the longer trailing feathers.

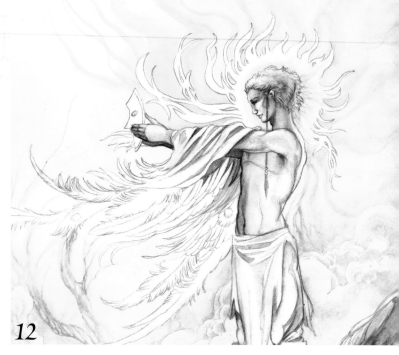

12

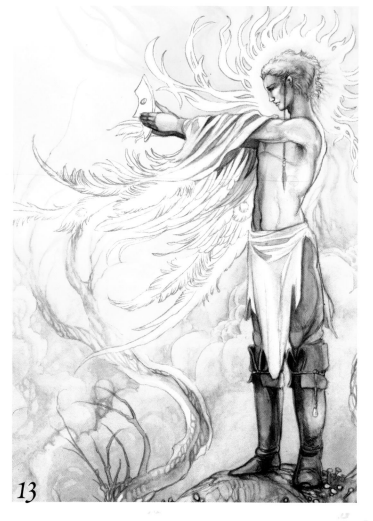

13

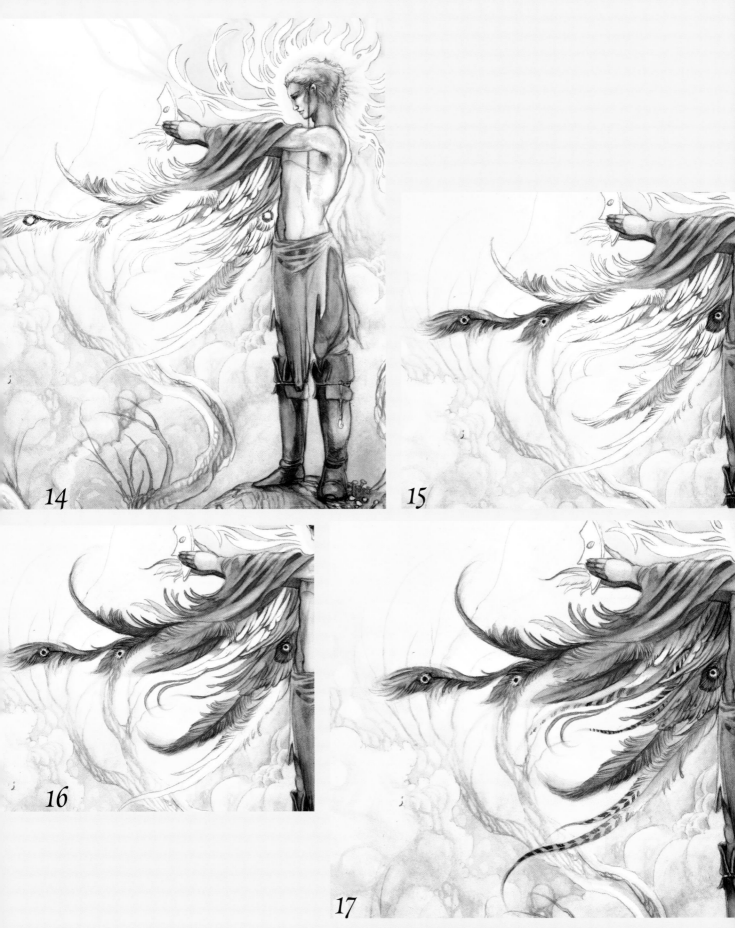

14

15

16

17

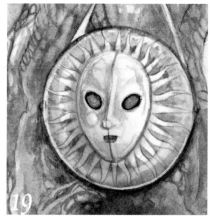

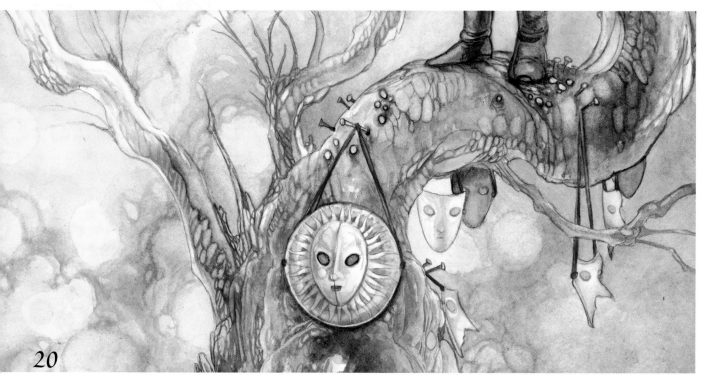

18 **Lay In Base Color of Central Mask**
Using a no. 1 round, paint a basecoat of Alizarin Crimson on the golden central mask. Leave plenty of white for what will be the shiny highlights and reflections.

19 **Add Golden Tones**
Paint a Cadmium Yellow glaze over most of the mask with a no. 2 round. Leave white highlights showing through along the rim and the upper edges. Finish off the eyeholes with Payne's Gray.

20 **Detail Other Masks**
With a no. 1 round and Yellow Ochre, paint the eyeholes of the other masks to match the background that shows through. Glaze shadows on the masks with a no. 1 round and Ultramarine Violet, and finish the ribbons off using Alizarin Crimson.

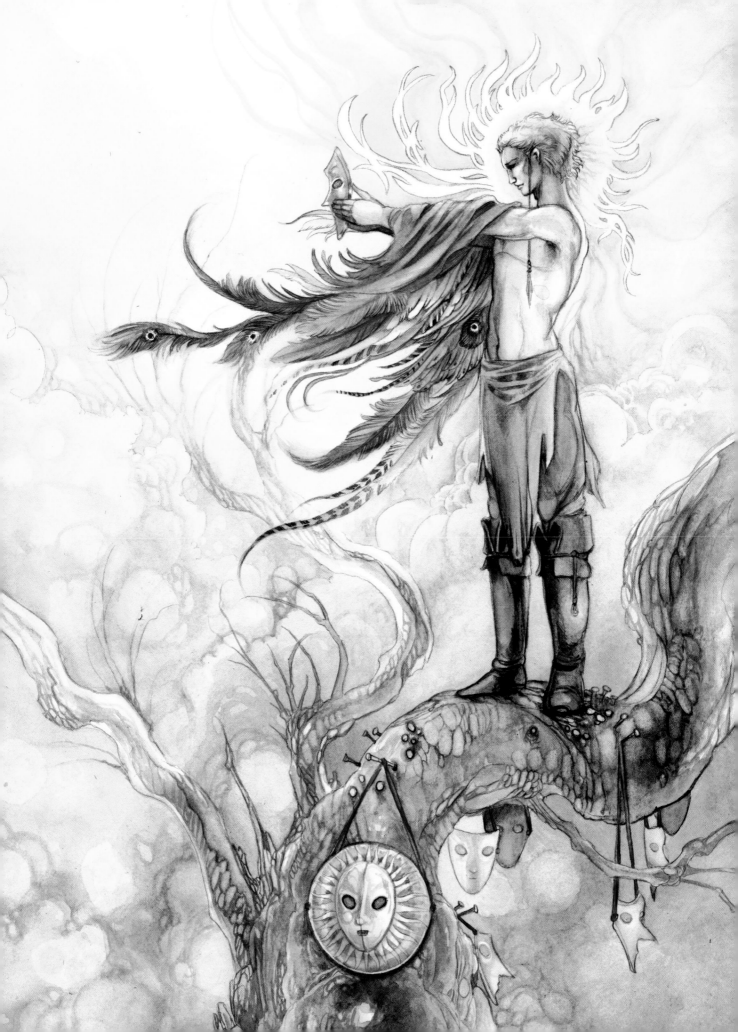

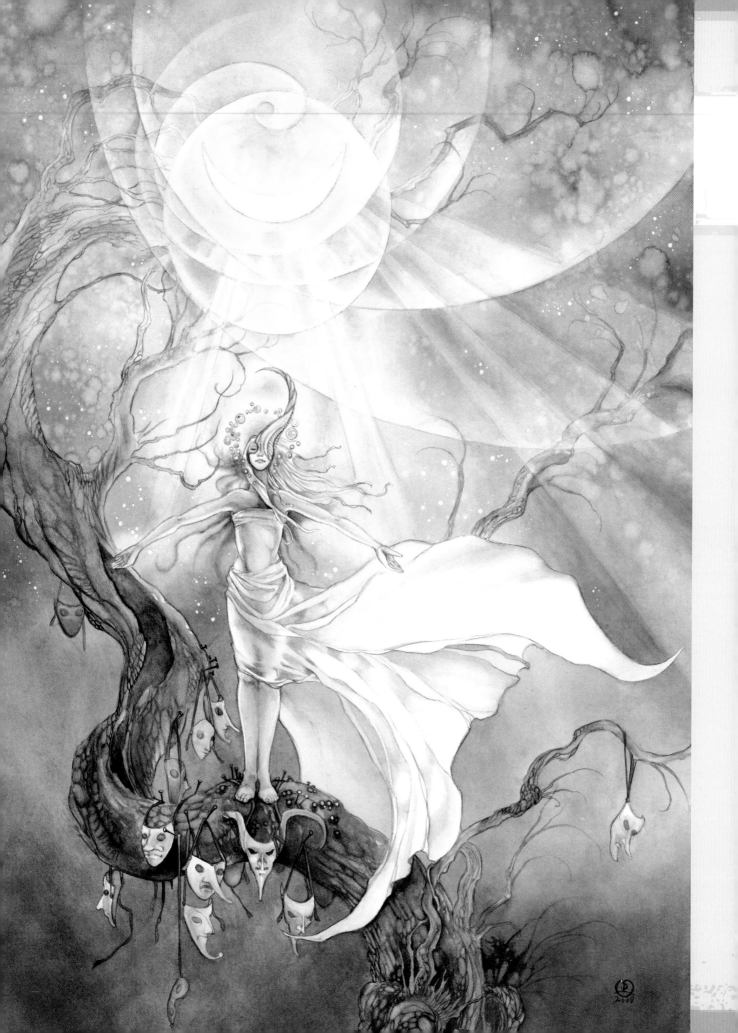

the MOON

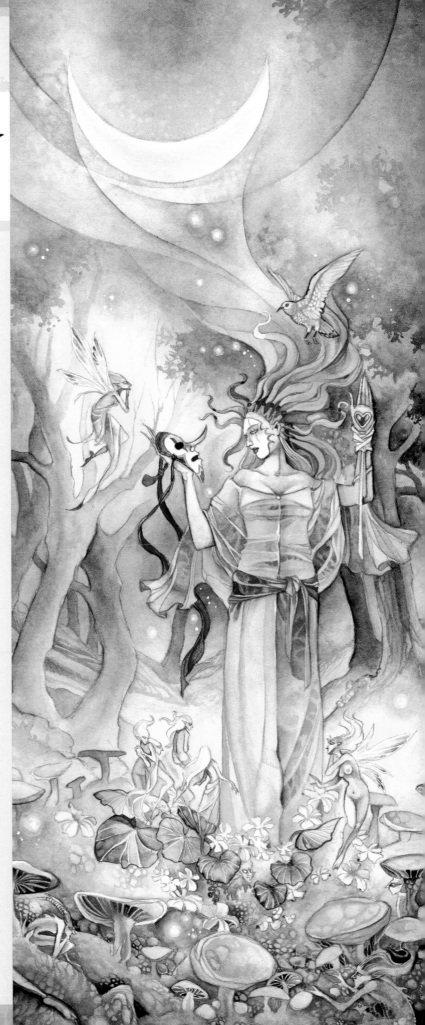

TWIN IN POWER TO THE SUN, THE MOON IS NOT frail—she is the ruler of the night skies. When the sun has settled to sleep just beyond the western horizon, it is she who soars into the heavens, illuminating the earth below.

Frequently tied to the divine feminine for the echo of her cycles, the moon has inspired fantasy in many cultures, proving herself a deity deserving of praise. Native Americans even assigned picturesque folk names for the full moon in each month: Flower Moon for May, who shone her light on the soils carpeted with spring blossoms; Harvest Moon for October, who kept watch when the corn was ready to be harvested; and Long Nights Moon, who ruled the sky during the frigid depths of December.

Likewise, the moon has been said to imbue madness. Some cultures believe that to be touched by moonlight while sleeping is to court lunacy. In fact, the word *lunatic* is derived from the Latin word for moon, *Luna*, who is also the Roman goddess of the moon.

With a myriad of legends from which to choose, it's no surprise that modern incarnations of the moon and her iridescent glow embody various combinations of all these attributes.

Depicting the Celestial Maiden

As you ponder how you'd like to portray your celestial maiden, there are a few questions you'll want to ask yourself. First, do you want to depict the maiden metaphorically as the moon, using her shape or a popular association to suggest she is a physical representation of the moon? Or perhaps you prefer a simpler symbolic association? Better still, how about a more fanciful and fantastical approach that tells a tale?

Ch'ang-O, the Maiden on the Moon

Ch'ang-O was an immortal in Heaven. For a transgression against the Jade Emperor, she was reborn in mortal form as a beautiful girl.

One day a strange thing happened, and ten suns rose into the sky. The blazing heat of these ten suns shriveled the land. A young hunter named Hou-Yi stepped forth and taking aim, he shot down nine of the suns and saved the lands. Ch'ang-O married him, and in time he became king.

However, power corrupted Hou-Yi and he turned into a tyrant. He sought immortality, and when Ch'ang-O discovered that he had at last acquired a pill that would grant him his desire, she stole the pill. Hou-Yi took chase, and in the confusion that followed she accidentally swallowed the pill. When she leapt out a window, she floated up into the sky and to the moon, where she lives to this day.

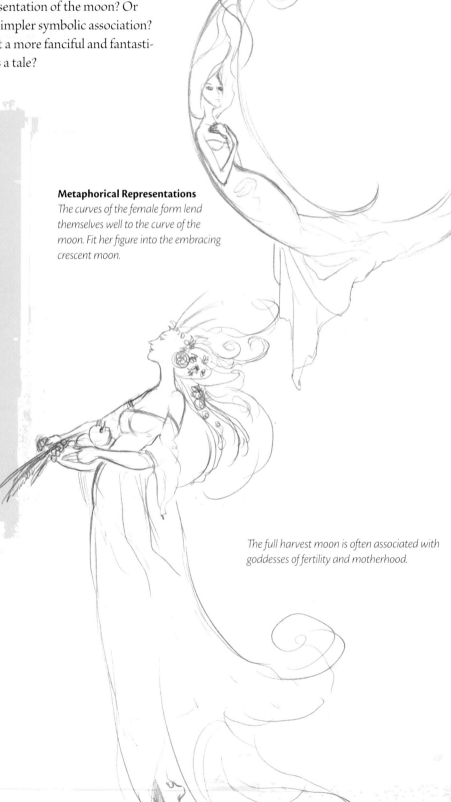

Metaphorical Representations
The curves of the female form lend themselves well to the curve of the moon. Fit her figure into the embracing crescent moon.

The full harvest moon is often associated with goddesses of fertility and motherhood.

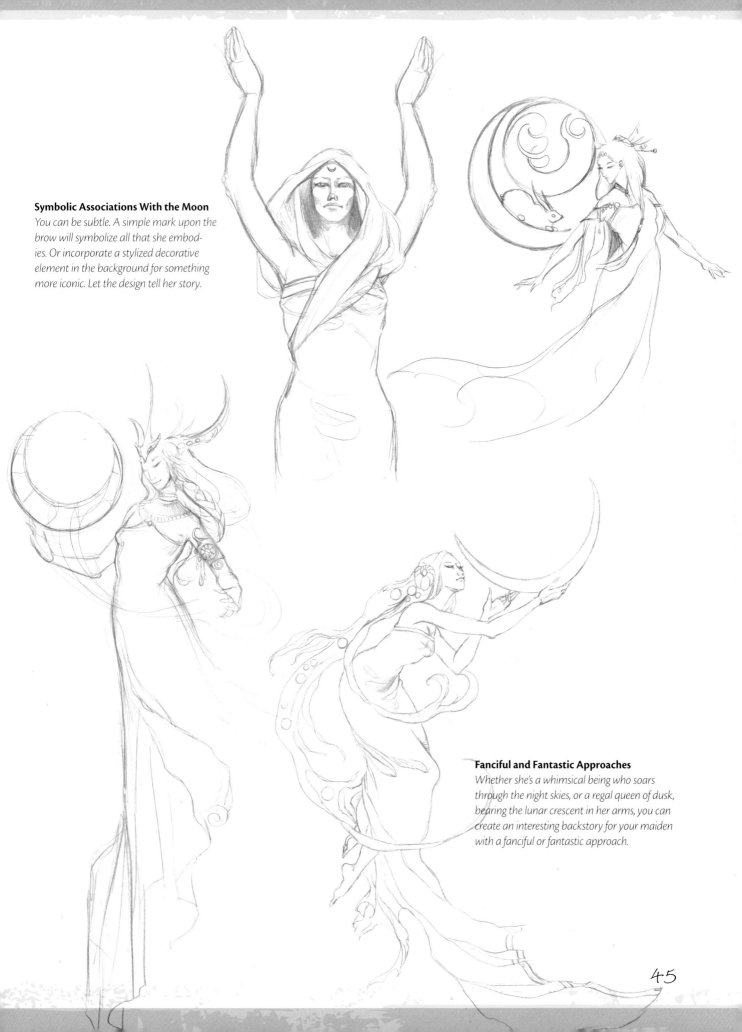

Symbolic Associations With the Moon
You can be subtle. A simple mark upon the brow will symbolize all that she embodies. Or incorporate a stylized decorative element in the background for something more iconic. Let the design tell her story.

Fanciful and Fantastic Approaches
Whether she's a whimsical being who soars through the night skies, or a regal queen of dusk, bearing the lunar crescent in her arms, you can create an interesting backstory for your maiden with a fanciful or fantastic approach.

The Moon
MOONLIT CLOUDS

There is a magical feeling inspired by the full moon on a dark night. When the Wind trails his fingers through the sky and breathes a lazy puff of air to part the clouds, then the bright disk gleams silver and lines the edges of the clouds and trees with a shimmering light.

MATERIALS LIST

Watercolors — Cobalt Blue, Indigo, Lemon Yellow

Brushes — ½-inch (12mm) flat, nos. 1, 2 and 6 rounds

Other — No. 0 round (optional), white gel pen, White gouache (optional)

1

2

1 Lay In the Moonlit Glow
Wet the entire area. Paint wet-into-wet in broad sweeping strokes with a ½-inch (12mm) flat, spiraling inward toward the moon with Indigo.

2 Enhance the Moon's Glow
When that has dried, erase the pencil lines. With a no. 6 round, paint a Cobalt Blue nimbus around the moon itself. Blend outward into the surrounding Indigo, and run a clean, wet brush along the inner edge to soften that contour as well.

3 Paint the Clouds' Shadows
Still with the no. 6 round, tap in clouds with more Indigo. Switch to smaller sized brushes to imply more delicate trailing cloud details.

4 Lift Highlights
Using a no. 2 round, dab a tiny bit of diluted Lemon Yellow to the clouds, using just enough paint to suggest a slight hint of color. Lift out highlights along the cloud bank by rubbing the brush in small circular motions then dabbing away the excess liquid with a paper towel.

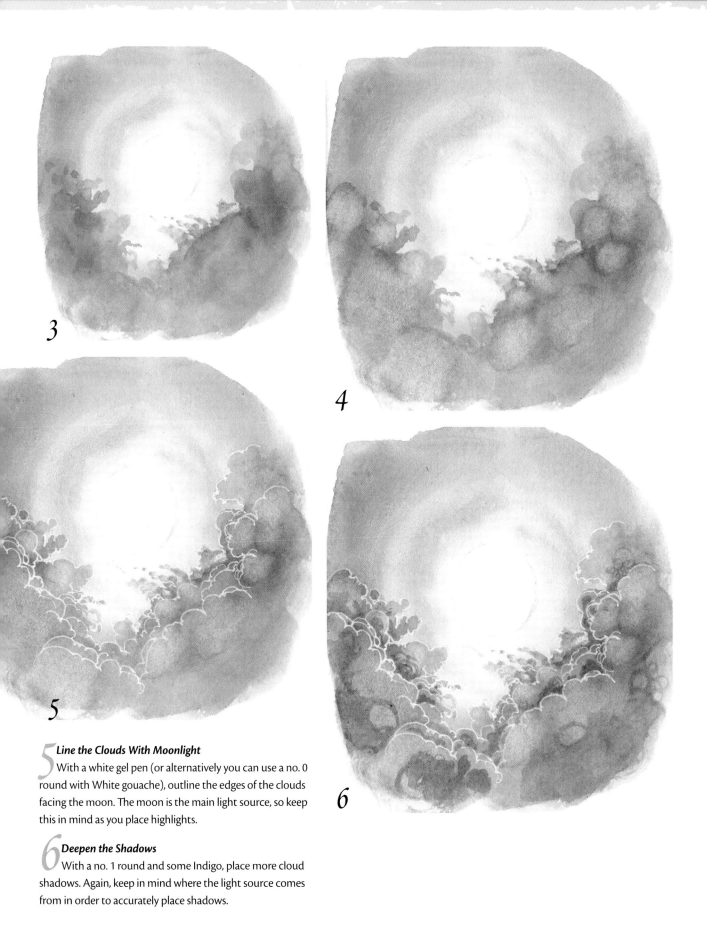

3

4

5

5 Line the Clouds With Moonlight
With a white gel pen (or alternatively you can use a no. 0 round with White gouache), outline the edges of the clouds facing the moon. The moon is the main light source, so keep this in mind as you place highlights.

6 Deepen the Shadows
With a no. 1 round and some Indigo, place more cloud shadows. Again, keep in mind where the light source comes from in order to accurately place shadows.

6

The Moon
LONE MOON

The crescent moon holds a different mystery than the full moon. The sliver of light gleams in the night sky, a symbol of beginnings and endings.

Instead of working from the dark space surrounding the moon inward toward the light, you can do the reverse and move outward from the moon. This method is sometimes useful when you have irregularly shaped objects.

MATERIALS LIST

Watercolors ～ Cerulean Blue, Cobalt Blue, Indigo

Brushes ～ ½-inch (12mm) flat, no. 6 round

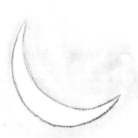

1

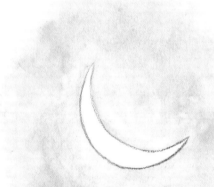

2

1 Sketch the Moon and Add the First Layer
Using a no. 6 round, paint a Cerulean Blue area around the moon's contour, blending outward into the white of the page.

2 Darken the Sky
Continuing the outward darkening, paint a glaze of Cobalt Blue from the edges of the Cerulean Blue. Again, blend outward with water into the white of the page.

3 Blend the Colors
Then using a ½-inch (12mm) flat and Indigo, blend the colors into the outer edge of the Cobalt Blue areas, moving in from the corners and using broad sweeping strokes to blend the tones.

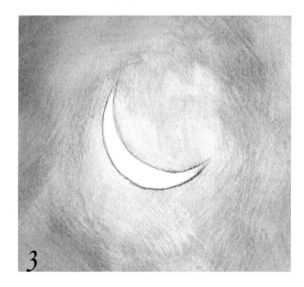

3

The Moon
STARRY SKIES

What painting of the nighttime sky would be complete without the moon's constant companions, the stars? There are two easy methods you can employ to indicate the stars in the heavens. Don't limit yourself to using just one of the two techniques—combine them in any number of ways to achieve your desired results.

MATERIALS LIST

Watercolors ～ Cerulean Blue, Cobalt Blue, Indigo

Brushes ～ ½-inch (12mm) flat, no. 0 and 2 rounds

Other Masking fluid, white gel pen, White gouache

Painting Opaque White on Top

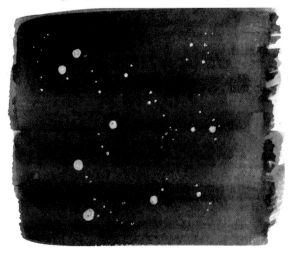

1 Lay in the background color of the sky.

2 Using a no. 0 round brush and White gouache, dot in a random pattern. White gel pens also work very well for this.

Masking Ahead of Time

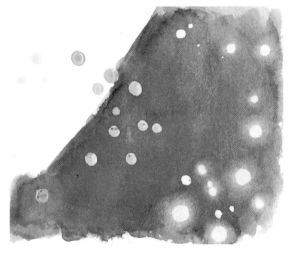

1 Dot in masking fluid stars. Then paint the sky in over the masked stars.

2 Once the paint has dried, remove the masking fluid. Then with a no. 2 round and clean water, lift around some of the larger stars to soften the hard edge left by the masking fluid and to create a glowing effect.

Combining Techniques

Combining Techniques
The larger stars here were created by masking and lifting to create a nice glow, while a smattering of smaller pinprick stars were added afterward with White gouache.

Keep Light Sources in Mind

Generally, the closer the light source to the subject of the piece—and the more focused in its intensity—the more dramatic the lighting becomes. If you pull the light source farther away, it becomes more of a secondary feature to the piece.

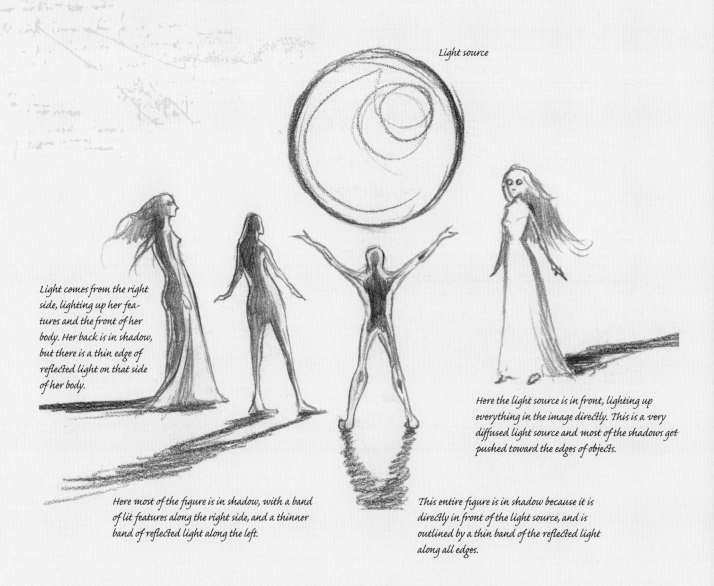

Light source

Light comes from the right side, lighting up her features and the front of her body. Her back is in shadow, but there is a thin edge of reflected light on that side of her body.

Here the light source is in front, lighting up everything in the image directly. This is a very diffused light source and most of the shadows get pushed toward the edges of objects.

Here most of the figure is in shadow, with a band of lit features along the right side, and a thinner band of reflected light along the left.

This entire figure is in shadow because it is directly in front of the light source, and is outlined by a thin band of the reflected light along all edges.

Always keep the light source of a piece in mind as you work. Determine the source of the lighting from the start. Once you have that established, keep the shadows in the piece consistent with that lighting.

The Moon
WINGS OF THE NIGHT

With her sister owl, the celestial maiden dances amidst the night sky. The stars are her ornaments, sparkling like gems in her hair, and the velvet fold of her gown is the curtain drawn across the horizon. She bears the moon aloft as a beacon in the darkness, and in its silver light, a quiet peace is rained down in silver-lined shadows and silver-edged dreams.

The light of the moon is different from the brightness of daylight. The silver-blue light leaches color, and the world becomes more monochromatic, as if viewed through a colored filter. By limiting the palette to a mostly monochromatic scheme with pinpricks of brightness, the sense of nighttime will be enhanced in the scene.

MATERIALS LIST

Watercolors ～ Alizarin Crimson, Burnt Sienna, Cerulean Blue, Cobalt Blue, Indigo, Lemon Yellow, Naples Yellow, Prussian Blue, Ultramarine Blue, Ultramarine Violet

Brushes ～ Nos. 0, 1, 2, 3, 4 and 6 rounds

Other ～ Masking fluid, rubbing alcohol, salt

1 Sketch the Figure and Prepare the Sky
With an old no. 1 round, dot masking fluid in the background for the stars.

When the masking fluid is dry, take a no. 4 round and paint a Cerulean Blue glow around the moon and upper figure. Let the color fade into the white paper surrounding the figure.

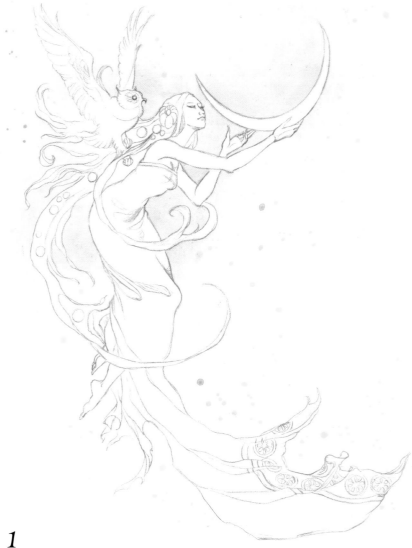

1

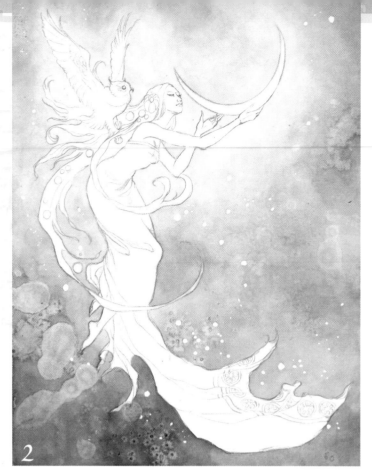

2 Lay In the Background Sky

Mix Prussian Blue with a touch of Alizarin Crimson. Use a no. 6 round to paint in the rest of the background, moving in from the edges of the piece. Fade out to the Cerulean Blue area by diluting the paint with water. Use a more concentrated tone at the bottom, away from the light source. While the paint is still wet, sprinkle salt and rubbing alcohol, concentrating the textures mostly near the bottom areas. Once dry, remove the masking fluid from the stars.

3 Create Glow Around the Stars

Use a bit of clean water on a no. 2 round to lift the color from around the stars and soften the hard edges left by the masking fluid. This gives them more of a feathered glow.

4 Suggest Moon Glow

Erase pencil lines from around the moon. Rub a no. 2 round with clean water along the contour of the moon's curve, lifting and blending the color into the white.

5 Add Background Texture

With a no. 2 round, use various mixtures of Cerulean Blue, Prussian Blue, Indigo and Ultramarine Violet to add texture and shadows into the background. Work in the areas between and around the stars and around the figure's upper body to enhance the glow effect she has.

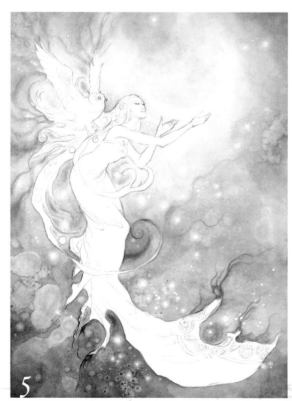

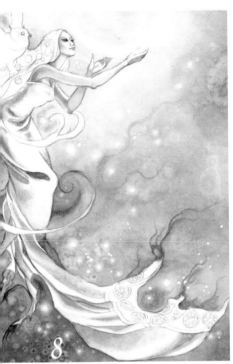

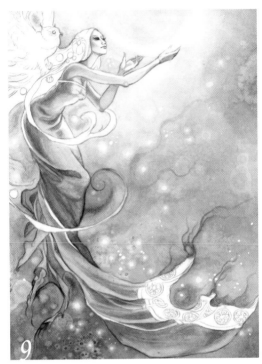

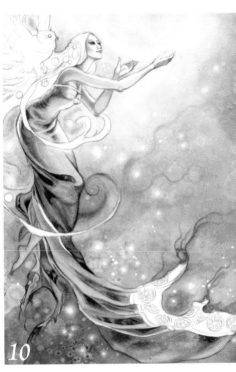

6 Indicate Shadows on Skin

With a no. 1 round, mix a tiny bit of Alizarin Crimson with Cobalt Blue to paint the shadows on her skin. Be sure to leave the brightest areas in her hands that are facing the moon unpainted.

7 Apply Glaze Over Skin

Mix Alizarin Crimson and Naples Yellow, and dilute the colors to make a very thin glaze of rose tones. Apply the glaze over her skin with a no. 2 round. Leave the front of her face, and the upper edges of her arms and hands white to take in the full glow of the moon.

8 Paint Shadows on the Dress

With a no. 2 round, mix Ultramarine Violet and Payne's Gray, and lay in the shadows on her dress.

9 Color In the Dress

With a no. 3 round, glaze a layer of Ultramarine Blue on her dress. At her chest and the upper part of her thighs facing the moon, use a bit of Cerulean Blue mixed in. Keep her left hip and the edges of her torso white, outlined by moonlit highlights.

10 Add Wrinkles and Creases to the Fabric

With a no. 1 round, use a mixture of Prussian Blue and Alizarin Crimson to paint in the darkest shadows in the creases of the robes and wrinkles in the material.

11

11 Add Decorative Border
With a no. 0 round, paint Lemon Yellow into the patterns on the border of her dress.

12 Fill In the Decorative Border
Mix Alizarin Crimson with Lemon Yellow. Fill in the decorative elements in the border. Add Ultramarine Violet to the mixture for shadows in the folds of the cloth.

13 Place Finishing Touches on the Decorative Border
Finish off the detail with Ultramarine Violet for some contrast to the pattern.

14 Create Glow Around the Jewels
With a no. 0 round, paint a Lemon Yellow glow around the cabochons in her hair.

15 Detail the Jewels
Mix Burnt Sienna and Lemon Yellow and add details to the gems. Leave a spot of white highlight.

12

13

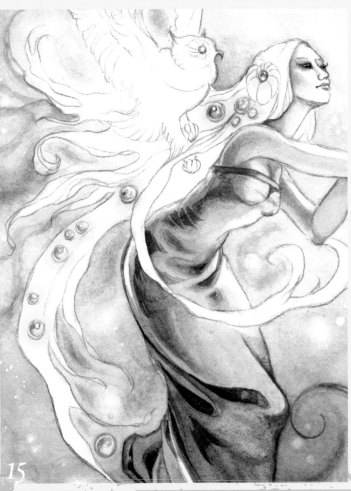

15

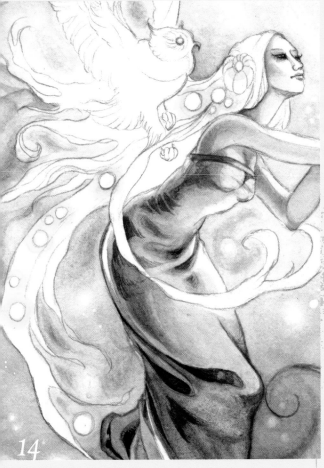

14

Glowing Cabochon Jewels

1 2 3

1 Paint a Lemon Yellow glow around the gem.
2 Paint the gem with Naples Yellow, being careful to retain
 the highlight areas of the white paper.
3 Mix a little bit of Prussian Blue with the Naples Yellow
 to add shadows and reflections. Blue is being used in
 this piece because that is the color of the surrounding
 elements and this is the reflected result. Different tones
 are used depending upon the background color of each
 individual piece of artwork.

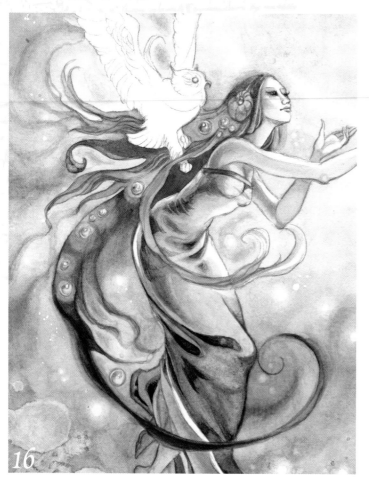

16 **Color In the Hair**
With a no. 0 round and a mixture of Burnt Umber and Payne's Gray, paint in her hair. Blend the color into the background blues by running a wet brush along the edges in the direction the hair flows. Wet the circle around each jewel, then use wet-into-wet to let the dark tones blend in around the glows.

17 **Place Shadows on the Owl**
Mix Cerulean Blue with a little bit of Ultramarine Violet and paint in the shadows on the owl's feathers with a no. 0 round.

18 **Finish the Owl**
Finish off the shadows and details on the owl by using Burnt Sienna on the claws, eyes and the edges of the wings.

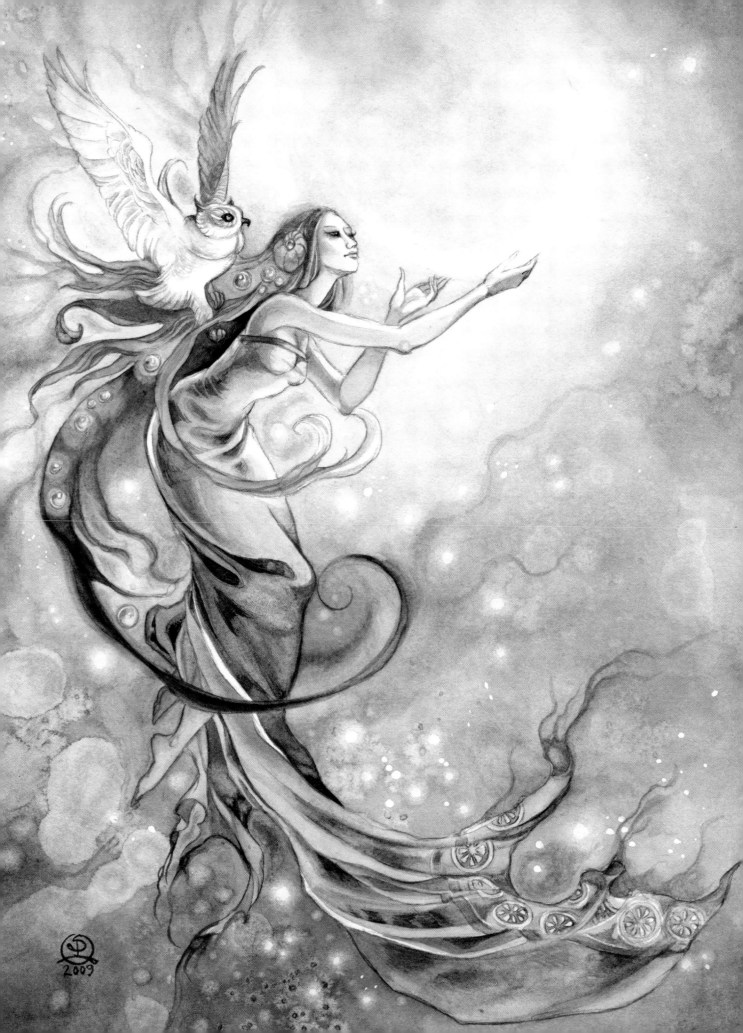

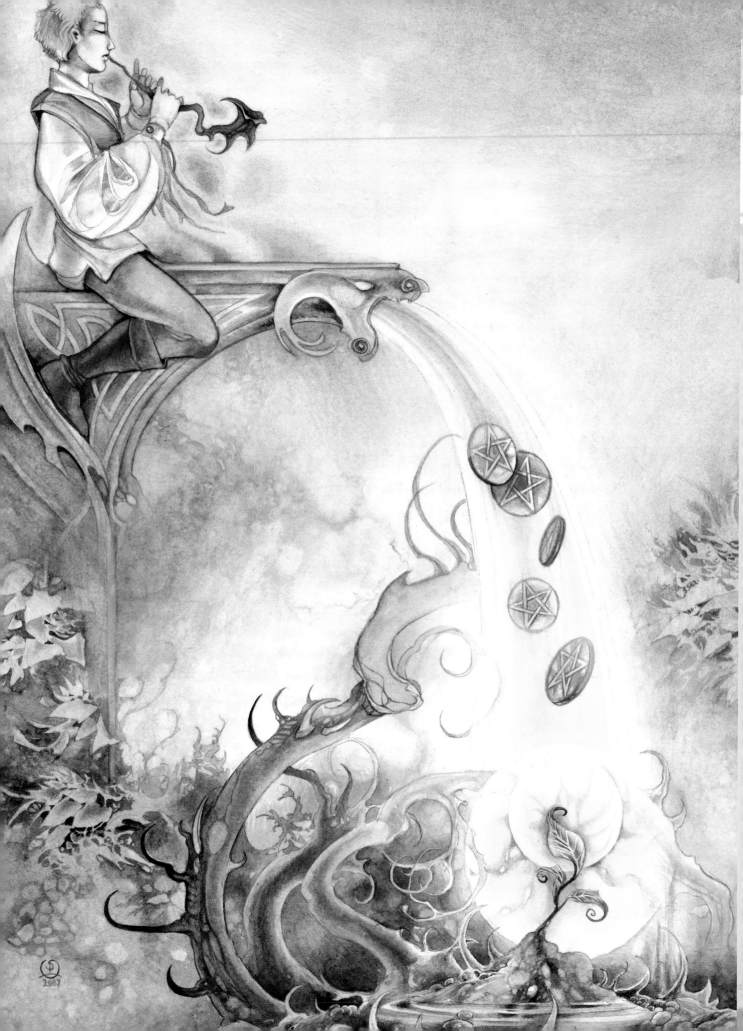

the BARD

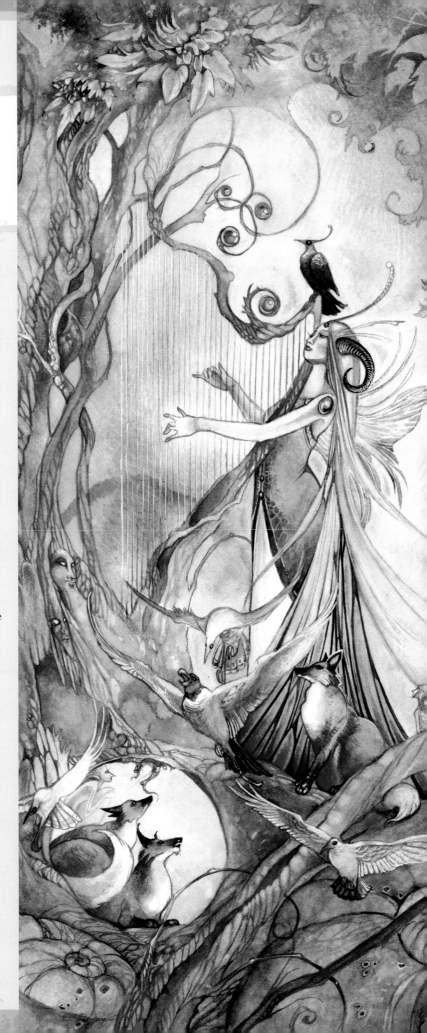

SOMETIMES A GOD AND SOMETIMES ALL TOO human, the bard weaves a spell with a voice that cannot help but be sway mortals and immortals alike. In fact, these men and women of legend sometimes hold influence over the very powers of life and death, and are often the only humans to be made immortals.

Famed stories about the bard seem almost countless. Thomas the Rhymer, who kissed the Queen of Elfland and was whisked away to her faery realms for seven years, was a bard. Taliesin, Arthur Pendragon's friend and advisor, was a bard. Scheherazade, who spun the thread of 1,001 nights to stay the hand of death by entrancing the ing with her fanciful tales was also a bard.

But perhaps the most widely known bard of all is Orpheus, who made Hades and Persephone weep with the beauty of his music and was thus granted his wish to take the soul of his beloved back to the mortal realms above. In Orpheus's impatience, however, he did not follow the spell that was laid upon him, "Do not look back, though you will not hear the tread of her footfall, nor the sound of her breath." On the final stretch of the arduous climb back to the land of the living, Orpheus doubted and turned to see if Eurydice was truly with him. As she dwindled back into the netherworld, he saw that he had lost the impossible gift that his music had so nearly granted him.

rawing Hands and Feet

So much emotion and movement can be expressed with hands. For example, if you're drawing a dancer, a storyteller or, in this case, a musician such as the bard, half of the impact of the piece will come from the hands. This means avoiding hands in your compositions is out of the question! Luckily, you have two perfectly good models right in front of you. Just use your own hands as a reference whenever you have a pesky hand pose you need to figure out.

Feet can be more easily and adeptly avoided than hands by using long grass, shoes and the hems of long skirts. But on those occasions when you do want to have bare feet peeking through, you should not let fear of drawing them stop you. The compositions and poses should be dictated by what the piece needs, not by your own artistic limitations. And, like hands, you can always take photos of your own feet to use for reference in a painting.

The Hand

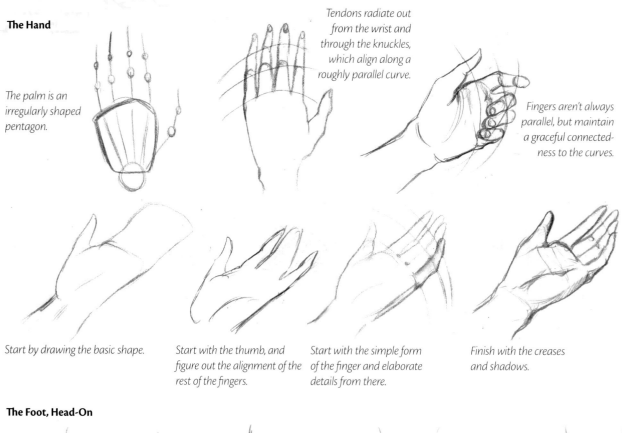

The palm is an irregularly shaped pentagon.

Tendons radiate out from the wrist and through the knuckles, which align along a roughly parallel curve.

Fingers aren't always parallel, but maintain a graceful connectedness to the curves.

Start by drawing the basic shape.

Start with the thumb, and figure out the alignment of the rest of the fingers.

Start with the simple form of the finger and elaborate details from there.

Finish with the creases and shadows.

The Foot, Head-On

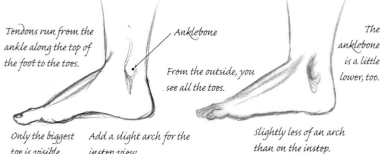

Tendons run from the ankle along the top of the foot to the toes.

Anklebone

From the outside, you see all the toes.

The anklebone is a little lower, too.

Start with just a basic form. The anklebone on the instep is higher than on the outside.

Concentrate on drawing what you see. A hint of the tendons, the toes lined up and the ball of the foot is a slight bulge on either side of the toes. Finish up with the details.

Only the biggest toe is visible.

Add a slight arch for the instep view.

slightly less of an arch than on the instep.

A Sideview of the Foot
Drawing a foot straight on is a bit more complicated. Look at your foot in a mirror to see how it looks.

Sketching Instruments

As Henry Wadsworth Longfellow said, "Music is the universal language of mankind." A bard's instrument therefore is an intimate part of him—the vessel through which he pours out his soul to the listening world.

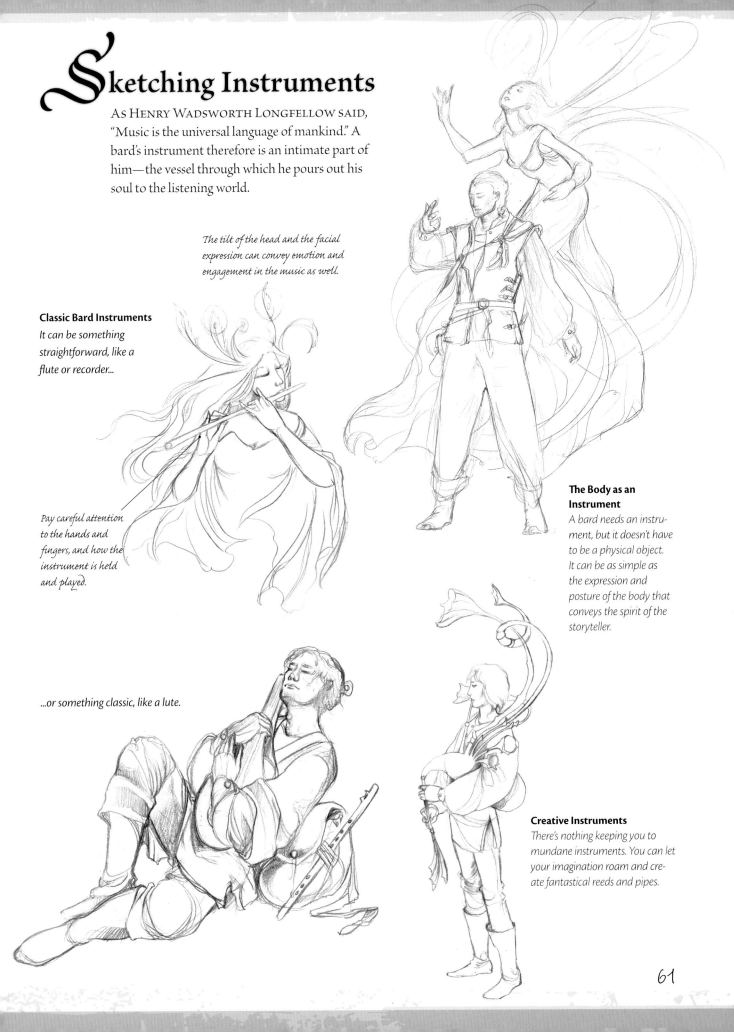

The tilt of the head and the facial expression can convey emotion and engagement in the music as well.

Classic Bard Instruments
It can be something straightforward, like a flute or recorder...

Pay careful attention to the hands and fingers, and how the instrument is held and played.

The Body as an Instrument
A bard needs an instrument, but it doesn't have to be a physical object. It can be as simple as the expression and posture of the body that conveys the spirit of the storyteller.

...or something classic, like a lute.

Creative Instruments
There's nothing keeping you to mundane instruments. You can let your imagination roam and create fantastical reeds and pipes.

Coloring Skin

As you move on to create the many figures of myth and magic in this book, you'll want to familiarize yourself with how to achieve proper skin tones. Painting skin tones can be very tricky—getting the right mixture of colors to accomplish the living glow of flesh is quite a daunting prospect! Hopefully, referring to this chart will take the mystery out of making mixes.

Here's a chart to show what kind of color mixtures you can use for various skin tones.

1 Very pale with a green or blue tinge
Shadow layer — *Viridian Green*
Main glaze — *Lemon Yellow, Alizarin Crimson, Cerulean Blue; medium intensity glaze*

2 Very pale, unnaturally white
Shadow layer — *Ultramarine Violet*
Main glaze — *Naples Yellow, Alizarin Crimson, Ultramarine Violet; very thin glaze*

3 Naturally pale
Shadow layer — *Ultramarine Blue*
Main glaze — *Naples Yellow, Alizarin Crimson, Ultramarine Blue; very thin glaze*

4 Medium tones
Shadow layer — *Burnt Umber*
Main glaze — *Burnt Sienna, Ultramarine Blue; light glaze*

5 Darks and browns
Shadow layer — *Prussian Blue*
Main glaze — *Burnt Umber, Naples Yellow, Prussian Blue; medium glaze*

6 Ebony
Shadow layer — *Payne's Gray*
Main glaze — *Burnt Umber, Prussian Blue; dark glaze*

Highlights
Highlights can really be any color, depending on the surroundings. Just remember to use a light touch when applying them. Dilute the colors and only glaze in selective areas to bring out highlights.

Dark shadows
Shadows are also reliant on their surroundings. However, cooler tones generally work better because they will contrast the main warm tones of the flesh.

Things to Avoid When Coloring Flesh

Don't just mix a peach color and paint this by itself over the skin areas. It will result in a cartoonish and very flat appearance (see below). Remember: Real skin tones have variation in color that require layers of glazes to accomplish. There is a lot of subtlety to the shifting of colors, and it is not just a uniform shade.

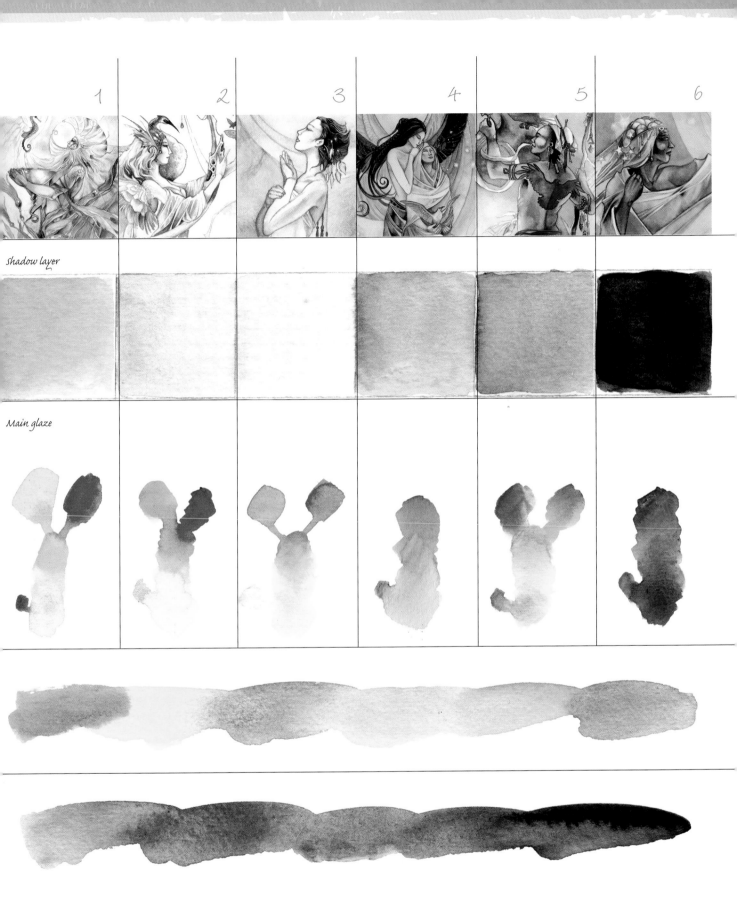

1 2 3 4 5 6

shadow layer

Main glaze

The Bard
PAINTING SKIN TONE

Each person's skin tones can be subtly different with multiple characters in a scene. It's important to show variation and individuality.

MATERIALS LIST

Watercolors ～ Alizarin Crimson, Burnt Umber, Naples Yellow, Prussian Blue, Sap Green, Ultramarine Blue, Ultramarine Violet, Viridian Green

Brushes ～ Nos. 0 and 2 rounds

For very pale skin, use lighter colors like blue and green. Viridian Green works well. Use a light touch and a no. 2 round so these colors don't overwhelm subsequent tones and give the skin a sickly hue.

1 Add the Shading Layer
Start by examining the shadows of your own skin. Notice how they are affected by the color of your surroundings, as well as the natural tone of your skin.

2 Make the Main Glaze
When the shading layer has dried, mix some colors for the main glaze.

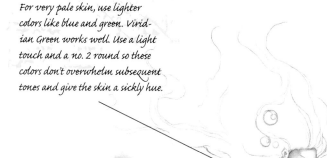

1

For very dark skin, paint shadows of Ultramarine Violet or Prussian Blue.

For pale skin try Ultramarine Blue or Sap Green.

For a light brown skin tone, or a tanned complexion, try Burnt Umber shadows.

Naples Yellow

Alizarin Crimson

Mixed

Diluted

2

A touch of Ultramarine Blue (not too much or it will turn the mixture greenish)

When painting this glaze, it doesn't have to be a flat layer. Use a no. 2 round and work wet-into-wet to create shadows and highlights, leaving some white of the paper showing.

An example of a variation for darker skin:

Naples Yellow

Burnt Umber

Mixed

Diluted

A touch of Prussian Blue added

Final mixture used for glazing the skin over the initial shadows

3 Suggest the Reflected Light

In some paintings, those two steps might be enough to accomplish your goal. But sometimes there is ambient lighting or reflections of strong colors from surrounding areas that also have an effect on the skin. If this be the case, you'll want to show this reflected light in the highlighted areas in particular.

If the figure is in a forest setting, there might be a bit of reflected Sap Green, or if underwater, Cerulean Blue. Use very diluted glazes over select areas. This helps to tie your figure into the background.

4 Deepen Shadows

You might also want to emphasize the shadows further if the initial shadow layer isn't dark enough. Or perhaps you need to enrich the shadows by layering a secondary color.

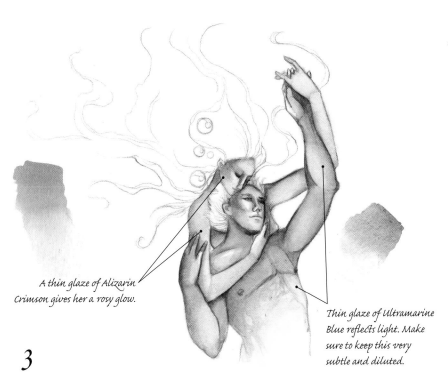

A thin glaze of Alizarin Crimson gives her a rosy glow.

Thin glaze of Ultramarine Blue reflects light. Make sure to keep this very subtle and diluted.

3

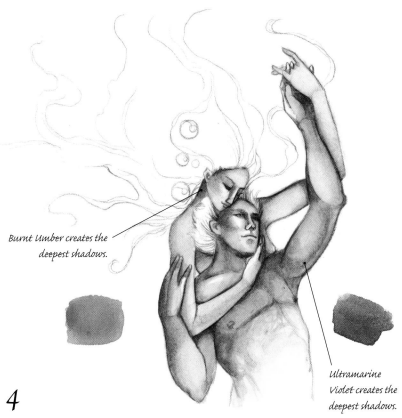

Burnt Umber creates the deepest shadows.

Ultramarine Violet creates the deepest shadows.

4

Mixing Skin Tones

Feel free to vary the mixture for the main glaze in any number of ways. For example, use Lemon Yellow and Brown Madder in the initial mix, or Burnt Umber alone. You can dilute the mixture more for lighter skin, or keep it intense for darker skin. Use more blue or Ultramarine Violet to pull the bright edge down. Experiment to find the right mixture for what you need.

Essentially, the basic concept here is that you want to mix some type of very diluted orange (yellow plus browns or reds) and then add just enough blue to take away the clownish bright orange overtones and to mute the colors a bit.

The Bard
BENEATH THE EILDON TREE

The Eildon tree was a sacred hawthorn in the hills of Erceldoune, where Thomas the Rhymer was said to hail from. The hawthorn is also sometimes known as the faery bush, for the fae folk are said to inhabit its branches and to keep it safe from outside harm. Sprigs of hawthorn and its flowers were gathered to serve as protection from evil.

There are many ballads sung of Thomas the Rhymer, called "True Thomas" for his prophetic words and his inability to speak untruths. Out alone in the hills of Erceldoune, he was come upon by the Queen of Elfland underneath the Eildon tree. He kissed her, and the price of that kiss was to be borne away with her from Middle Earth and the mortal realms. For seven years, he stayed in Elfland before being returned to the world, gifted thenceforth with Truth.

MATERIALS LIST

Watercolors — Alizarin Crimson, Burnt Sienna, Burnt Umber, Cadmium Yellow, Lemon Yellow, Naples Yellow, Payne's Gray, Prussian Blue, Raw Sienna, Sap Green, Ultramarine Blue, Ultramarine Violet, Viridian Green

Brushes — ½-inch (12mm) flat, nos. 0, 1, 2 and 4 rounds

Other — Salt, White gouache

1 Add Glow and Lay In the Base for the Background
With a no. 4 round and some Lemon Yellow, paint the glow around the faery's wings. Let this dry. Then, working from the outer corners, use a ½-inch (12mm) flat to paint a wash with a mixture of Prussian Blue and Viridian Green. Let the background color fade in toward the yellow glow.

2 Blend the Background
To keep her glow from becoming too sickly green as the yellow blends into the outer blues, paint the transition areas in between with a no. 4 round and a mixture of Cadmium Yellow and Alizarin Crimson.

With a ½-inch (12mm) flat, darken the outer corners with a glaze of Payne's Gray mixed with Viridian Green.

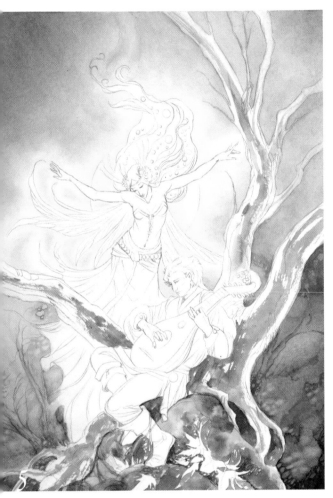

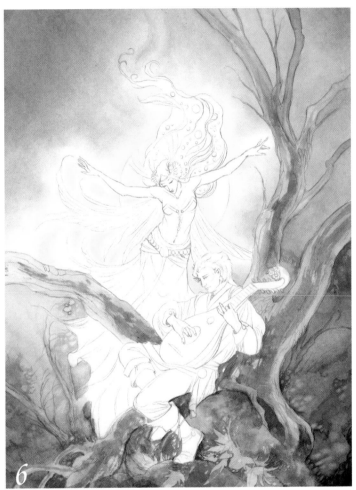

3 Suggest Distant Foliage
Using a no. 2 round and clean water (or work while the previous step is still wet), wet the lower corners to suggest distant branches reaching upward and hazy background leaves. Sprinkle the area with salt while it is still wet.

4 Pick Out Background Details
Dampen a no. 2 round with clean water, then lift highlights and hazy spots of light peeking through the leaves by gently scrubbing the areas. Add fine twigs and branches with a no. 0 round and diluted Viridian Green.

5 Base Colors for the Ground and Tree
With a no. 4 round and variations of a Payne's Gray and Burnt Umber mixture, paint the ground using a wet-into-wet technique. Let your brush skip over the paper to leave bits of white showing through. Then, with a ½-inch (12mm) flat and a mixture of Viridian Green and Payne's Gray, use the dry-brush technique to paint the tree, saving the white of the paper along the borders of the branches.

6 Glaze the Ground and Tree
Using a ½-inch (12mm) flat, glaze the ground with Sap Green. Sprinkle salt into the wet paint. Then, glaze the tree trunk with Raw Sienna.

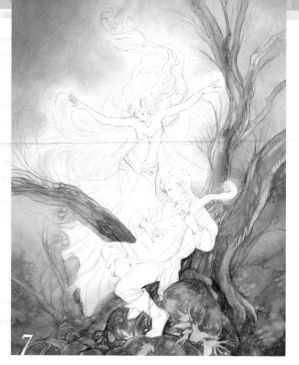
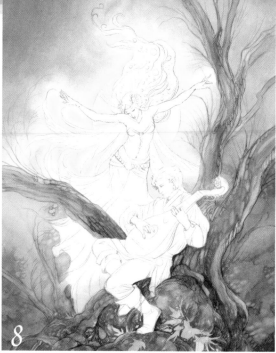

7 Add Texture to the Ground and Tree

Using a no. 0 round and variations of a mixture of Viridian Green and Sap Green, add fine details of stone and mossy texture to the ground. Use the irregularities created by the previous steps and emphasize what is already there.

Using a no. 0 round and a mixture of Raw Sienna and Naples Yellow, paint in fine bark texture on the lighted side of the tree trunk (all edges facing the faery). Use a mixture of Viridian Green and Payne's Gray for the dark side of the trunk. Then, lightly trail twigs off at the upper branches using Naples Yellow, making sure to curl them inward toward the faery.

8 Insert Highlights and Ambient Lighting

Use a dampened no. 1 round to lift highlights out along the tree bark, particularly along the lighted side of the branches. With a no. 4 round, glaze Lemon Yellow along the light sides of the tree. This will also help to smooth out the texture as well.

9 Fill In the Leaves

Paint the leaves at the base of the tree with Sap Green using a no. 0 round. Leave the edges lighter, keeping the color more intense toward the stem and the centers.

10 Suggest Leaf Highlights and Shadows

With a no. 0 round, glaze a bit of Cadmium Yellow along the edges of the leaves to tie them in with the rest of the image's golden light. Paint shadows along the edges and undersides with Payne's Gray.

11 Create Clothing Shadows

Use a no. 1 round and Ultramarine Violet to create shadows along the faery's lower skirts. Mix in a bit of Viridian Green as you get to her torso. For Thomas's clothing, use a mixture of Burnt Umber and Ultramarine Violet shadows.

12 Color In the Clothing

Use a no. 4 round and a mixture of Naples Yellow and Sap Green to glaze the faery's dress. Let the color fade to white down at the lower hem. With a no. 2 round, apply Lemon Yellow to the sash around her waist and Burnt Sienna to her girdle. Leave white sparkles.

Using a no. 4 round, glaze Thomas's pants with Raw Sienna. Use Burnt Umber for the boots. For the belt and trim, mix Prussian Blue and Viridian Green.

13 Indicate Highlights and Accent Shadows

Use a no. 2 round with Viridian Green to accent the shadows and wrinkles of the faery's dress. Glaze along the lower hem of her dress with Lemon Yellow, then glaze Cadmium Yellow on her girdle, the trim at the upper edge of her bodice and along the edges of her upper body, outlined by the light from her wings. Leave bits of white glittering through.

Use a no. 4 round to glaze Lemon Yellow around the edges of Thomas's clothes, particularly those areas in the direction of the faery. These are reflected highlights, and serve to soften the shadows. On his shirt, lightly glaze Prussian Blue along the deep edges around his lute, as well as on the right side of his leg and foot. Use a no. 0 round to accent the deepest shadowy corners with Payne's Gray.

9

10

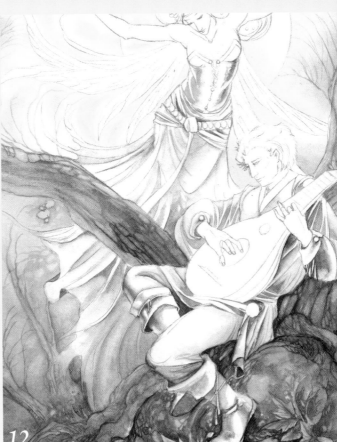

12

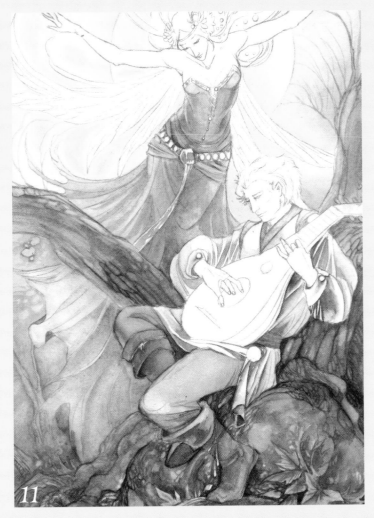

11

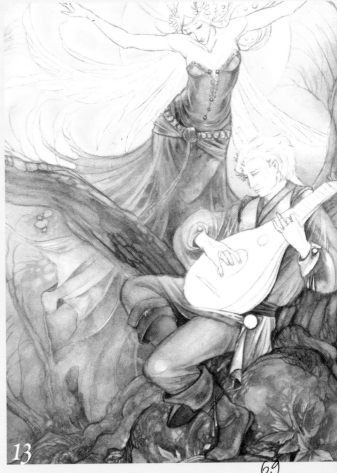

13

69

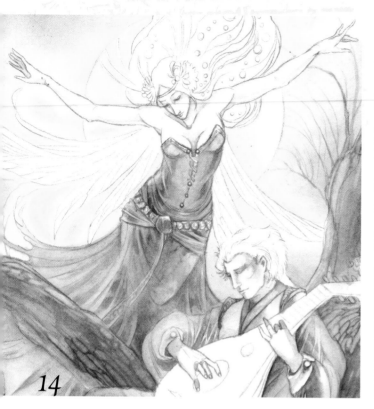

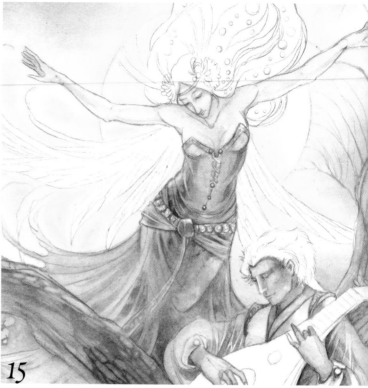

14 **Lay In Base Skin Shadows**
With a no. 2 round and Ultramarine Blue, blend the shadows of the faery's skin. For Thomas's skin, use a base layer of Burnt Umber. This sets up the initial tones for their flesh so that she will be ghostly pale, while he will have a healthy ruddiness to his complexion.

15 **Build Up the Main Skin Tones**
With a no. 2 round, glaze the faery's skin with a mixture made from a very diluted Naples Yellow and Alizarin Crimson, with just a faint touch of Ultramarine Blue. Glaze Thomas's skin with a mixture of Burnt Sienna and Ultramarine Blue.

16 **Add Highlights and Shadows to the Skin**
Use a no. 0 round and extremely diluted Alizarin Crimson to give the faery a faint blush. Glaze the rosy tones lightly across her cheeks, eyebrows and over the shadows of her torso and arms. Use concentrated Alizarin Crimson on her lips, and finish her eyebrows and eyelashes with Burnt Umber.

For Thomas, use a bit of Alizarin Crimson on his cheeks. Use Burnt Umber to emphasize the deeper shadows of his eyes, eyebrows and under the clothing lines.

17 **Color the Hair**
For Thomas's hair, use a no. 2 round and paint a base layer of Burnt Sienna fading to Naples Yellow. Use a no. 0 round and Burnt Umber to suggest the shadows.

For the faery, start by painting around each of the gems in her hair using a no. 2 round and Lemon Yellow. Blend into this with a mixture of Naples Yellow and Cadmium Yellow. Be sure to leave white showing through for highlight strands. Then with a no. 0 round, trail Naples Yellow strands in a wave curling upward.

18 **Add Golden Details**
Using a no. 0 round and Naples Yellow, pick out detailed strands in her hair.

19 **Detail the Gems and Wings**
Finish off the gems in the faery's hair with a no. 0 round and some Naples Yellow. Leave a white glimmering shine showing on each gem, and accent the shadows with a bit of Viridian Green mixed with Ultramarine Violet.

Use varying mixtures of Viridian Green and Ultramarine Violet to paint the outer edges of her wings. Leave a delicate white tracery of veins in the wings. As you approach her body, blend in a bit of Naples Yellow, gradually fading to the white of the paper closest to her body.

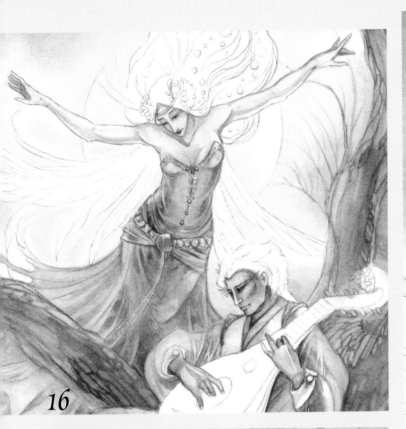

16

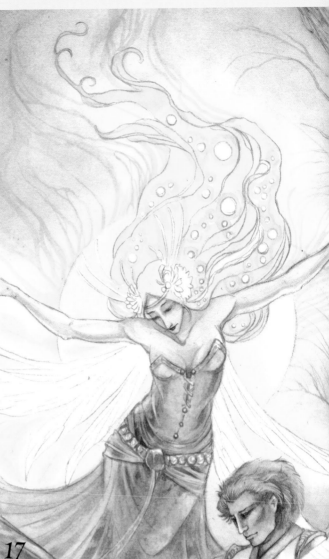

17

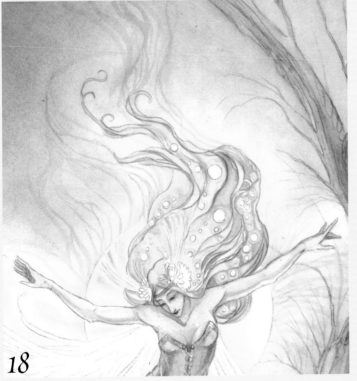

18

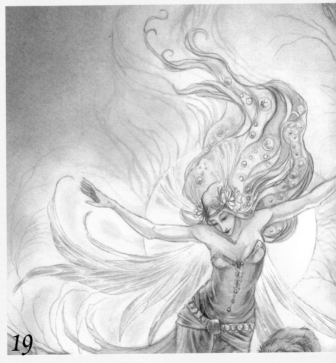

19

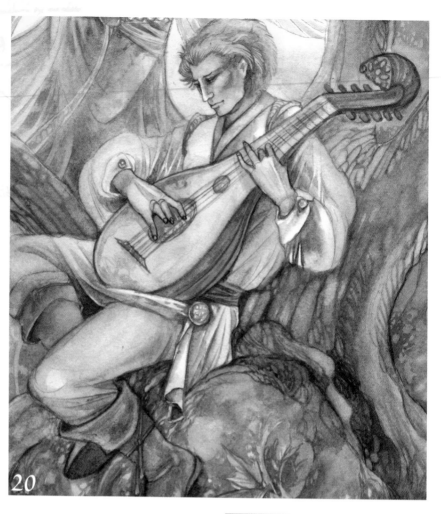

20

20 **Paint the Lute and Finish the Boots**
With a no. 4 round, add a base of Burnt Sienna to the lute. Add shadows and details with a no. 0 round and Burnt Umber.

Finish off the buttons and ties on Thomas's boots with Naples Yellow.

21 **Create the Will-o'-the-Wisps**
Using a no. 4 round and very concentrated Lemon Yellow, blend in small spheres of light. Dot the centers of each with White gouache for a finishing touch.

21

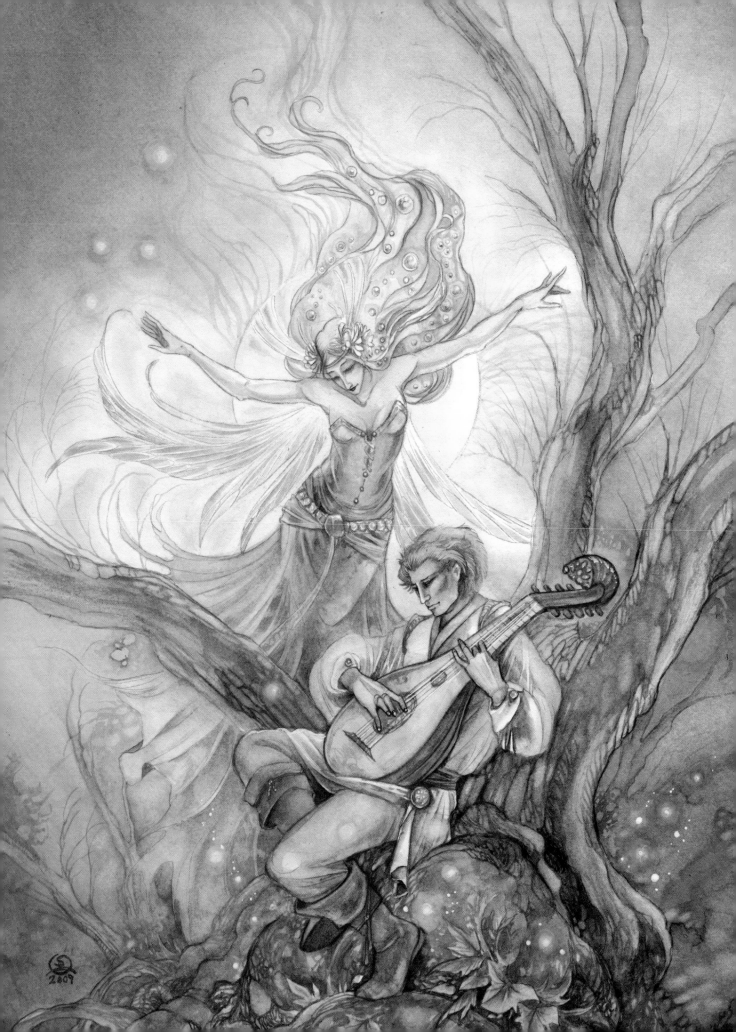

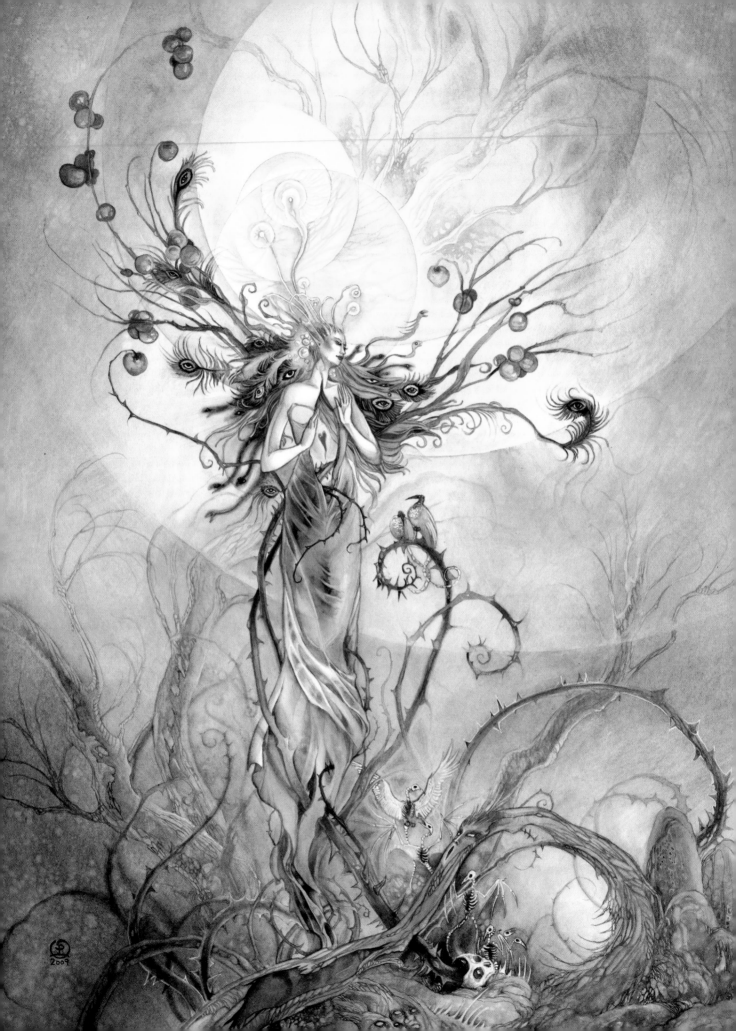

the WITCH

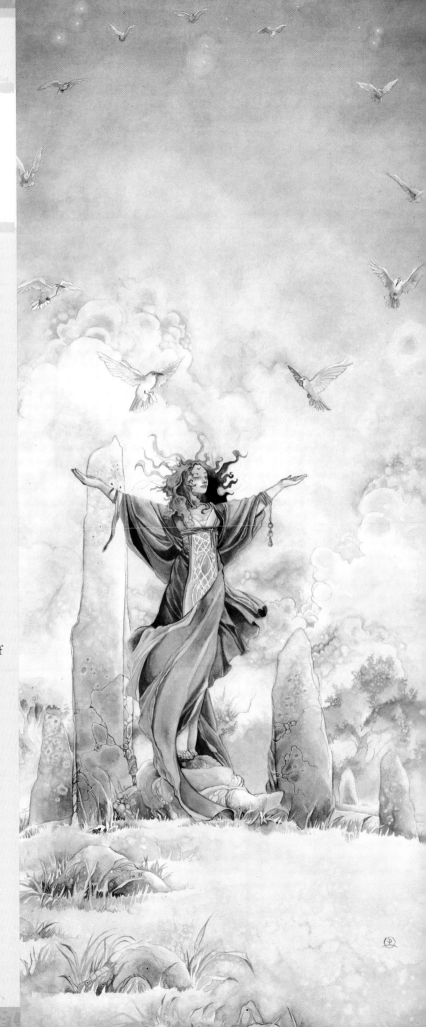

THE MOST IMMEDIATE THOUGHT THE WORD *witch* often brings to mind is a woman cloaked in a black dress, wearing a cone-shaped hat and riding a broomstick across the night sky. However, folklore is rich with witches who fall nowhere within this stereotype.

One such example is Baba Yaga, a witch from Russian folktales. She may be an ancient crone, but she doesn't fly upon her broomstick. Rather, she uses it to sweep clear her tracks as she flies through the air on a huge mortar. It is said that for every question asked of her, she ages a year.

But not all witches are hags, either. There is an array of young and beautiful witches—powerful, confident women with no traces of meekness—skilled in the arts of self-knowledge, healing, life and death. In "La Belle Dame Sans Merci," a ballad by John Keats, a knight wanders through a barren land and meets a fair maiden with wild eyes. He lifts her to his horse and they ride to an elfin hill. There she weeps, and as he falls asleep to her sighs, he dreams of pale kings and princes who cry to him , "La Belle Dame sans Merci hath thee in thrall!" The enchanted knight is startled awake and finds himself alone upon the hillside.

Portraying Age

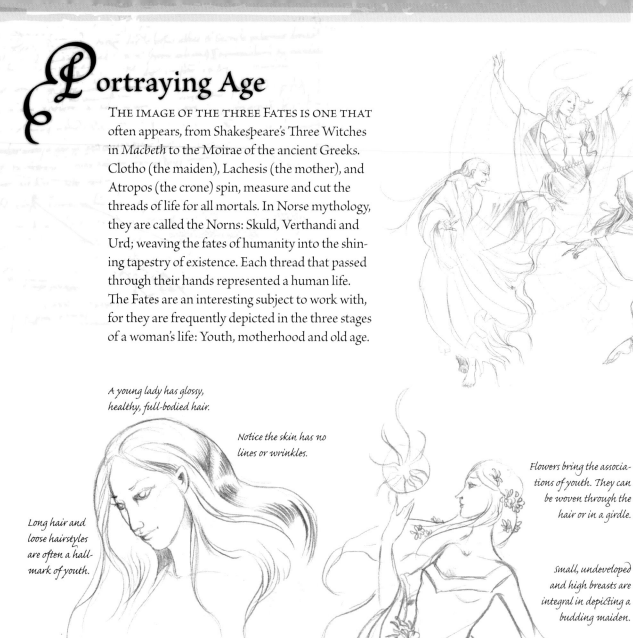

THE IMAGE OF THE THREE FATES IS ONE THAT often appears, from Shakespeare's Three Witches in *Macbeth* to the Moirae of the ancient Greeks. Clotho (the maiden), Lachesis (the mother), and Atropos (the crone) spin, measure and cut the threads of life for all mortals. In Norse mythology, they are called the Norns: Skuld, Verthandi and Urd; weaving the fates of humanity into the shining tapestry of existence. Each thread that passed through their hands represented a human life. The Fates are an interesting subject to work with, for they are frequently depicted in the three stages of a woman's life: Youth, motherhood and old age.

A young lady has glossy, healthy, full-bodied hair.

Notice the skin has no lines or wrinkles.

Long hair and loose hairstyles are often a hallmark of youth.

Firm flesh and skin and unobscured bone structure are also cornerstones when portraying youth.

Flowers bring the associations of youth. They can be woven through the hair or in a girdle.

Small, undeveloped and high breasts are integral in depicting a budding maiden.

A blossoming young woman wears form-fitting clothing that accentuates her body.

A well-toned body certainly speaks to youth.

Agile hands and fingers with smooth flesh are a sign of young age.

Youth

Drawing a youthful visage is perhaps the easiest, as we are inundated by such images in the media. Keep in mind that youthful beauty can be conveyed in other ways, though; sometimes the odd characteristics and slight flaws are what elevate something from being merely "pretty" to compellingly "beautiful."

The Legend of Medea

Another famous witch is Medea, from the ancient Greek myth of Jason and the Argonauts. Jason arrived at the island of Colchis in search of the golden fleece. The princess Medea instantly fell in love with him and promised to help him achieve this end. Her father, the king, gave Jason three heroic tasks to perform, expecting failure at each turn; for without magical aid, they would have been impossible to fulfill. But the enchantress Medea helped him defeat each of the seemingly unbeatable challenges, and victorious, Jason took Medea with him as he fled the island. To prevent pursuit, Medea slew her own brother and scattered the pieces of his body, knowing that her father must stop to retrieve the pieces and properly bury his son.

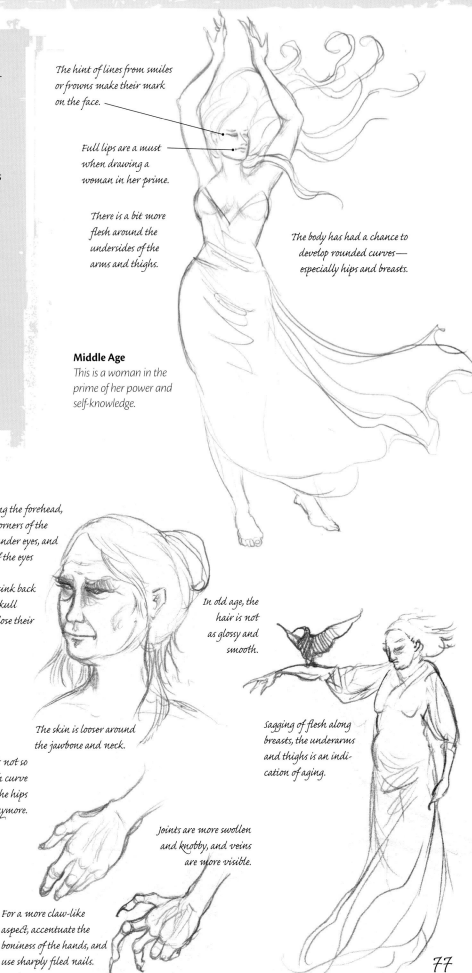

The hint of lines from smiles or frowns make their mark on the face.

Full lips are a must when drawing a woman in her prime.

There is a bit more flesh around the undersides of the arms and thighs.

The body has had a chance to develop rounded curves—especially hips and breasts.

Middle Age
This is a woman in the prime of her power and self-knowledge.

Elder
The aged woman has knowledge and experience etched into the lines of her face and figure. Age does not necessarily mean frailty. It conveys power as well.

Lines along the forehead, around corners of the mouth, under eyes, and corners of the eyes

The eyes sink back into the skull and lips lose their fullness.

In old age, the hair is not as glossy and smooth.

The skin is looser around the jawbone and neck.

There's not so much curve to the hips anymore.

Sagging of flesh along breasts, the underarms and thighs is an indication of aging.

Joints are more swollen and knobby, and veins are more visible.

There is more of a slope from the neck down the arms and back, as well as a rounding of the shoulders.

For a more claw-like aspect, accentuate the boniness of the hands, and use sharply filed nails.

77

Sndicating Patterns on Fabric

WHEN DESIGNING COSTUMES, YOU MAY WANT TO EMBELLISH the clothing with patterns. Subtle details including emblems of power or traces of spells can literally be woven into the very threads of the witch's garb.

The simplest pattern on cloth is a single stripe.

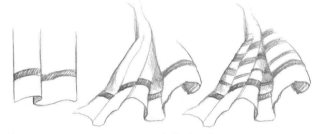

On a flat piece of cloth a stripe is very easy to represent.

If the cloth curves, the pattern should follow it.

As long as the fabric remains relatively flat, the pattern is easy to replicate.

Folds are more complicated because the pattern breaks up along the folds.

It's even more difficult to draw a pattern on clothing when the fabric gets bunched up and the folds are no longer flat to the plane of the viewer. In this case, you have to think of following both the curves, as well as breaking up the pattern as the folds hide parts of it from view.

Another simple pattern is checkered.

The pattern has to follow the curve of the cloth, as well as breaking up when the cloth folds over on itself.

With a more complex draping, take into account the distortion of the pattern as well as how the perspective changes from a flat plane to a more perpendicular plane.

Flat checkered pattern

Flat organic pattern

A drape of cloth

Because the cloth folds back on itself, there are parts of the pattern that will be hidden from view (shaded portions).

The pattern also becomes distorted to follow the curve of the cloth.

Only portions of the pattern remain when drawn onto the cloth.

As you practice this more, you will get better at visualizing how this fits together.

Working with organic patterns is much more difficult, and as such, requires more patience. However, you can break it down in your mind in the same way as a simplistic pattern.

The Witch
BABA YAGA

There is a witch in Russian folklore named Baba Yaga. She is a powerful crone who appears in numerous stories—sometimes as a wise woman helping heroes, bestowing upon them truth and magical gifts, and sometimes as a terrifying enemy who crunches on bones with her iron teeth. She has her two sides, and those who are armed by a purity of heart or the blessing of a loved one are shielded and safe, as is often the case in faery tales.

Baba Yaga's most common portrayal is as a hag flying through the skies on an enormous mortar, using a pestle to steer and a broom of silver birch to sweep away traces of her passage. She lives in a hut that seems to have its own mind and moves about on giant chicken legs! Baba Yaga is an elemental force, guardian and foe, death and wisdom.

MATERIALS LIST

Watercolors ～ Alizarin Crimson, Burnt Umber, Naples Yellow, Payne's Gray, Prussian Blue, Ultramarine Blue, Ultramarine Violet

Brushes ～ Nos. 0, 1, 2, 4 and 6 rounds

Other ～ Salt

1

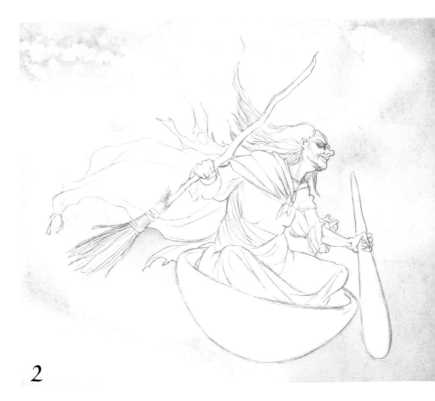

2

1 Finish Sketch
With a pencil, sketch Baba Yaga in her mortar, flying through the skies.

2 Create Cloud Streaks in the Sky
With a no. 6 round and clean water, wet the background. Then, paint Ultramarine Blue wet-into-wet in diagonal streaks up toward the left corner. Sprinkle salt in the wet paint in the upper left. The diagonal striations of the clouds help to emphasize her movement and speed.

3 Lay In the Shadows
Paint the shadows using nos. 0 to 2 rounds and a mixture of Burnt Umber and Payne's Gray.

4 Add Color to the Clothes
With a no. 2 round, paint her clothing using the glazing technique. For the skirt, apply a Prussian Blue glaze, then mix a little bit of Payne's Gray and Prussian Blue to emphasize the shadows, painting wet-into-wet.

For the cloak, use an Ultramarine Violet glaze mixed with a little bit of Prussian Blue, again using the wet-into-wet technique to emphasize the deeper shadows. Leave the glaze lighter across her shoulders for highlights. Use a no. 0 round to pick out loose threads from the end of her cloak, trailing in the wind of her passage.

For the shirt, use a Naples Yellow glaze along the side of her body and the undersides of her sleeves.

3

5 Create the Patterns on the Cloak
Paint a pattern on the cloak using a no. 0 round and Burnt Umber. When working a pattern into cloth, be sure to account for the wrinkles of the material distorting the pattern.

6 Paint Skin, Hair and Eyes
Glaze the skin using a no. 1 round and a mixture of Naples Yellow, a little bit of Payne's Gray and Alizarin Crimson.

For the hair, use a no. 0 round and paint the shadows with Payne's Gray. As always when painting hair, resist the temptation to paint the actual strands; instead, simply paint the shadows around the strands.

Use a little bit of Prussian Blue for the iris of her eye and Alizarin Crimson for some bright touches of ribbon along her sleeve, collar and broom.

7 Color In Her Accoutrements
With a no. 4 round and Payne's Gray, paint her iron mortar wet-into-wet to darken the shadowed area. Do the same for the pestle, leaving a bit of highlight along the edge.

Paint the handle of the broom with Burnt Umber and the straws with Naples Yellow. Finally, add shadows using Payne's Gray.

Painting Shadows

Don't just paint shadows over the straight pattern. Unless the surface is almost completely on a flat plane with the viewer, this will only flatten the piece.

Instead, let the pattern disappear in and out of the folds, and around the curves of body parts.

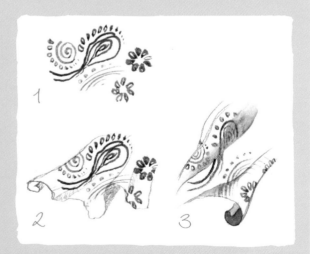

4

5

6

7
2009

The Witch
MORGAN LE FAY

In some versions of the Arthurian legends, as in Malory's *Morte d'Arthur*, Morgan le Fay was Arthur's half sister, born of their mother Igraine's first marriage to Duke Gorlois of Cornwall. In other tellings, there is the whisper that faery blood runs through her veins (thus her name "of the Faeries" or perhaps "Fate") and she was trained in the magical arts on the Isle of Avalon, the lake where Arthur received Excalibur. There are some legends where she is believed to be an incarnation of the Celtic goddess of death, Morrigan. Yet in all stories there is the thread of an enchantress attached to her. She is paradoxically a healer and destroyer, a charmer and a sorceress. And when the mighty King Arthur passed from this life, he was taken on a barge to his final sleep on Avalon by three queens: the Queen of Northgalis, the Queen of the Wastelands and Queen Morgan le Fay.

MATERIALS LIST

Watercolors — Alizarin Crimson, Burnt Umber, Cadmium Orange, Cadmium Red, Cerulean Blue, Naples Yellow, Payne's Gray, Prussian Blue, Raw Sienna, Sap Green, Ultramarine Violet, Viridian Green

Brushes — ½-inch (12mm) flat, nos. 0, 1, 4 and 6 rounds

Other — White gouache (optional)

1 Finish Sketch and Create the Smokey Haze
After sketching, paint the smoke rising from her incense bowl using a no. 6 round and some Ultramarine Violet and Cerulean Blue. When this is dry, slightly soften the edges by brushing over the smoke with a soft ½-inch (12mm) flat and some clean water.

2 Lay In the Background Tones
Using a ½-inch (12mm) flat, paint a wash of Naples Yellow into the background. Avoid painting over the main column of smoke, but overlap some of the outer edges of the purple so that the colors blend into one another smoothly.

With a no. 4 round and Cadmium Orange, paint wet-into-wet to create a glow around the poppies in the lower areas. Trail the brush upward into hazy distant stalks of flowers that are out of focus, adding more depth to the piece.

3 Paint the Poppies
Using a no. 1 round and variations of a mixture of Cadmium Red and Alizarin Crimson, create a basecoat for the flowers.

4 Add Flower Details
Paint the stems of the poppies with a mixture of Viridian Green and Payne's Gray, using a no. 0 round. Lift out highlights by brushing down the centers of the stems with clear water after the initial layer has dried. Trail a mixture of diluted Viridian Green and Payne's Gray upward to suggest distant stalks.

1

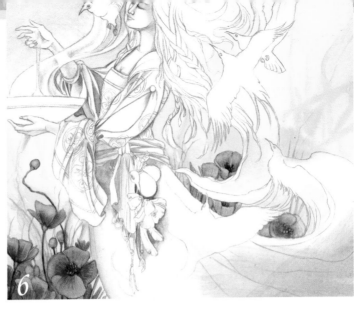

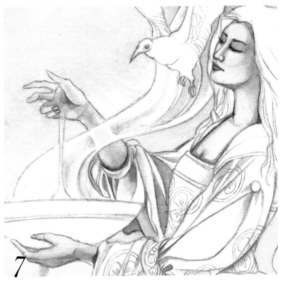

5 Finish the Poppies

Add some texture to the petals of the poppies with Alizarin Crimson. Use a no. 0 round and paint striations outward from the center of each cup. Blend the top edges of each petal with some clean water. Paint the center of each cup with a Payne's Gray stamen, leaving bits of white highlights.

6 Indicate Shadows on the Figure

Using a no. 0 round and Sap Green, paint shadows on her face. For the shadows on her dress, use Viridian Green mixed with a bit of Payne's Gray. Paint the shadows directly over the patterns, as those are affected by shading as well.

7 Color In the Skin

Mix a very diluted Naples Yellow with a tiny touch of Alizarin Crimson. Then, with a no 1 round, glaze a layer of this mixture across her skin. Use a little more Alizarin Crimson in the shadows on the underside of her left hand, under her jawline, the shadows of her eyes, and in the rosiness of her cheeks. Mix in a touch of Burnt Umber in the deepest corners under her hairline, the top of her bodice, and where her sleeves close. Using a no. 0 round, finish off her lips with Alizarin Crimson and her eyelashes and eyebrows with Burnt Umber.

83

8 Paint the Dress

Mix Alizarin Crimson and Ultramarine Violet, and with a no. 4 round glaze over her dress. Switch to smaller brushes as necessary to paint around the patterns on her sleeve and bodice. With a no. 0 round, paint the poppy flower patterns in her dress with Cadmium Red.

9 Add Golden Trim

Using a no. 0 round and Naples Yellow, add a glaze to her sash, the circles of the poppy pattern, along her golden armband, the thin trim at the top of her bodice and the edge of her sleeve.

10 Finish the Dress Details

With a no. 0 round and Raw Sienna, paint stripes along her sash. For the white trim along the edge of her bodice and the sleeve, and in the poppy patterns, add shading with Ultramarine Violet. Be sure to leave bits of white paper showing through for highlights. Accent dark shadows on her armband and in the corner creases with Burnt Umber.

11 Paint the Accoutrements

Using a no. 0 round, paint in the accoutrements dangling from her belt. Use Burnt Umber for the bags at her waist, adding Payne's Gray to suggest shadows.

Give the poppies the same treatment as the ones growing in the background, only this time use a Cadmium Orange base color instead, ensuring the poppies stand out from her gown. Use Alizarin Crimson for the texture details and Payne's Gray for the stamen.

For the feathers and bird skull, paint details with Payne's Gray, and for the cords tangling all of these together, use Cadmium Orange. Lift highlights from the dry layer with clean water.

Finally, for the incense bowl in her hand, use a base of Naples Yellow, leaving white highlights along the edge of the bowl. Indicate a shadowed reflection of the poppies by adding Cadmium Red along the left side. Also paint a thin line of Viridian Green accent along the reflection at the left edge to indicate a reflection of the green stems.

12 Color In Hair and Surrounding Birds

With a no. 4 round and a mixture of Burnt Umber and Prussian Blue, paint the witch's hair and the surrounding ravens. Use a bit more Prussian Blue in the mixture for the birds, and range more toward Burnt Umber for her hair. Run a brush of clean water along the edges to blend and blur with the surroundings.

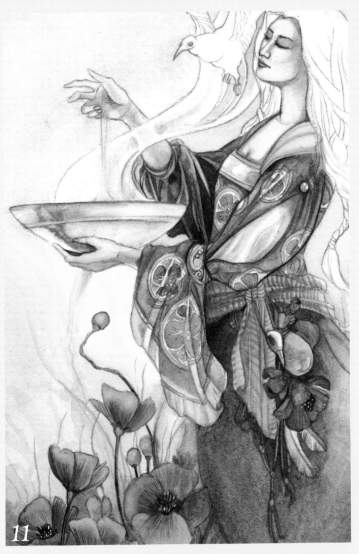

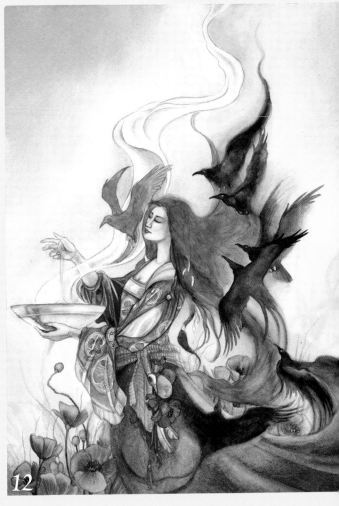

13 Indicate Shadows on the Hair and the Ravens
Using a no. 0 round, darken the shadows with glazes of Payne's Gray.

14 Place Highlights on the Hair and the Ravens
Finish off by adding some highlights to her hair and the ravens. Using a wet no. 1 round, gently rub the desired areas to lift highlights. This will also help blend the edges of the shadows more smoothly.

Add remaining details using a no. 0 round. Paint the ribbons in her hair with Cadmium Orange, and emphasize the eyes of the birds with a bit of Cadmium Orange as well, leaving a bit of white for the gleam in the eyes. If needed, go back with White gouache to add the gleam to the birds' eyes. Finally, paint the claws with Naples Yellow.

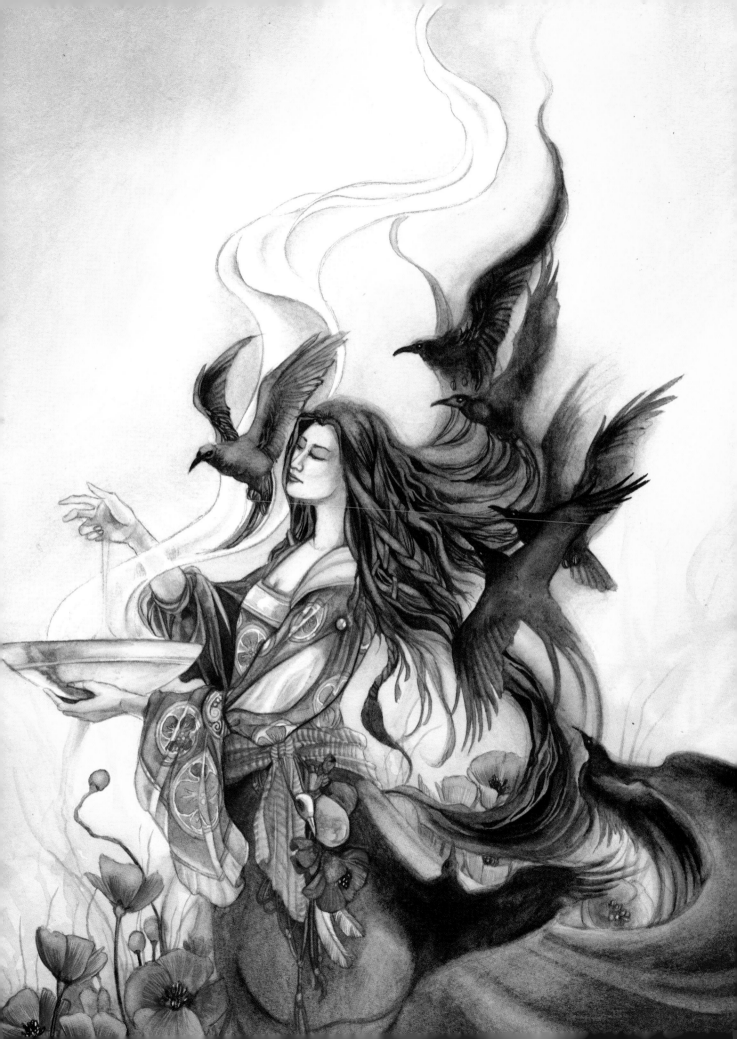

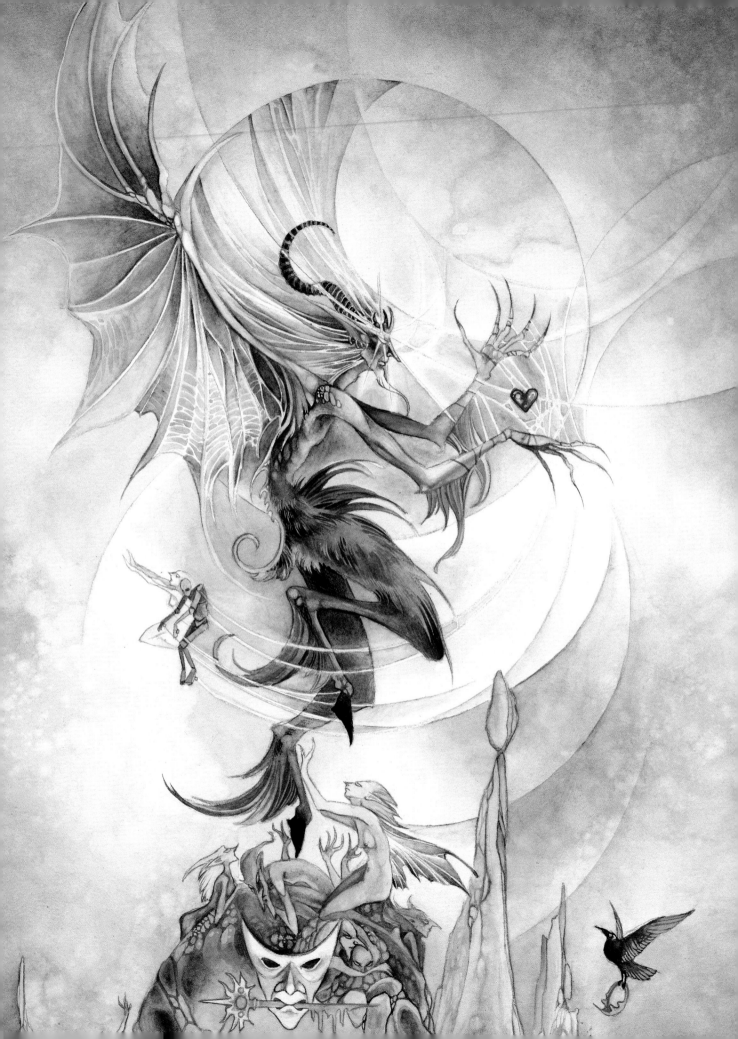

the TRICKSTER

Tricksters are often shape-shifters—half animal and half human—anthropomorphic, or possessing of a nature melded to that of an animal. They slide nimbly from one form to the next for the purposes of their current need, coaxing laughter and admiration for both the cleverness and sheer audacity of their actions.

They are rule breakers—cunning, mercurial and mischievous as they make their way through the world with the help of wit and deceit. The harm the trickster causes, or the disaster he leaves in his wake, is frequently unintentional, for his cleverness isn't always paired with the wisdom to see the long-term effects of actions.

His rebellious nature can have dire consequences, as when Coyote of Native American tales steals the sun and moon and thereby disrupts the seasonal cycles. Sometimes that quixotic turn greatly benefits humans, as with Greek Prometheus stealing fire from the gods and giving it to men. But not all tricksters' actions are so far-reaching. Sometimes it is as simple as Aesop's Reynard the Fox plying the vain Crow with sweet flattery. "Such a lovely creature must have a lovely voice to match! Let me hear your song!" he pleads. And with a raucous and harsh, "Caw!" she drops her prized cheese into his waiting paws.

Drawing Fur

When starting any drawing, don't get bogged down with details like fur. There's nothing worse than spending a great deal of time and effort in getting the fur *just right* only to realize later that you have a major anatomy or compositional flaw. To avoid such a disastrous situation, focus on the basic form first and add details later.

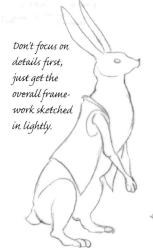

Don't focus on details first, just get the overall frame-work sketched in lightly.

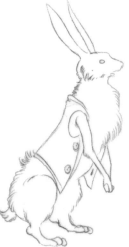

Drawing Short Fur
Let's practice on the beloved trickster, Br'er Rabbit.

Add fur to the frame's edges. Use short, quick, relaxed strokes with a bit of a curve. Think of the contours of the body and which direction the fur would grow. Vary the lengths of your strokes, indicating short, smooth fur on the paws, ears and top side of the face. Keep the fur longer along the chest, the back of the haunches, and under the vest at the back.

Add shadows and inner fur using the same strokes used along the edges, just more densely. Leave highlights relatively untouched. When you see fur, you're basically seeing the shadows around the strands or collection of strands. Remember the fur's direction, and shade with lines that match.

Drawing Longer Fur
When fur becomes long enough like in a mane or tail, think of it more like hair.

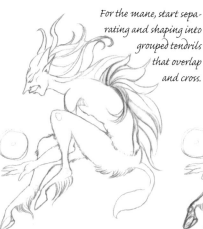

For the mane, start separating and shaping into grouped tendrils that overlap and cross.

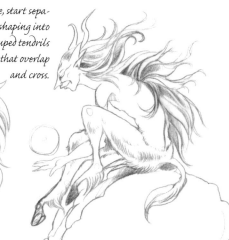

Start with the basic shapes. You don't have to be exact, just give yourself a basic outline to work with.

Fill out the areas of shorter fur along his legs. Pull out the tendrils near his hooves with sweeping curves.

Don't feel constrained by your initial outline. Make any changes you like. Draw a few individual stray strands.

Sketching Puck

PUCK, ONE OF THE BEST KNOWN TRICKSTERS in Western tradition, is a strange little figure—sometimes grotesque, a hobgoblin, a wild faery, and a shape-shifter of many forms. In English folklore, he is called Robin Goodfellow or Puck, and to the Irish, Pooka. In medieval times, his name was sometimes a term for the devil.

William Blake pictured Puck like Pan from Greek mythology. Our Puck will borrow from this image, with a mixture of hobgoblin and satyr characteristics. Like a satyr, he has a goat's hindquarters and cloven hooves. And, like a hobgoblin, his features are distorted—with a wiry muscular frame and an angular, feral face.

Feral—wide flat nose, bushy expressive eyebrows and tufted ears

Impish—long, thin beakish nose, pointed elfin ears, sly sidelong glance of the eyes, high forehead, and defined cheekbones

Brute—bulbous nose, facial hair, heavily shadowed brow and a shorter forehead

Hobgoblin Features
Look to these common hobgoblin features to draw inspiration for your sketch of Puck.

Twisted like an antelope horn

Simple curved-cone horn

A bit more of a fantasy twist to the antelope horn

Curved and coiled like a ram's horn

Horn Designs

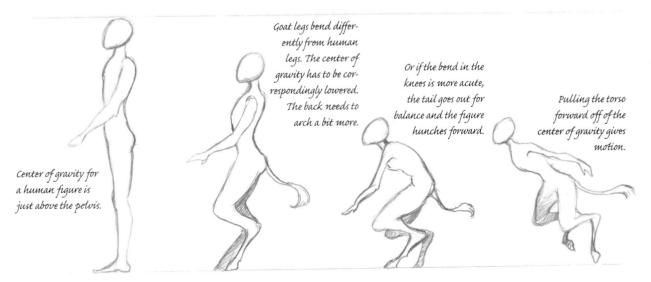

Center of gravity for a human figure is just above the pelvis.

Goat legs bend differently from human legs. The center of gravity has to be correspondingly lowered. The back needs to arch a bit more.

Or if the bend in the knees is more acute, the tail goes out for balance and the figure hunches forward.

Pulling the torso forward off of the center of gravity gives motion.

Satyr Characteristics
A satyr takes the upper body of a man, and the lower body and hindquarters of a goat.

91

The Trickster
PAINTING FUR

Painting fur is not much harder than drawing it. The same strokes you drew with a pencil can be done with a no. 0 round. Over successive layers, the texture is blended and darkened until it starts to build mass. In this demonstration, you'll be painting Shakespeare's popular trickster, Puck.

Thou speakest aright; I am that merry wanderer of the night.
∽ Shakespeare's Puck in A MIDSUMMER NIGHT'S DREAM ∽

MATERIALS LIST

Watercolors — Alizarin Crimson, Brown Madder, Burnt Umber, Indigo, Lemon Yellow, Naples Yellow, Payne's Gray, Raw Umber, Sap Green, Ultramarine Violet, Viridian Green

Brushes — Nos. 0, 1, 2 and 4 rounds

Other — Salt

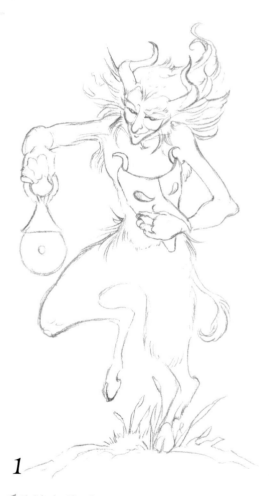

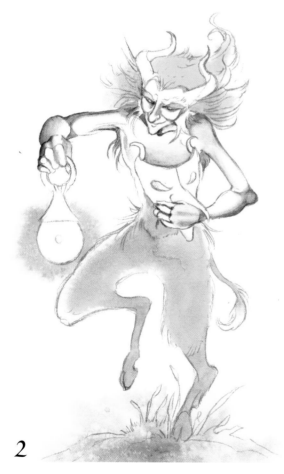

1

1 Finish the Sketch
Sketch the merry wanderer in pencil with an active dancing pose.

2

2 Lay In Base Tones
With a no. 1 round and Burnt Umber, paint the shadows on Puck's upper body and face. Use a no. 4 round and Brown Madder for his lower body and hair, painting with the wet-into-wet technique. Keep the horns, face and shoulders dry when preparing the wet area to keep the color from bleeding.

Still using the no. 4 round, apply Sap Green around the lantern, letting the color spread and fade into the white surroundings. Do this in the grass as well. Sprinkle salt into the wet paint.

Ruddy Skin Tones

To give this Puck an earthy feel, his skin will be ruddy.

1 *Start with a base of Burnt Umber for shadows.*
2 *When that base is dry, mix Naples Yellow and Brown Madder.*
3 *Dilute the Naples Yellow and Brown Madder mixture for the glaze on top of the shadows.*
4 *Add deep shadows with Indigo.*
5 *Add rosy tints of Alizarin Crimson.*

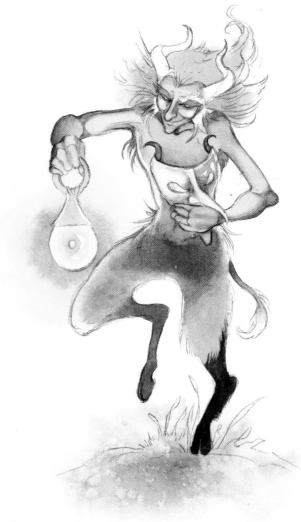

Brushstrokes

1 ***Don't*** *make your strokes too straight and homogeneous.*
2 ***Do*** *vary the curves and weight of the lines for a more natural appearance.*
3 ***Don't*** *let the strokes get too wild, though. If they're not generally moving in the same direction it just becomes a messy crosshatching.*

3

3 Lay In Color

Using a no. 1 round and a diluted mixture of Naples Yellow and Brown Madder, lay in a wash on Puck's upper body and face. Leave highlights along the knuckles of his right hand, cheekbones, nose, and along the left edge of his chest where the light of the lantern strikes.

With a no. 4 round, wet up to his thigh on his lower right leg and paint a wet-into-wet Ultramarine Violet glaze. Do the same along his upper thighs and groin. On his lower left leg, paint a Burnt Umber glaze, leaving a hard edge to the fur where the shadow meets his thigh. With a no. 1 round, darken the shadowed bit of his tail.

Switching back to the no. 4 round, paint a Lemon Yellow glaze around the outside of the lantern on top of the green. Let the glaze extend over his thigh as well, since the light he holds should tinge his thigh with yellow. With a no. 0 round, use Lemon Yellow around the spark at the center of the lantern. Paint the top of the lantern and the handle with Naples Yellow, and add an edge of Lemon Yellow along the left side of his torso (reflected lantern light).

Paint the shadows on the mask with a no. 1 round and Ultramarine Violet. Blend the edges of the shadow with water.

Using the Dry-Brush Technique to Suggest Fur

Another way to indicate fur texture is to charge a flat brush with paint, dab most of it dry on a paper towel, then drybrush. The bristles spread apart and with a single stroke, you create a whole line of fur. Repeat the strokes with gentle curves and overlap for large areas. Though this method isn't great for tight details, it works beautifully to suggest fur. This works better with smoother papers; too much texture makes the brush skip.

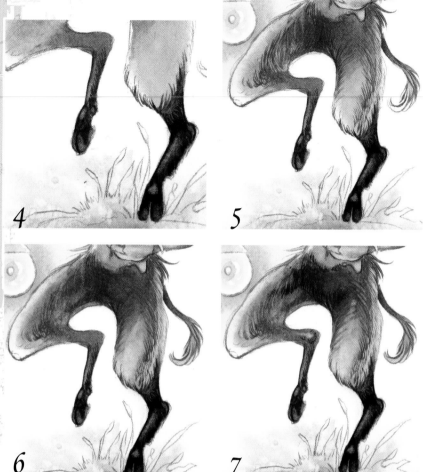

4 Add Fur Texture Along the Lower Legs

Mix Burnt Umber and Payne's Gray for a dark neutral tone. Then, with a no. 0 round, paint short quick strokes to suggest the fur along the hooves and lower legs. Lift out highlights along the ridge of the shins. Keep the shadowed edge along his left leg sharper than along his right leg, since it's more distant from the light.

5 Define the Fur on the Upper Legs

Using a no. 0 round and Brown Madder, further fill out the fur on the upper legs.

6 Soften the Fur

With a no. 2 round, paint a very pale Naples Yellow glaze across the mid-shadowed areas of the thighs. Use minimal strokes so as not to disturb the fur texture layers that you just created. The purpose is only to lightly blur the hard edges.

7 Place Final Shadows

With a no. 0 round and Payne's Gray, add the final darker-shadowed tufts of fur. Also lift out some soft-edged highlights where the light would strike brightest.

94

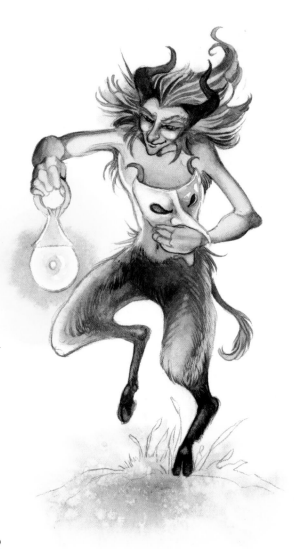

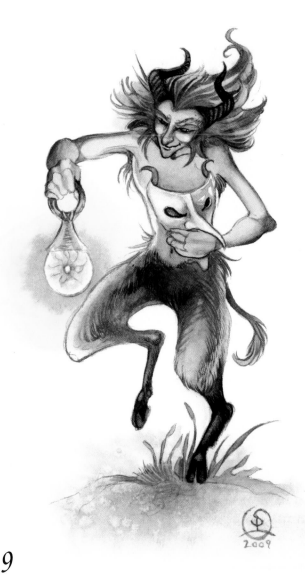

8

9

Finish the Upper Body

Using a no. 0 round, paint the shadows in the hair with Burnt Umber. Mix some Indigo with Burnt Umber for the horns.

With the same brush, use Alizarin Crimson to work in some rosy red bits above the cheekbones, nose, chin and along the shadows on his arms (away from the light source). Fill in the features on his face using Indigo, and mix Burnt Umber and Indigo for the shadows of the mask's eyeholes.

Add Final Touches

With a no. 1 round and Naples Yellow, paint a light glaze in the hair around the area closest to the face, softening the strands a bit. Using clean water and dabbing the area as you go with a paper towel, gently scrub with a slightly damp no. 0 round to lift ridged highlights out from the horns. Finish off the lantern handle and top with Raw Umber shadows. Use Viridian Green to create the wet-into-wet crackles of light sparkling in the center of the lantern. Also use Viridian Green to add details in the grass. Let the lower edge blend out into the Sap Green.

The Trickster
Fox Spirits

As a young fox spirit, this shape-shifting trickster has not yet learned to completely control her appearance. And, as she preens in the mirror among the soft fall of plum blossoms, her true reflection in the hand-mirror smiles back at her.

MATERIALS LIST

Watercolors — Alizarin Crimson, Brown Madder, Burnt Sienna, Burnt Umber, Cadmium Orange, Cobalt Violet, Lemon Yellow, Naples Yellow, Payne's Gray, Ultramarine Violet, Viridian Green

Brushes — Nos. 0, 1, 2, 4 and 6 rounds

Other — Rubbing alcohol, salt

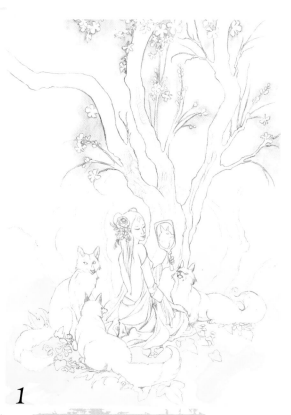

1

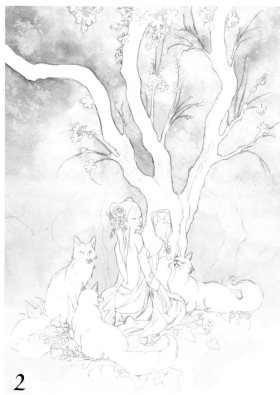

2

Preparing the Composition

The three foxes form a circle, looking in toward the woman. The focus of their gaze helps draw the viewer's eye into the center of the painting—the shape-shifter's face. The branches of the cherry tree also pull the eye down toward the center of the circle, further emphasizing the focal point.

When drawing this scene, make sure to sketch in the leaves close under the foxes' bodies, as they are important in defining weight and shadow. The rest can remain nebulous and undefined until you begin painting.

1 Lay In the Background

Once you've finished your sketch, begin laying in the background color. Using a no. 4 round and Cobalt Violet, blend outward from around the plum blossoms, fading into the white of the page. Use a pointed brush or a smaller brush to get into the tight spaces around the flowers.

With a no. 6 round and Lemon Yellow, apply loose strokes of color to the foreground. Avoid painting over the figures, but don't worry about being too careful, as this is a fairly light tone.

2 Blend Background Colors

With a no. 6 round, apply Ultramarine Violet to the sky and around the pink flowers. Paint all to ground level, then sprinkle the wet paint with salt. Let this dry, then paint Burnt Sienna about halfway up the page, layering on top of the Ultramarine Violet.

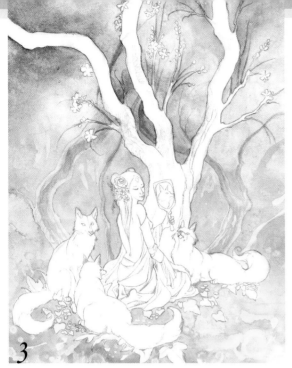

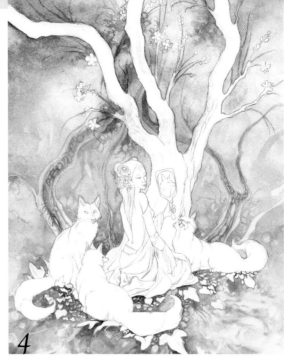

3

4

3 Pick Out Background Details
Mix Ultramarine Violet and Cobalt Violet, and with a no. 6 round paint another layer over the sky. Don't worry about painting over the smaller twigs. Then, using a no. 4 round and a mixture of Ultramarine Violet and Payne's Gray, paint the distant trees. Blend the edges into the background by running a slightly damp brush along the edges. As you move lower, mix Ultramarine Violet and Burnt Sienna and paint with loose strokes to create a bark texture.

Still using a no. 4 round, mix Naples Yellow with a touch of Viridian Green, and with loose brushstrokes, layer above the middle third of the background. Let gaps of the previous layers show through. Leave the borders of the distant trees clear for an edge of highlights.

Add some Burnt Umber to the Naples Yellow and Viridian Green mixture, and continue painting all the way down to the bottom of the page, being careful to work around the foreground leaves. Sprinkle salt and rubbing alcohol into this bottom area to texturize it.

4 Suggest Foliage Details
Mix Naples Yellow, Burnt Umber and a little bit of Viridian Green. Then, using a no. 1 round, add texture to the bark of the distant trees. Afterward, wet the brush with clean water and scrub along the edges of the distant trees to lift highlights.

Using the same color mixture and brush, work in the background foliage in the upper branches. Leave gaps of light coming through the leaves. Blend edges into the background with clean water. As you come near the flowers, switch to varying mixtures of Ultramarine Violet and Cobalt Violet and use quick dabbing round strokes to paint the shadowy flowers.

In the lower background foliage, use a mixture of Viridian Green and a tiny touch of Indigo, lifting from dry to indicate the gaps of light in the leaves. Try to keep all the borders soft.

Wet the lower ground area, and work wet-into-wet with an Ultramarine Violet and Viridian Green mixture. Darken the shadows under the foreground leaves. In the darkest areas, really push the Ultramarine Violet shadows. Wet the lower left and right corners, and drag tendrils into the corners wet-into-wet.

Changing Form

Fox spirits are adept shape-shifters. They are able to assume human form—a young girl, a beautiful woman or even an old man. They are long-lived and, perhaps, as a result, become bored and seek entertainment among humans. The older and more powerful spirits often have multiple tails, the oldest ones having nine. They have a quixotic nature, sometimes using their talents to play tricks, and other times acting as faithful guardians or lovers.

In Japan, fox spirits are frequently associated with the god Inari. They are celestial guardians whose talents are used for benevolence toward the humans who worship Inari.

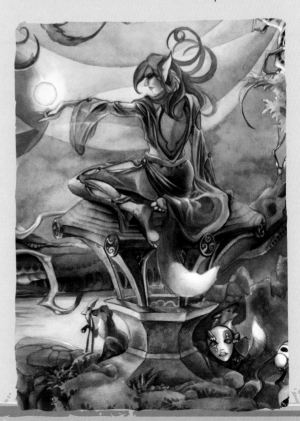

5 Refine Flowers and Leaves

Wet the flowers in the upper branches, and with a no. 1 round and a mixture of Cobalt Violet and Alizarin Crimson, dab a dot of color into the center of each flower, letting it bloom out to the petals.

Wet the leaves on the ground, and with various mixtures of Sap Green, Lemon Yellow and Cadmium Orange, dab a bit of color in the center of the leaves, near where the stem would be. When those have dried, apply another layer of the same colors to the larger foreground leaves and add some leaf vein textures by painting the negative space around the patterns.

6 Add the Basecoat to the Tree

With a no. 6 round and a mixture of Payne's Gray and Burnt Umber, apply a basecoat to the tree using the drybrush technique. Switch to a no. 1 round to get into the tight corners near the flowers at the top and along the little twigs. At the tips of the twigs, use a wet no. 1 round to pull the ends out into the surrounding background.

7 Glaze the Trunk

Using a no. 6 round and Burnt Umber, add a glaze to the trunk of the tree. Keep the brushstrokes minimal in order to keep the texture of the dry brush underlayer intact.

8 Indicate Shadows and Highlights

Create a dark mixture of Burnt Umber and Payne's Gray. Then, using a no. 4 round, darken the cavities of the tree. Pull out some highlights by lifting.

9 Create Bark Texture

Still using a mixture of Burnt Umber and Payne's Gray, switch to a no. 0 round and paint horizontal striations on the bark. Lift out from the center of the bark chips to get highlights.

10 Apply Base Shadows on Maiden's Skin and Clothes

With a no. 0 round and a mixture of Ultramarine Violet and Viridian Green, paint the shadows on the maiden's skin. This slightly greenish tone matches the shadows of the foliage around her. Then add Ultramarine Violet shadows on her clothing using the same brush.

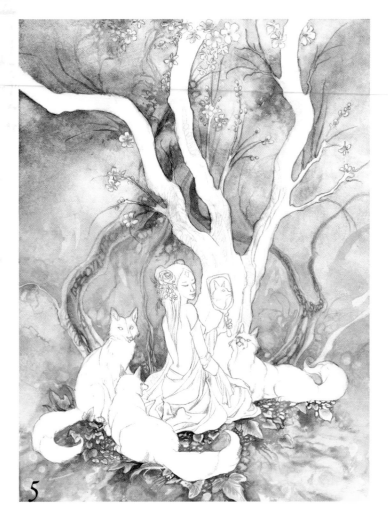

5

11 Color In Maiden's Skin, Hair and Clothes

For the skin, mix Naples Yellow with a touch of Alizarin Crimson. Dilute the mixture with water to create a very faint blush of color, then glaze this over the maiden's skin with a no. 1 round. Leave highlights of white paper along her cheekbones and the ridge of her nose.

Use Payne's Gray with a little bit of Burnt Umber for the basecoat of her hair.

Switch to a no. 4 round. Mix Alizarin Crimson and Cadmium Orange and glaze a layer over her clothing.

12 Finish the Figure

Using a no. 0 round and varying mixtures of Alizarin Crimson and Cadmium Orange, paint the wrinkles on her clothes.

Sparingly add deeper shadows on her skin with Burnt Sienna. Use tiny bits of Payne's Gray on her eyes, nostrils and eyebrows, keeping them delicate. Paint her lips using Alizarin Crimson, and dab a tiny bit of Cobalt Violet on the buds in her hair and on the rose.

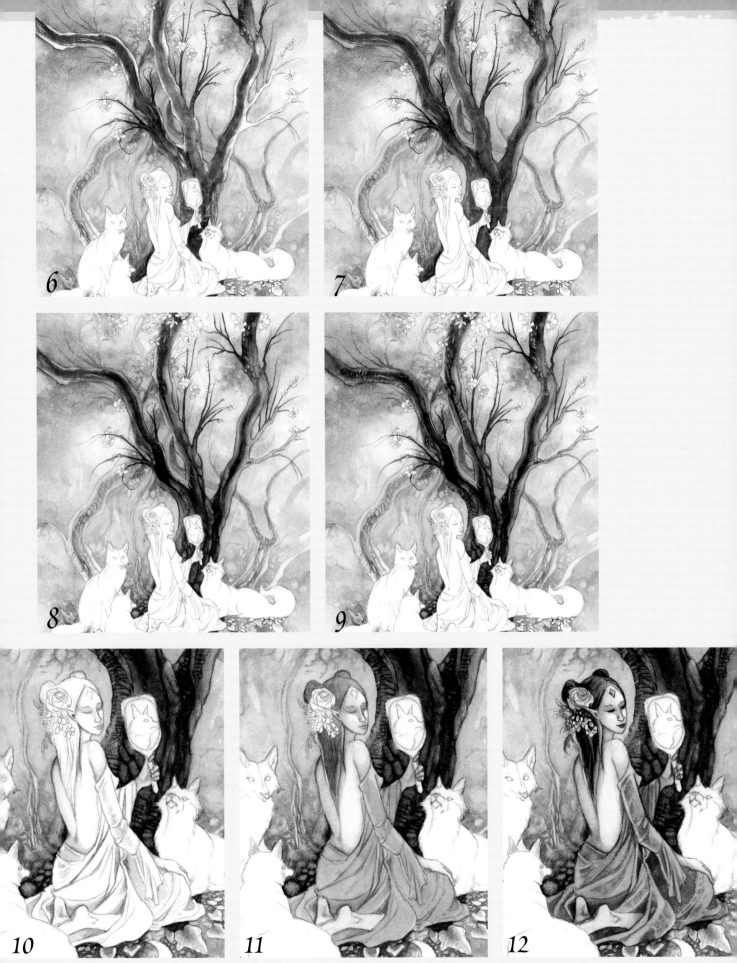

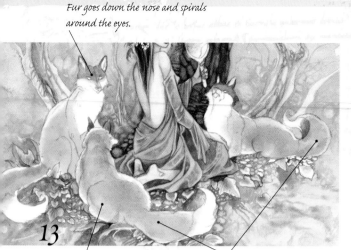

Fur goes down the nose and spirals around the eyes.

13

Spiraling pattern of the fur around the haunch

Run follows along the direction of the body.

13 **Color In the Foxes**
Add the base layer to the foxes painting wet-into-wet with a no. 4 round and Burnt Sienna. Leave the bibs, insides of the ears and the tail tips white.

14 **Indicate Fur**
Using a no. 0 round and varying mixtures of Burnt Umber and Brown Madder, paint short curved strokes to suggest fur, following the direction of the foxes' bodies.

15 **Blend the Fur**
With a no. 2 round, lift highlights from patches along the back of the middle fox. Using a damp brush, run across the upper sides of the fur details to smooth into the highlights. Glaze diluted Naples Yellow along the edges closest to the highlights.

16 **Refine the Details**
Using a no. 0 round and a mixture of Burnt Umber and a bit of Payne's Gray, paint the foxes' ears, eyes, nose and paws. Lift out highlights on each of the toes in the paws.

17 **Add White Shadows**
Suggest bits of white fur along the bibs and tails using a no. 0 round loaded with Ultramarine Violet. Use longer strokes on the tail, where the fur is longer.

18 **Blend the Fur in Light Areas**
Dilute a mixture of Lemon Yellow and Ultramarine Violet, then brush a light glaze over the shadows in the white areas using a no. 2 round. Leave some areas completely untouched. Use Lemon Yellow in the mirror background. Finish off the mirror frame in the maiden's hands with Naples Yellow and a no. 0 round.

14

15

16

17

18

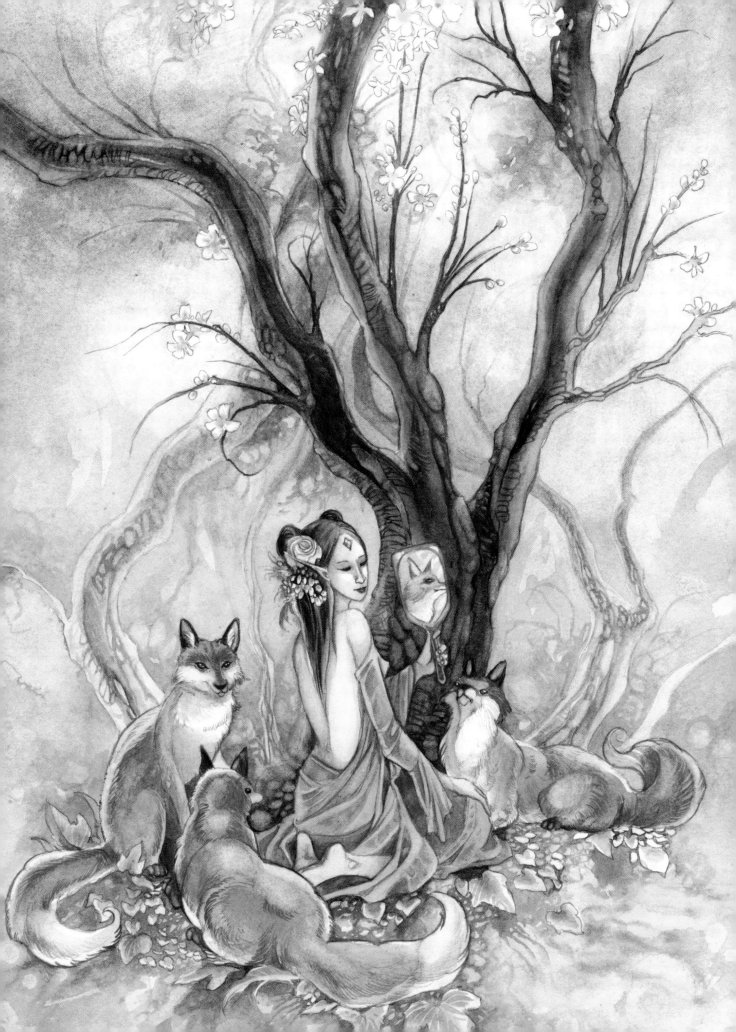

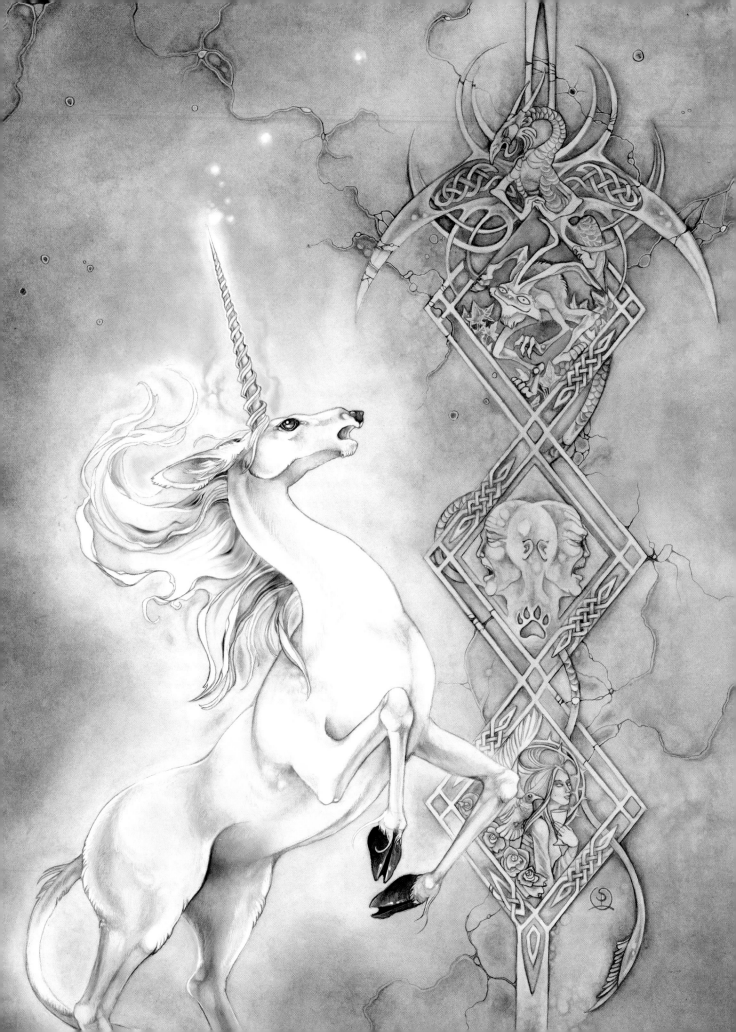

the UNICORN

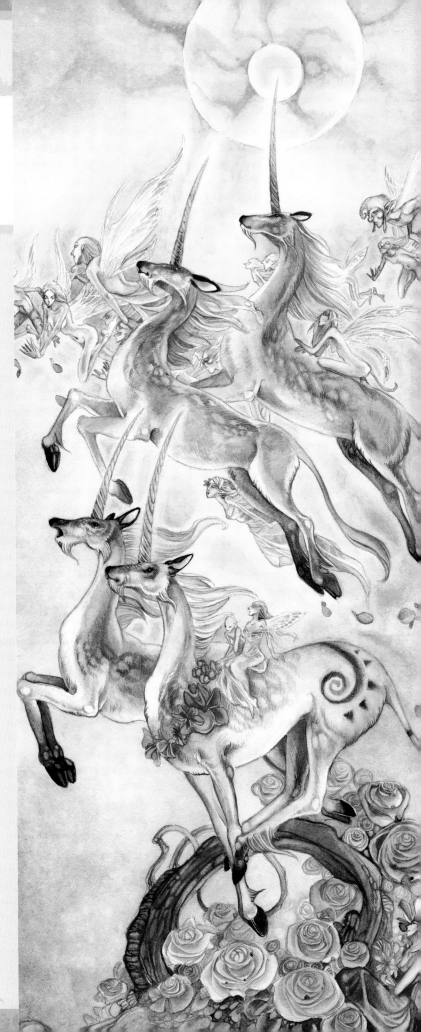

STORIES OF THE UNICORN TELL OF A CREATURE born of the sea: An equinelike beast that possessed characteristics akin to those of several commonplace animals, with a horse's trailing mane, the sinewy grace and elegance of a deer, the cloven hooves of a goat, and the tail of a lion. But this legendary and mythical creature also boasted a feature that was anything but ordinary—a magical trait that was all its own—a spiraling ivory horn at its crown.

It is thought that perhaps the story of the unicorn's origin stemmed from the gleaming horns of narwhals that sailors saw darting about the watery depths. In fact, during medieval times, northern traders sold narwhal tusks to princes, claiming the tusks were authentic unicorn horns—precious treasures imbued with magical properties.

These stories weren't unique to a single culture. Chinese alchemist, Ge Hong, a man who experimented with the uses of unicorn horns in his quest for immortality, spoke of their miraculous antipoison properties. The Greek physician, Ctesias, echoed this belief, spreading word about a creature from India whose horn could protect men from poisons. With such anecdotes spanning the globe, it's no wonder the unicorn was hunted by so many.

Depicting the Unicorn

UNICORNS ARE GENERALLY DEPICTED AS A creature that mostly looks like a horse with a horn on its head. Although this is a very popular look, don't be afraid to merge characteristics of other animals into the creature as well. Afterall, the unicorn of legend is no mundane horse.

Basic Horn Techniques

The spiral horn is basically a long cone that has been twisted. This form is easy to replicate with the following technique shown on this page.

The Qilin

In China, the Qilin is sometimes called the Asian unicorn. Though it is a gentle creature and a known protector and guardian, its appearance makes it seem more akin to a lion or dragon than a horse.

Create a basic horn shape by lightly penciling in two guidelines.

Creating a Spiraled Horn

Define the twisting shape by drawing a long, S-shaped curve between the guidelines.

Add parallel S-curves up the length of the horn and erase the guidelines when you're done.

Try angular lines and irregularly spaced lines.

Create various looks by stretching the S-curve long and thin.

Narwhals

Narwhals are creatures of the arctic seas, and their long spiral tusk was thought to have been the inspiration for the delicate ivory horn of a unicorn.

Start with a curved shape for the guidelines.

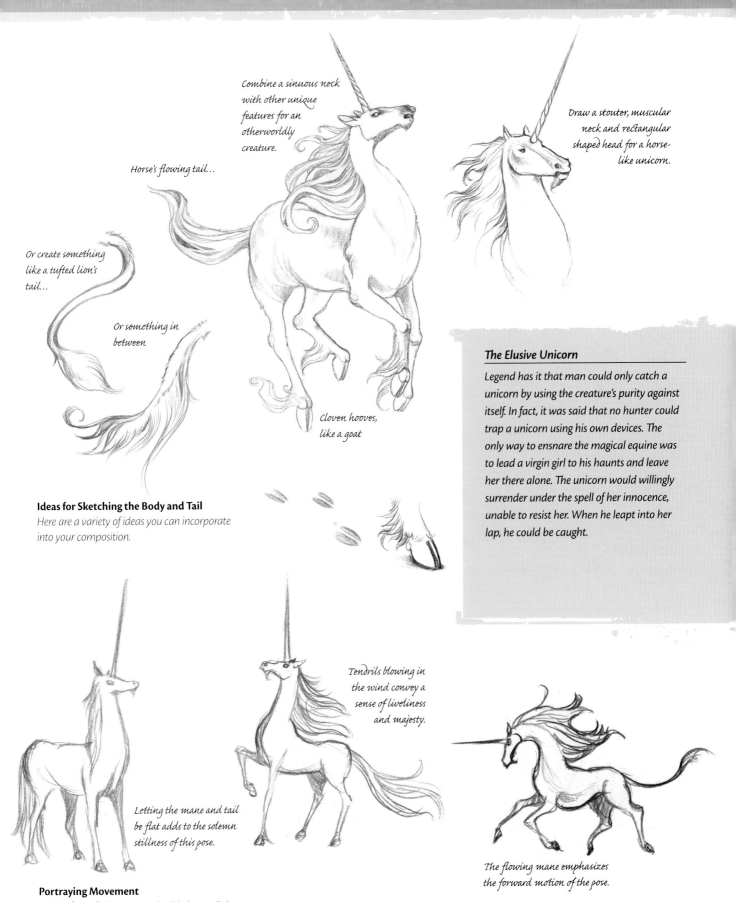

Combine a sinuous neck with other unique features for an otherworldly creature.

Draw a stouter, muscular neck and rectangular shaped head for a horse-like unicorn.

Horse's flowing tail...

Or create something like a tufted lion's tail...

Or something in between

Cloven hooves, like a goat

Ideas for Sketching the Body and Tail
Here are a variety of ideas you can incorporate into your composition.

The Elusive Unicorn

Legend has it that man could only catch a unicorn by using the creature's purity against itself. In fact, it was said that no hunter could trap a unicorn using his own devices. The only way to ensnare the magical equine was to lead a virgin girl to his haunts and leave her there alone. The unicorn would willingly surrender under the spell of her innocence, unable to resist her. When he leapt into her lap, he could be caught.

Tendrils blowing in the wind convey a sense of liveliness and majesty.

Letting the mane and tail be flat adds to the solemn stillness of this pose.

Portraying Movement
Let the flow of the mane and tail help to tell the story of the movement of your creature.

The flowing mane emphasizes the forward motion of the pose.

105

Painting Water

SINCE THE UNICORN IS SAID TO BE BORN OF the sea, you'll likely want to add the element of water to your composition. When painting water, it's important to remember that the surface is always shifting and moving, creating undulating waves and ripples. This constant state of movement causes the sunlight to glint along the surface unevenly, causing little beams of light to dance along the troughs of the waves.

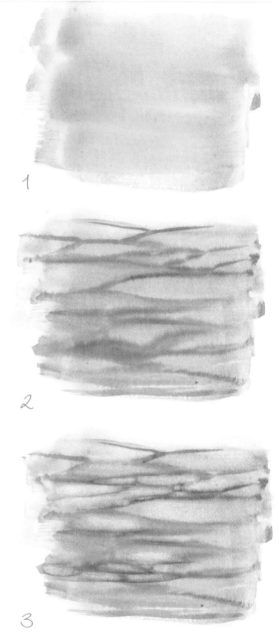

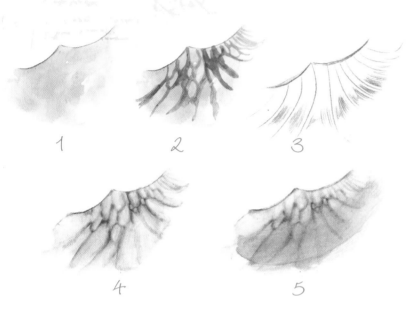

Showing Sunlight Through the Wavetops

1. Lay in a base wash of color.
2. With a round brush and a darker tone, paint shadows of the ripples.
3. Keep in mind the curve of the wave's surface as you paint the ripples of light and shadow.
4. With a stiff round brush lift and blend the shadows by brushing with clean water along the edges.
5. With a medium-sized round brush, take clean water and brush parallel along the top of the wave to smooth out the shadows even further, as this is where the most light would be piercing through the water. In the lower part of the wave's trough, brush a diluted wash of a darker tone horizontally to shadow the lower part of the wave.

Illustrating Movement on the Water's Surface

1. Lay in a base wash of color across the surface.
2. Either while the base wash is still wet, or else re-wetting the surface with a flat brush of clean water, take a medium-sized round brush and paint wet-into-wet shadows onto the surface of the water.
3. Lift out highlights in the lighter areas with a medium-sized round brush dipped in clean water, and dab the areas with a paper towel.

The Unicorn
PAINTING WHITE

Because watercolors are a transparent medium, painting something white can be tricky. With an opaque medium like acrylics or oils, you would simply add white paint to the desired area. With watercolors, however, you have to think about painting *around* the white, defining it by what surrounds it—especially the shadows.

Because white reflects all the colors around it, the whites in a watercolor painting are actually made of light glazes of faint color, with bits of white paper saved for the brightest highlights. For this demonstration, you'll use a palette of yellows, greens and blues to create the perfect white for your unicorn.

MATERIALS LIST

Watercolors ~ Burnt Umber, Lemon Yellow, Naples Yellow, Payne's Gray, Prussian Blue, Raw Umber, Sap Green, Ultramarine Violet, Viridian Green

Brushes ~ ½-inch flat (12mm), nos. 0, 2, and 4 rounds

Other ~ Pencil

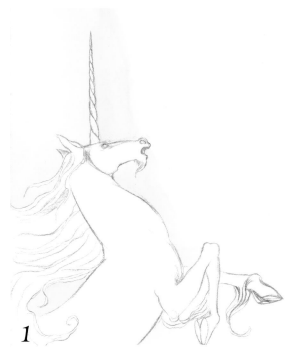

1 Finish the Sketch and Apply the First Layer of Background Color
After sketching the unicorn with a pencil, use a no. 4 round and Lemon Yellow to paint around the body. Blend outward into the surrounding background using clean water.

2 Continue to Build Up Background Color
Using a ½-inch (12mm) flat, wet the background with water. With a no. 4 round, paint wet-into-wet using Viridian Green in the upper corners, fading to Sap Green, and then to clean water as you move inward toward the unicorn. While this is still wet, trail shadowy tree branches with Prussian Blue in the background, switching to smaller brushes to pull the color out into the thinner twigs.

3 Color In the Body and Mane

With a no. 0 round mix a bit of Ultramarine Violet into Viridian Green. Place short parallel strokes in the direction of the fur along the unicorn's face and body. With a no. 2 round loaded with clean water, blend the strokes to create very diluted washes of shadow across the body. Using the same mixture as before, glaze a light layer of color over the trailing hair in the mane.

4 Add Fur Texture and Shadows

Using a no. 0 round and a mixture of Raw Umber and Payne's Gray, add fur details to the shadows along the body as you did in step 3. Add texture to the fur, painting with short parallel strokes in the direction of the fur growth along the shadows of the body. Then briefly swipe a wet no. 2 round and clean water over these strokes to soften them. With a no. 2 round, wash some shadows over the background leg, body and tendrils of hair.

5 Place Final Details

Using a no. 0 round and a mixture of Payne's Gray and Burnt Umber, paint the hooves and eye. Lift some highlights out.

On the horn, place short strokes of Payne's Gray parallel to the twisting spiral. Soften the texture by brushing heavily diluted Naples Yellow vertically up the horn.

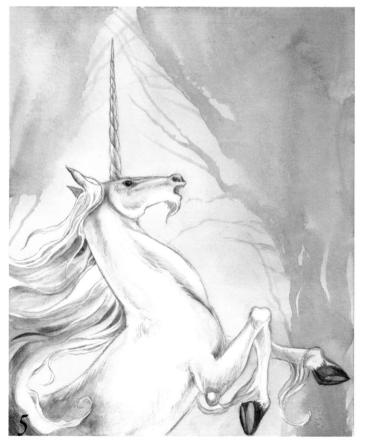

The Unicorn
BORN OF SEA FOAM

The concept of magical equines being birthed from the sea is a powerful image repeated in many myths. The Greek god Poseidon was the creator of the horse; mighty white-maned creatures would surge up from the ocean's floor in bursts of sea foam and crashing waves. The Celtic goddess, Epona, was also said to have been born of sea foam, taking the form of a white mare when she stepped onto land. And then there are the narwhals, called the *unicorns of the sea* for their long spiral tusks shaped like a unicorn's horn, that were traded and sold as the genuine article for centuries. With so many tales of the unicorn's origin, there is a wonderfully rich base from which to choose when portraying the magical beast in your paintings.

MATERIALS LIST

Watercolors ~ Alizarin Crimson, Burnt Umber, Cerulean Blue, Naples Yellow, Payne's Gray, Prussian Blue, Raw Umber, Sap Green, Ultramarine Blue, Viridian Green

Brushes ~ ¼-inch (6mm) and ½-inch (12mm) flat, nos. 0, 1, 2, 4, and 6 rounds

Other ~ Masking fluid, rubbing alcohol, salt

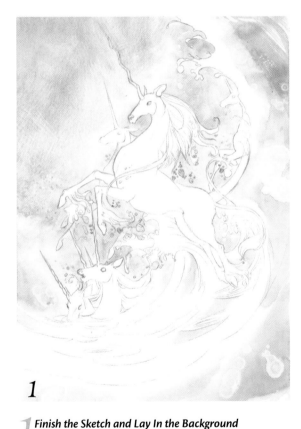

1

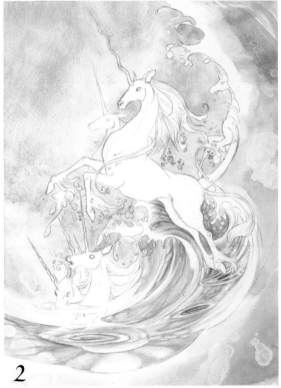

2

1 Finish the Sketch and Lay In the Background
Sketch the unicorns. Paint masking fluid onto the droplets of water spraying from the waves. Then, with a no. 6 round and a mixture of Cerulean Blue and Prussian Blue, paint in the background layer. In the tighter corners close to the unicorns' hooves, switch to smaller-sized brushes. As you work your way around while the paint is still wet, sprinkle with salt and rubbing alcohol to add a misty sea spray texture.

2 Create the Ripples on the Sea
With a no. 4 round and various mixtures of Cerulean Blue and Viridian Green, fill in the waves, adding shadows and ripples.

3 Darken the Water

Using a ½-inch (12mm) flat, darken the lower waves and the upper right side with a layer of Cerulean Blue and Viridian Green. Splash more rubbing alcohol into the wet glaze to add more texture.

4 Suggest Foreground Ripples

With varying mixtures of Viridian Green and Prussian Blue, use a no. 4 round to paint more shadows and ripples on the foreground waves. Keep in mind that the bottom curves gently out and radiates toward the viewer. Leave the upper right wall of the wave curving up and over the unicorns. With a no. 2 round and clean water, lift out highlights along the top edges of the waves. Once this has dried, remove the masking fluid.

5 Add Details to the Waves

Using a ½-inch (12mm) flat and some Sap Green, glaze the lower corners in the shadowed trough of the wave and the upper right. Switch to a no. 1 round and paint some Sap Green ripples in the waves near the unicorns to create visual contrast. Mix in some Prussian Blue in the shadowed areas closer to the unicorns.

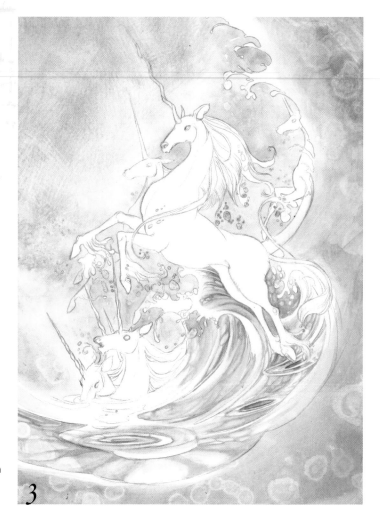

3

6 Paint the Shadowed Unicorns

Mix Ultramarine Blue and Payne's Gray, and using nos. 0 to 2 rounds, paint the unicorns in the background. Since they are in the background (and in the shadows), don't sharpen the details too much, or it will distract attention from the foreground. Blend the paint into the surroundings by brushing lightly over the dried paint with a ¼-inch (6mm) flat and some clean water.

7 Color in Manes and Water Droplets

With a no. 0 round, use a mixture of Viridian Green and Payne's Gray to paint the manes of the unicorns in the foreground and the droplets of water. Keep an edge of white paper showing through on the little drops.

For the main foreground unicorn, lay in Cerulean Blue on the mane. To suggest shadows, mix in some Payne's Gray.

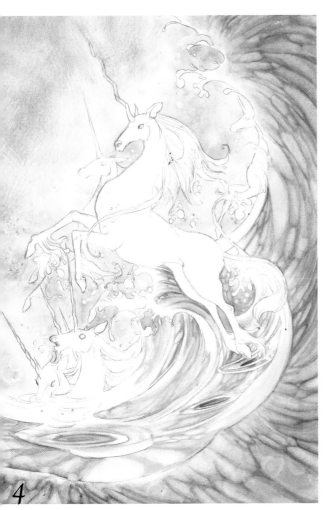

4

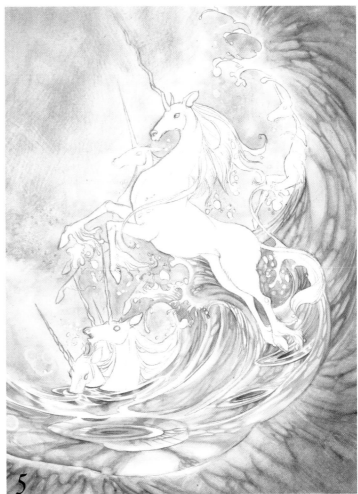

5

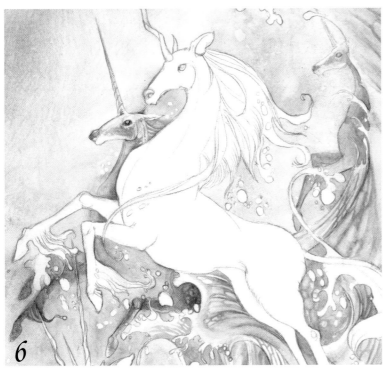

6

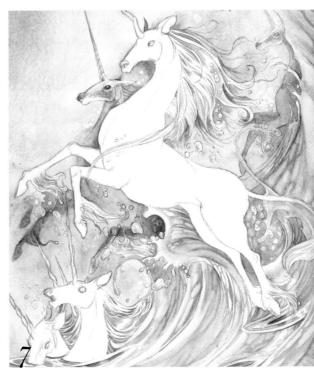

7

Water Droplet Details

A Closer Look

White highlight from direction of light source

Shadow

White paper showing through for the highlight around the droplet

Defining Large Splashes and Droplets

1 Paint the area around the splash. If it's small, you might want to use masking fluid.

2 Paint the shadows of the drop. Since water is clear, this matches the color of the surroundings (Prussian Blue).

3 Add some reflected colors from the surroundings into the shadow as well (Viridian Green).

Defining Small Splashes and Droplets

For smaller splashes and droplets, simplify the process.

1 Leave the white of the droplets, either by painting around them, using masking fluid, or maintaining the splattered texture of rubbing alcohol.

2 Leave white around the edges of the droplets. Add shadows to the center of each droplet using the background color.

Creating Mist

To suggest the fine misty spray off of the wave tops, use a toothbrush soaked in rubbing alcohol. Holding the toothbrush with your right hand, run your left thumb across the bristles, splattering droplets of alcohol over a wet wash of paint. As you rotate the brush against your thumb, the rubbing alcohol will spray out onto the page, resulting in randomized droplets of white in your wet paint. The closer you hold the brush to your page, the closer together the speckles will be.

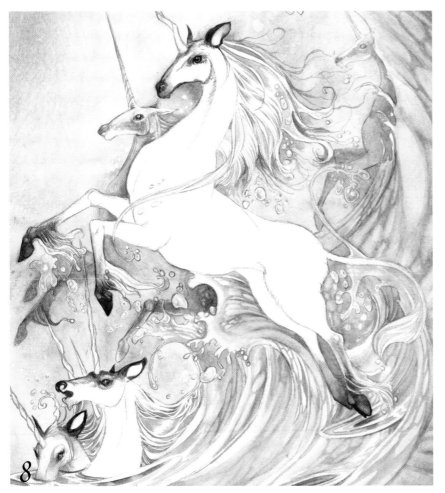

8 Fill In the Hooves, Ears, Snouts and Eyes

With a no. 0 round, use a mixture of Burnt Umber and Payne's Gray to paint the hooves. As you move up the forelegs, use short parallel strokes for the fur, then blend by brushing a little clean water over the strokes. Use the same treatment on the ears and snout. Use short parallel strokes for the fur moving around the eyes and face. Dot in a little bit of Payne's Gray for the eyes, leaving a glint of white shine.

9 Paint Shadows on the Coats

Mix Raw Umber and Cerulean Blue, using various shades of this mixture to create the shadows on the unicorns' fur using a no. 0 round. As with the fur near the eyes and hooves, use short parallel strokes in the direction of the fur. Then, brush over these areas with clean water to lightly blend, still keeping faint, distinct strokes visible. Let these areas of texture overlap as you build up the depth.

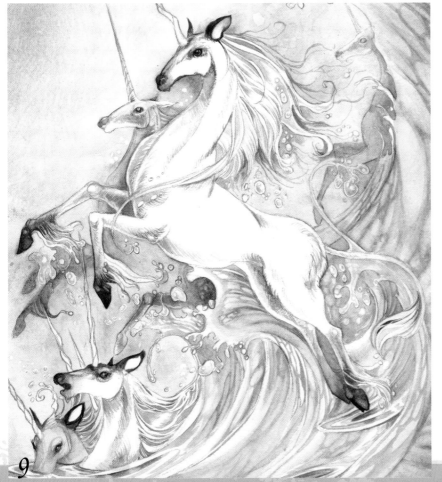

10

Smooth out the Textures

10 With a no. 2 round and highly diluted Naples Yellow, add a wash to the unicorns' fur to smooth out the texture and simultaneously deepen the shadows. Mix in a touch of Payne's Gray to the shadows of the background legs to create more depth.

Refine the Horns and Ears

11 With a no. 0 round, paint Payne's Gray shadows on the twists of the horns. Dab a little bit of Alizarin Crimson in the centers of the ears, painting wet-into-wet and fading out toward the tips.

11

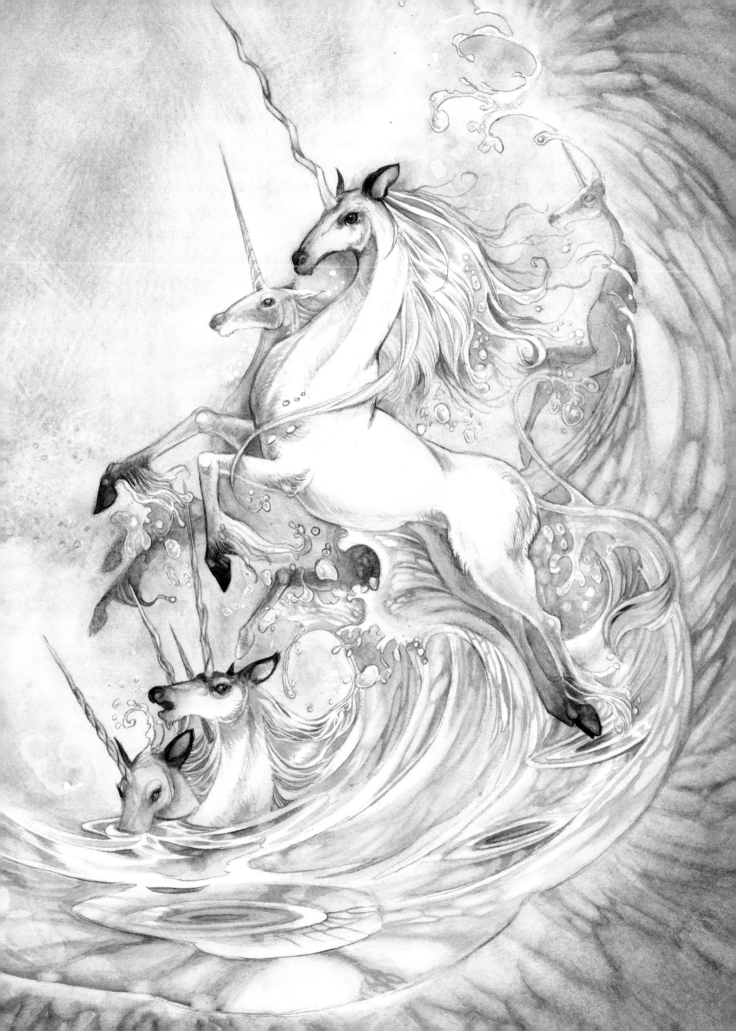

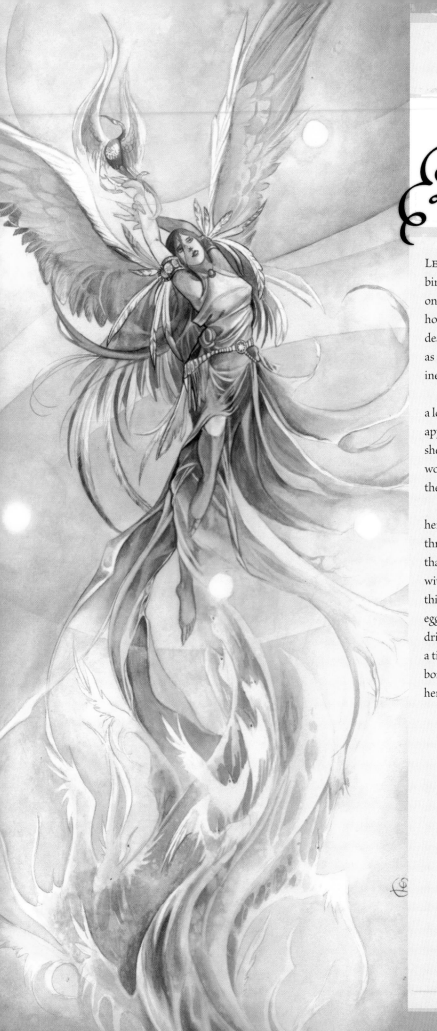

the PHOENIX

Legend has it that the Phoenix is a flaming bird, a creature so wondrous and magnificent that only one can exist at any given time. A perpetual symbol of hope, the Phoenix embodies both sides of fire: life and death, endings and beginnings. Her very existence serves as a reminder of the cyclical nature of the world and the inevitable duality that is a part of everything.

As the only one of her kind, the Phoenix endures a lonely existence. Even so, when the dusk of her life approaches, she does not mourn her last hour. Rather, she gathers up dry tinder to build a nest high above the world—a nest in which she will lay a single egg that holds the promise of the future: her successor.

When the hour of death arrives, the Phoenix perches herself on the lone egg. As her last breath leaves her throat—hotter than any mortal-made fire and brighter than the sun—her heart surges forward as if to escape with her soul, and her body bursts into flame. Only in this tremendous heat of her death does the shell of the egg grow hard and brittle. And, as her ashes fall in a drifting snow of benediction on the remains of her nest, a tiny form bursts free from the egg. The new Phoenix is born, birthed within that very element that consumed her mother.

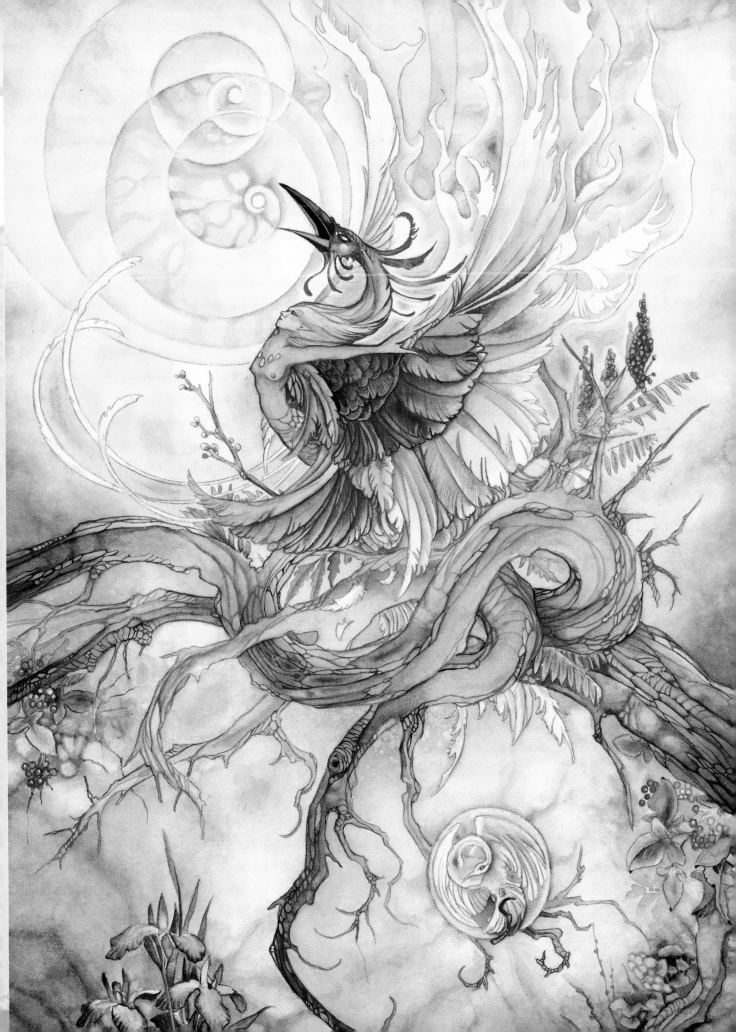

Drawing Feathers

Though fantastical and fiery in nature, the Phoenix is still a bird, and you will have to detail her with feathers and the general form of a bird. From there, you can branch out into imaginative whimsy, letting the flames shape the creature.

Drawing a Single Feather

1 Draw the spine of the feather with a slight curve.

2 Draw the basic form around that. Note that it's not completely symmetrical.

3 Add texture by running short parallel strokes to meet along the spine on both sides.

Things to Avoid

Never draw a solid or even texture on a feather. It flattens the feather and makes it look less realistic.

For a more natural look, vary the lines, breaking up the strokes along the outer edge and adding a slight curve.

Overlapping Feathers

If the feathers don't overlap, they will be too sparse, and look like they are glued in place.

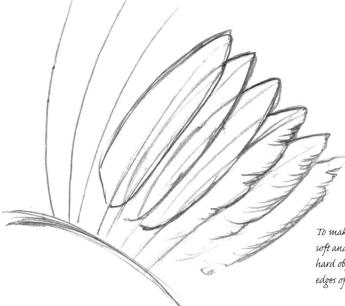

To make the feathers look soft and not like solid hard objects, break up the edges of your lines.

Drawing Shorter Downy Feathers

1 Start with overlapping arcs, a bit like scales.

2 Soften their edges to turn them into feathers.

Wing and Tail Feathers

A wing or tail is basically a fan of feathers radiating out along the arch of the muscles. Notice the feathers overlap one another slightly.

Painting Feathers: A Quick Tutorial

1 Sketch the feathers.
2 Blend in the shadows.
3 Paint a glaze of the main color.
4 Paint the filaments and details with the main color in a more concentrated form. Use a no. 0 round to make short parallel strokes. Alternatively, if the area is large enough to accommodate it, use a small flat brush and drybrush with the flat edge.
5 If necessary, blend the texture a little bit by brushing clear water over the edges.

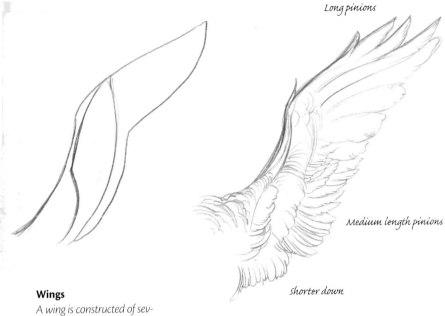

Long pinions

Medium length pinions

Shorter down

Wings
A wing is constructed of several layers of feathers.

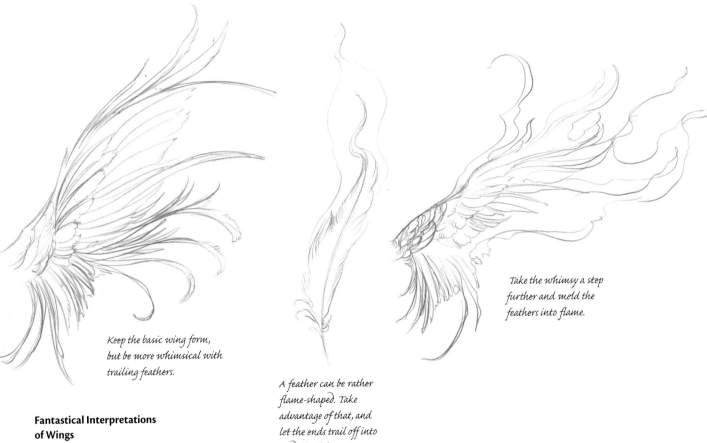

Keep the basic wing form, but be more whimsical with trailing feathers.

Fantastical Interpretations of Wings

A feather can be rather flame-shaped. Take advantage of that, and let the ends trail off into tendrils of fire.

Take the whimsy a step further and meld the feathers into flame.

Forming the Phoenix

THE BODY TYPE YOU CHOOSE FOR YOUR
Phoenix not only speaks to the type of creature
you are creating, but it also sets the mood for the
piece. Is it an ethereal creature of air and light to
inspire awe? Or is it something more physically
powerful with a daunting presence? The choice
is yours.

A Statement of Elegance
*You might decide on a slender,
elegant form, like an egret,
stork or crane.*

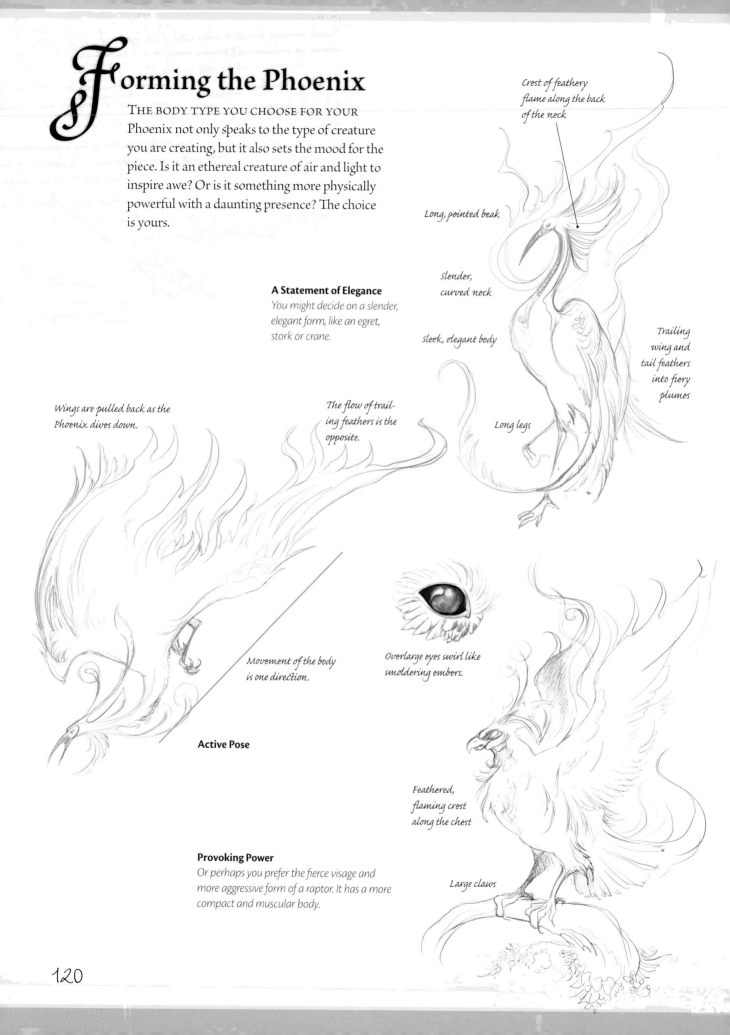

Crest of feathery
flame along the back
of the neck

Long, pointed beak

Slender,
curved neck

Sleek, elegant body

Trailing
wing and
tail feathers
into fiery
plumes

Long legs

Wings are pulled back as the
Phoenix dives down.

The flow of trail-
ing feathers is the
opposite.

Movement of the body
is one direction.

Active Pose

Overlarge eyes swirl like
smoldering embers.

Feathered,
flaming crest
along the chest

Provoking Power
*Or perhaps you prefer the fierce visage and
more aggressive form of a raptor. It has a more
compact and muscular body.*

Large claws

Sketching and Painting Fire

Something as simple as lighting a match or a candle can help you in your quest to portray fiery flames on a two-dimensional surface. Notice how the colors vary with the intensity of the heat; detect the absence of hard edges; observe the way the flame flickers and dances through the air. By examining and understanding such characteristics, you can only make your Phoenix composition stronger.

A Closer Look at Fire
Here color corresponds to heat: the hottest part of the fire burns white, the medium heat has an orange and yellow hue, and the darkest and coolest part is closest to the burning object.

The flame has no hard edge because it's not a solid object.

Medium heat and color

The brightest and hottest part of a fire

The darkest and coolest part of a fire is this dark area closest to the burning object.

Capturing the Movement of Fire
Waft a gentle breeze at a flame using your hand and watch how the flame flows and wavers. It seems to dance in the air. Can you see the potential in those dancing flames for the fiery plumage of a Phoenix?

Using a Contrasting Background

When you're ready to transition from sketching to painting, contrasting colors placed side by side can really help accentuate one another. This is certainly the case when painting flames. Using contrasting colors in the background helps a fiery flame pop right off the page.

The flame with the dark green background stands out much more dramatically than the one that is against a pale yellow background. The green is a contrast of both color and light value. Green is the complementary color to red, and the darkness nicely offsets the nimbus of white light around the flame.

Painting Flames

FIRE IS EMBLEMATIC OF BOTH LIFE-GIVING, nurturing warmth, and a greedy, consuming heat that can enshroud its enemy with death. Its warmth tempts you to come near, but venture too close and you'll feel its painful sear. These are the two sides of fire, and the Phoenix embodies them both.

Creating the Glow

To begin adding color, wet the area around the flame. Use mixtures of Cadmium Orange and Cadmium Red and run a no. 2 round along the edges, wet-into-wet. Let the color bleed outward around the flame.

Softening the Edges

Glaze Lemon Yellow to soften the edges. Leave a white core to the flame.

Contrasting Background

Wet the area around the flame and paint a contrasting color wet-into-wet. By painting a dark background, the light becomes that much more striking.

Wet-Into-Wet Flames

Go from the lightest to the darkest colors—Lemon Yellow to Cadmium Orange to Cadmium Red with a round brush. Before it is completely dry, take a ½-inch (12mm) flat and gently blend and pull the colors upward in hazy streaks.

The Phoenix
FIERY GLORY

The Phoenix folds her wings close to her body and plummets from the heavens like a blazing comet across the sky. Her feathers seem to burn and her flames lick the clouds. The sun itself seems to pale in comparison to the glory of the Phoenix as she streaks across the horizon.

MATERIALS LIST

Watercolors ～ Alizarin Crimson, Burnt Umber, Cadmium Orange, Cadmium Red, Cadmium Yellow, Lemon Yellow, Naples Yellow, Payne's Gray, Raw Sienna, Viridian Green

Brushes ～ 1-inch (25mm) flat, nos. 0, 1, 2 and 4 rounds

Other ～ Paper towels

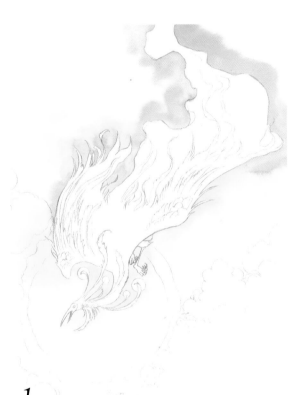

1

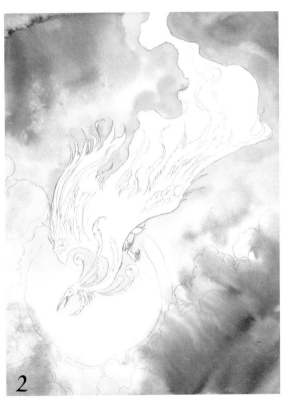

2

1 Finish the Sketch and Add Fiery Glow
Once the sketch has been completed, use a no. 4 round to wet the areas around the edges of the flames. Switch to smaller brushes if necessary. Paint wet-into-wet with a range of warm colors—Lemon Yellow, Cadmium Yellow, Cadmium Orange and Cadmium Red—moving from lightest near the head to darkest near the tail. Don't worry about creating the entire glow at once; instead, paint one section at a time. For example, start at the head area with all the tricky corners, then move along the right for the underside of the wing, ending in the top right corner. Since the wet-into-wet bleeds outward, the sections will blend easily.

2 Create the Clouds
Wet the rest of the background with clean water using a 1-inch (25mm) flat. Paint wet-into-wet with Payne's Gray, fading to clear as you come near the Phoenix. Keep the more intense darks near the corners of the paper. This focuses attention on the bird. Use different techniques to suggest cloud texture, including dabbing the surface with a paper towel (see top right corner) and gently blowing on the wet paint (see bottom right corner).

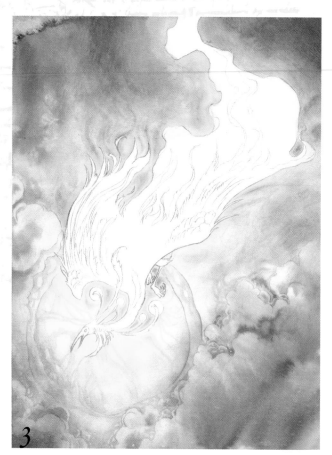

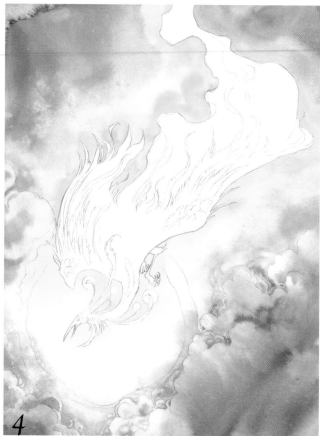

3 **Indicate Cloud Shadows**
Using a no. 2 round, wet areas of the clouds, painting wet-into-wet with Payne's Gray to add shadows and further define the cloud forms.

4 **Continue to Build Up the Fiery Glow**
With a no. 2 round, glaze Lemon Yellow over the edges of the clouds near the head. Trail little bits of the yellow wet-into-wet into the fiery glow around the head. Continue glazing the edges of the clouds closest to the Phoenix, using darker tones as you go: Cadmium Yellow, Cadmium Orange and up to Cadmium Red at the very top edge. For the larger areas up top, switch to a 1-inch (25mm) flat to blend the colors more easily.

5 **Add More Flames**
Work in the flames trailing from the Phoenix's wings painting wet-into-wet with a no. 4 round and Naples Yellow. Be sure to leave white showing around the edges for contrast where this meets the more sullen red tones.

6 **Place Shadows on the Phoenix**
Using a no. 0 round and a mixture of Viridian Green and Payne's Gray, paint the shadows on the Phoenix along the feathers, neck and head. This green not only complements the warm tones of the fiery glow, but serves as a nice contrast as well.

7 **Fill In Colors**
Use a no. 2 round and Raw Sienna to paint the head and neck, making sure to leave white edges. Because you painted the background surrounding this, the white becomes a defining edge of light. As you move along toward the back and wings, glaze over the shadows and fade to Cadmium Red.

8 **Pick Out Feather Details**
Further define the feathers by painting the details of their texture with a no. 0 round and Alizarin Crimson.

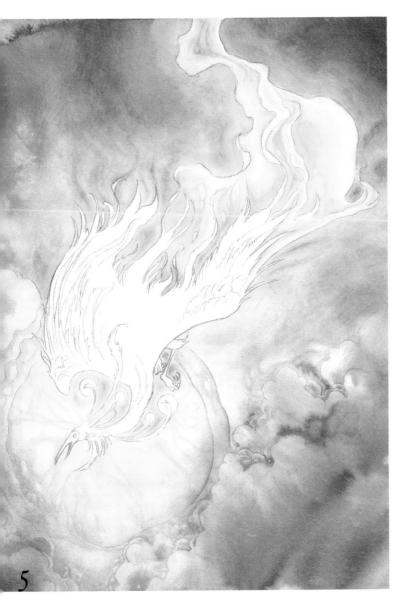

5

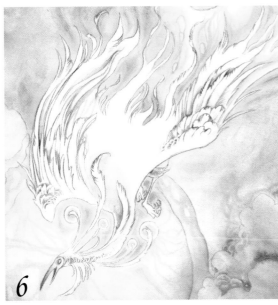

6

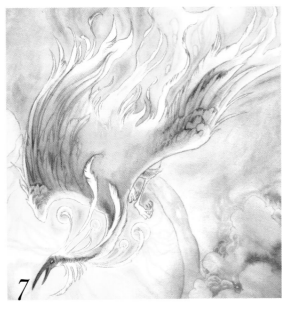

7

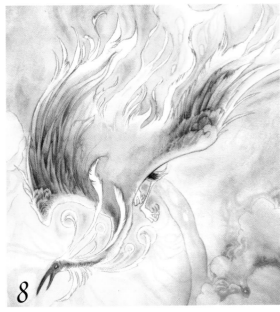

8

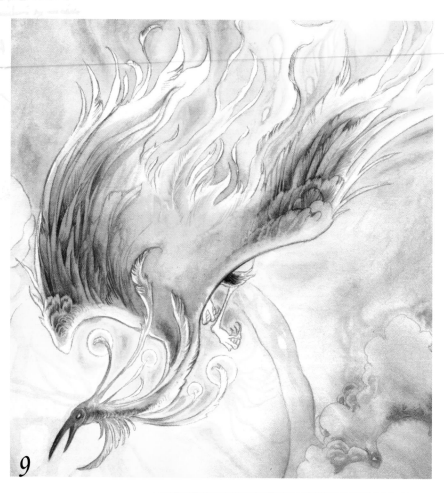

9

10

9 **Add More Feathers**
With a no. 0 round, paint Cadmium Orange feathers along the head, crest and tail.

10 **Paint the Eye, Beak and Claws**
With a no. 0 round, use a mixture of Payne's Gray and Burnt Umber to finish off the final details of the eye, the tip of the beak and the claws.

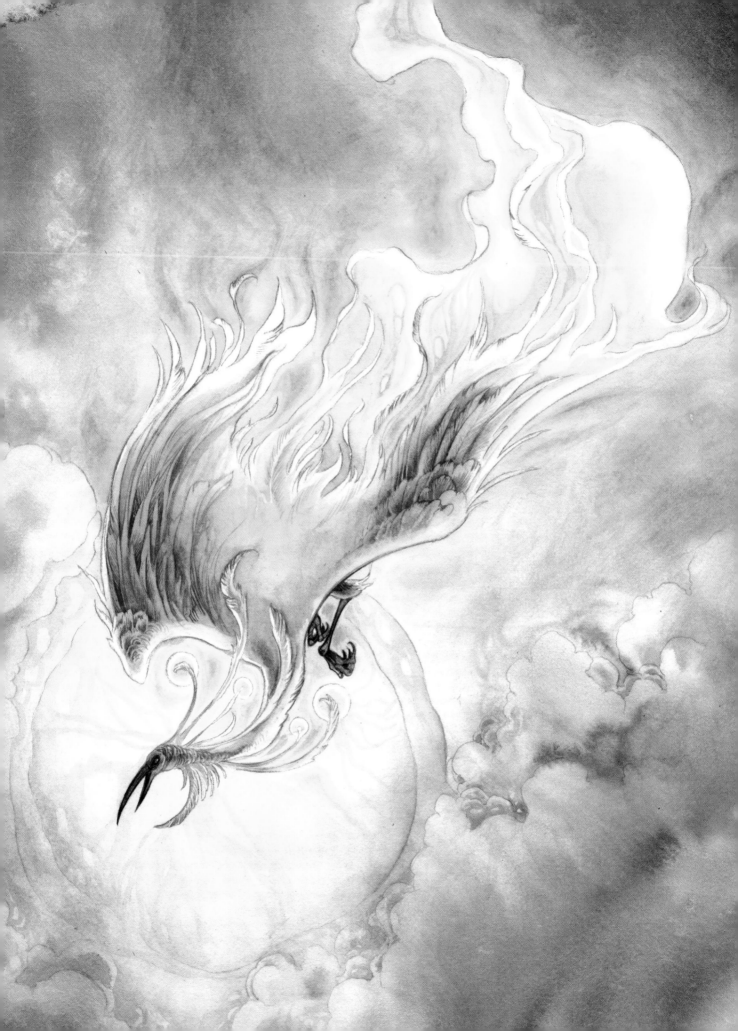

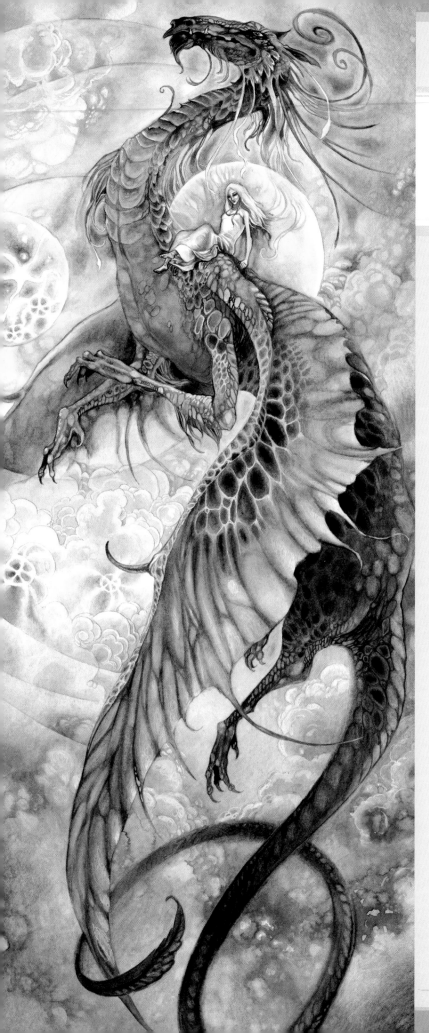

the
DRAGON

DRAGONS ARE SYMBOLS OF POWER—SOMETIMES for good, sometimes for ill. Regardless of which, they are an elemental power; an embodiment of strengths and forces beyond human control. Their appearance is a fantastical combination of creatures of all sorts—the manes of lions, the horns of a stag, the shape of a lizard, the wings of a bat and the tail of a snake, to name a few.

In Eastern mythologies dragons are representations of the divine. They are benevolent beings and incarnations of earth, sea and sky. They are sovereigns of their realms, intelligent beings and symbolic of imperial might.

In most Western mythologies, dragons are representations of evil. More animalistic in nature than their Eastern brethren, they are fierce, fire-breathing creatures capable of creating swaths of destruction. Often, they are cast as the great nemeses of brave knights who must march to battle in order to prove themselves.

Modern fantasy dragons have taken on aspects from all of these sources, granting them color, intellect or physical traits to mold the concepts of dragons to our own tales. How then to capture these brilliant beasts within the confines of paper, pencil and brush? The possibilities are limitless.

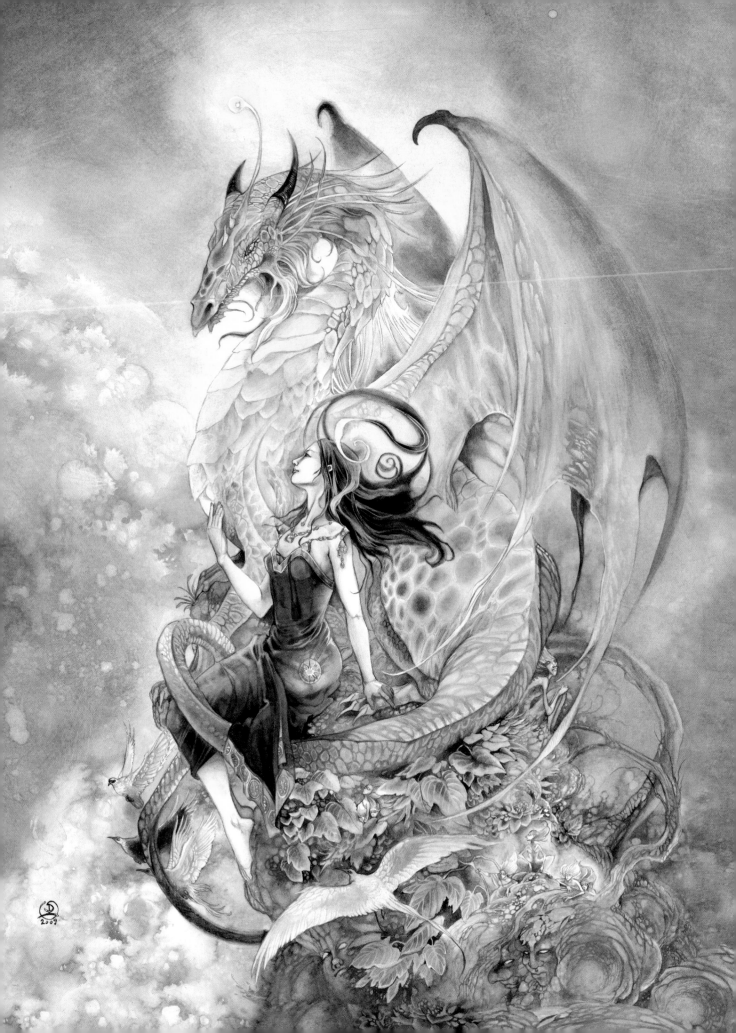

Drawing Serpentine Dragons

THE BODY OF AN EASTERN DRAGON IS MUCH more serpentine in appearance, with shorter limbs and the sinuous shape of a snake. It flies through the sky without the aid of wings, and its face reflects the features of strong and noble mammals such as the lion.

The Dragon's Pearl

One day, a young boy was out looking for food. He came across a beautiful giant pearl nestled in the rice fields. He took it home with him and showed it to his mother. Afraid that the other villagers would be jealous, she quickly hid it inside a near-empty rice jar.

The next day as the mother prepared to make food, she opened the rice jar and, to her astonishment, the jar was brimming with rice. The pearl gleamed among the white grains. "It is a miraculous pearl!" she exclaimed in wonder. Joyously, mother and son shared the rice among their neighbors, careful to keep the source of their plenty a secret.

But eventually the secret came out and the villagers became wild with jealousy. They raided the house of the boy and his mother, determined to possess the magical pearl, and in the confusion and violence, the boy swallowed it. He was transformed into a beautiful dragon, and he danced away into the heavens with the flaming pearl.

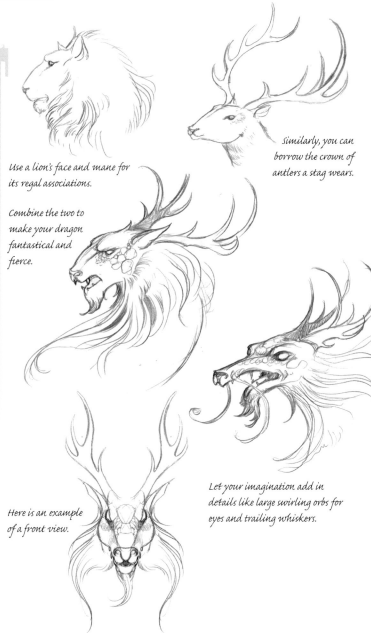

Use a lion's face and mane for its regal associations.

Similarly, you can borrow the crown of antlers a stag wears.

Combine the two to make your dragon fantastical and fierce.

Let your imagination add in details like large swirling orbs for eyes and trailing whiskers.

Here is an example of a front view.

Designing the Face
Asian dragon faces are more mammalian than reptilian. You can borrow from a variety of animals. The example above uses both lion and deer stag features.

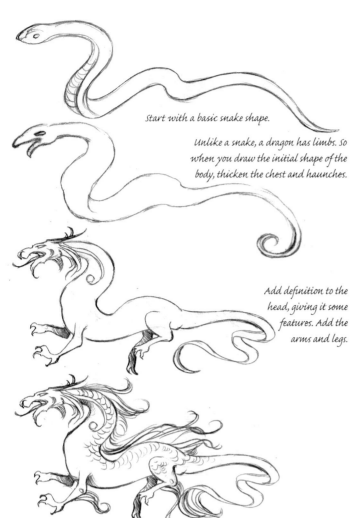

Drawing the Body
When drawing the body, use the sinuous form of a snake as your starting point.

Start with a basic snake shape.

Unlike a snake, a dragon has limbs. So when you draw the initial shape of the body, thicken the chest and haunches.

Add definition to the head, giving it some features. Add the arms and legs.

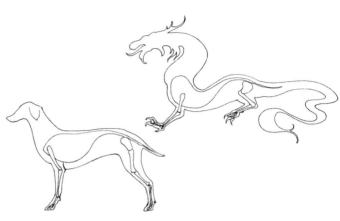

Finish off the details (like scales) according to your personal preferences. You can extend the mane down the spine, like a horse's mane. Or even turn these into fiery or watery tendrils, curling out from the body. You can also add more volume to the tail.

Define the Legs
If you are having difficulty with arranging the dragon's limbs, think of a familiar quadruped like a dog. The dragon's bone structure is similar, though placement of the limbs (as well as the length of the limbs) will differ.

Try to keep the knuckles aligned. Generally, a curved line can act as a guide for the structure.

To create the basic shape, work from the ball of the foot, the pad of the sole area, and the claw tendons.

Note the similarities to a human foot, with forward weight and pressure placed on the toes.

Depicting Claws
When thinking about the claws, it's easier to break down the whole into its underlying structure.

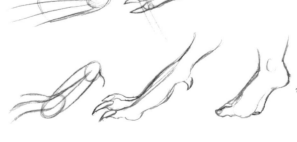

Here the foot is tensed aggressively and with claws bared.

Flat pads on each toe indicates weight is on this foot. Prominent tendons also indicate tension.

Here is a view of a relaxed foot.

131

Drawing Reptilian Dragons

In contrast to Eastern dragons, Western dragons are more reptilian in appearance. Often cloaked on either side by giant batlike wings, the Western dragon has a large and looming presence as he soars across the sky. While Eastern dragons are generally portrayed as benevolent creatures, Western dragons are often thought of as fierce beasts and worthy foes of knights-errant.

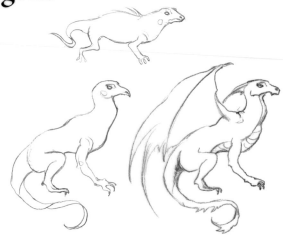

Drawing the Body

Use the basic shape of an iguana as a starting place for inspiration. Then, start creatively exaggerating and emphasizing features. For example, elongate the neck, limbs and tail. Draw larger claws for a more aggressive attitude. To accommodate the larger limbs, expand the chest cavity. Slowly fill in more of the details, like wings and distinctive facial features.

Saint George and the Dragon

A very well known evil dragon that has inspired paintings for centuries is the dragon slain by Saint George. This dragon once terrorized a small town, nesting at its spring. Unable to drink from their water source, the frightened citizens were forced to appease the terrible creature by drawing lots to see who would be sacrificed.

One day, the princess drew the lot that marked her as the sacrifice. Saint George came passing through on his travels, and upon hearing this dire tale, rode out to do battle with the beast. In the ensuing fight, he slew the dragon and rescued the maiden.

Flight Vs. Rest

Wings fully unfurl in flight to let the dragon glide. When resting, the wings fold up like a pleated fan.

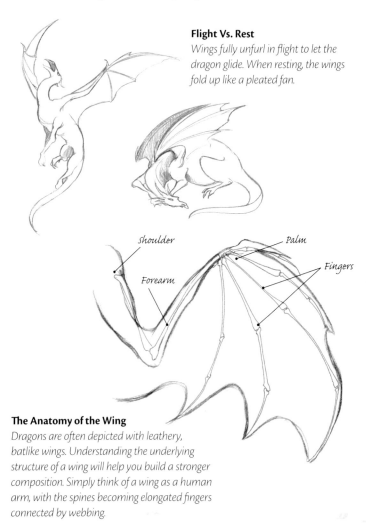

Shoulder

Forearm

Palm

Fingers

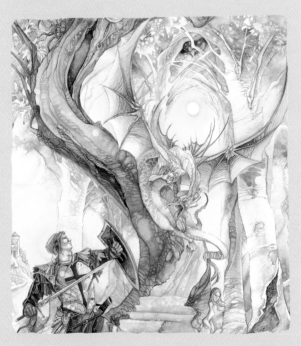

The Anatomy of the Wing

Dragons are often depicted with leathery, batlike wings. Understanding the underlying structure of a wing will help you build a stronger composition. Simply think of a wing as a human arm, with the spines becoming elongated fingers connected by webbing.

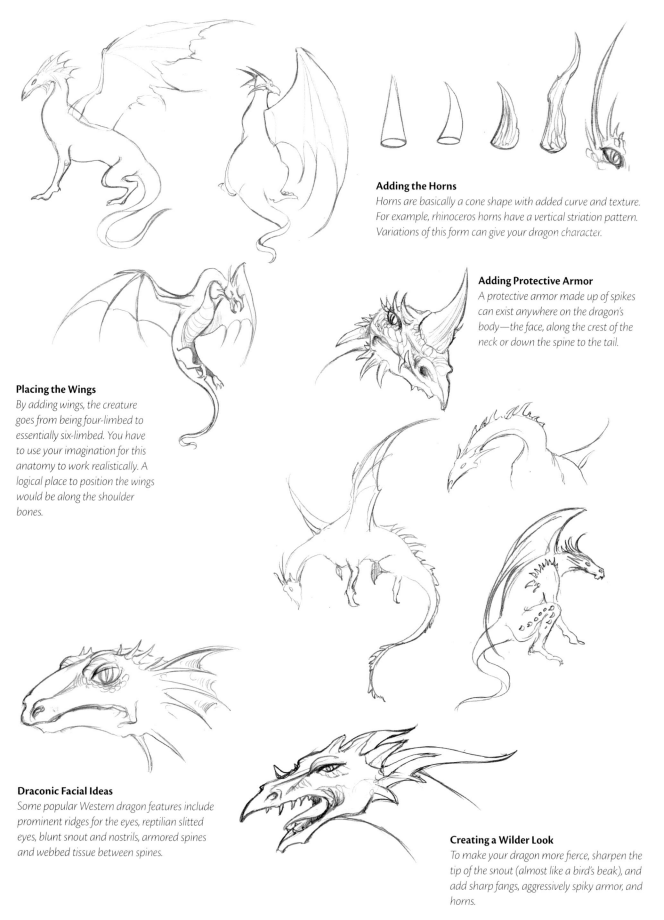

Adding the Horns

Horns are basically a cone shape with added curve and texture. For example, rhinoceros horns have a vertical striation pattern. Variations of this form can give your dragon character.

Adding Protective Armor

A protective armor made up of spikes can exist anywhere on the dragon's body—the face, along the crest of the neck or down the spine to the tail.

Placing the Wings

By adding wings, the creature goes from being four-limbed to essentially six-limbed. You have to use your imagination for this anatomy to work realistically. A logical place to position the wings would be along the shoulder bones.

Draconic Facial Ideas

Some popular Western dragon features include prominent ridges for the eyes, reptilian slitted eyes, blunt snout and nostrils, armored spines and webbed tissue between spines.

Creating a Wilder Look

To make your dragon more fierce, sharpen the tip of the snout (almost like a bird's beak), and add sharp fangs, aggressively spiky armor, and horns.

Rendering Scales

WHEN DRAWING SCALES ON A dragon, you can use several different techniques, depending on what part of the dragon's body you're tackling. Fish, lizards and sea turtles are all good examples of places to look for inspiration.

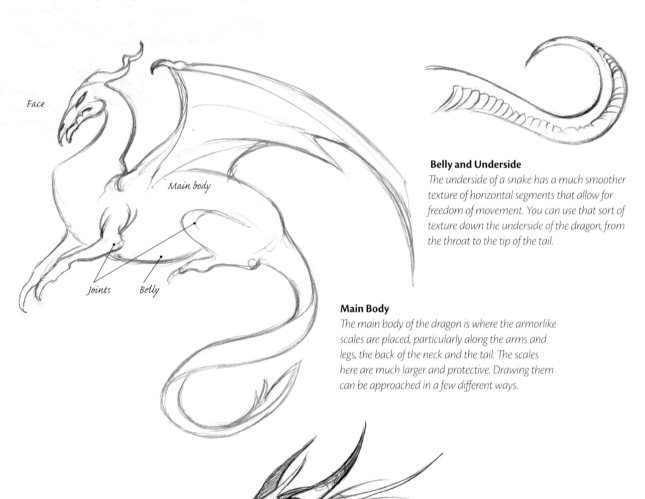

Face

Main body

Joints Belly

Belly and Underside
The underside of a snake has a much smoother texture of horizontal segments that allow for freedom of movement. You can use that sort of texture down the underside of the dragon, from the throat to the tip of the tail.

Main Body
The main body of the dragon is where the armorlike scales are placed, particularly along the arms and legs, the back of the neck and the tail. The scales here are much larger and protective. Drawing them can be approached in a few different ways.

Face and Joints
If you look closely at a lizard's or a snake's face, the skin has a pebbly texture that becomes more fine as you approach the eyes, snout, mouth and joints. The texture may be completely smooth around the eyelids and other sensitive places. Scales are a protective armor. In order to remain flexible there would be fewer (or more delicate) scales closer to fleshy areas like the eyes, mouth and nostrils. This would also apply to joints, otherwise the dragon would be unable to move.

134

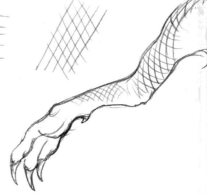

Fish Scales

Fish-type scales have crescent over-lapping shapes. They don't all have to be the same size, or completely even. In fact, you want some variety in size, or else it will look unnatural. Create larger plates across the back and hindquarters. As you get toward the tip of the tail, let the scales get smaller. To get a more draconic, armored look, put some randomized jagged edges on the plated scales.

Lizard Skin Scales

For a smoother type of scale, you can use a crosshatching pattern. This is basically a grid of lines. It is skewed at an angle to create diamond shapes, then rounded to cling to the three-dimensional form of the dragon's muscles.

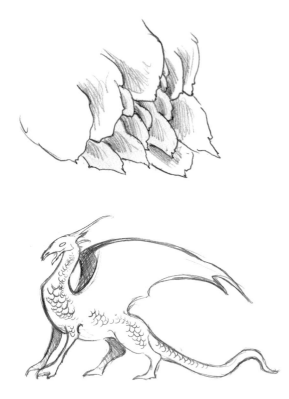

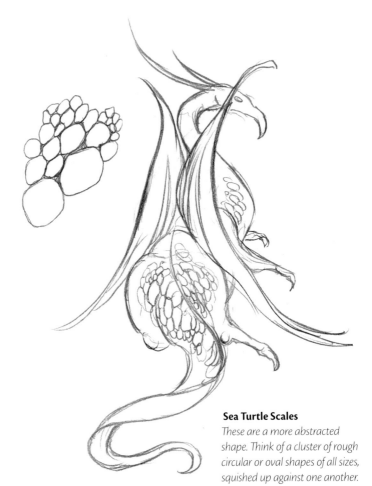

Consistency Is the Key

Keep the scales going in a consistent direction along the dragon's body, aligning with the limbs. They should move down the neck toward each limb and toward the top of the tail. Remember, you don't have to draw every single scale.

Sea Turtle Scales

These are a more abstracted shape. Think of a cluster of rough circular or oval shapes of all sizes, squished up against one another.

Designing Your Dragon

*You may be wondering how to begin designing your dragon.
The most important thing to remember is that while dragons
are fantastical creatures of imagination, their power is
grounded in the realities of this world. Their physical nature
draws from the various animal kingdoms. Without this tie
to the real world, they would be utterly alien and their spirit
would no longer be that of the earth. Keeping this in mind as
you create your design will open countless doors to unnum-
bered fantastical realms. The possibilities are truly endless!*

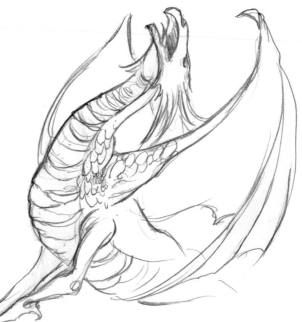

A Rough Look
*You can add a bit more character to the armor plat-
ing as well, making it more rugged.*

Painting Scales: A Quick Tutorial

1 *Start with the sketch.*
2 *Paint the shading on the scales with Ultramarine Violet.*
3 *Paint a wash of the dragon's main color on top of the shading
 in Prussian Blue.*
4 *Push the darks farther back on the upper part of the scales
 where they slip under the next layer. Blend in Payne's Gray,
 moving downward. You can repeat step 3 and 4 several times
 if you want to build up the intensity of the dragon's colors and
 smooth out the shadows.*
5 *Pull out highlights by lifting along the outer edges of the scales.
 Each scale is overlapping the scale beneath it, so keep this in
 mind when painting the darks and lights. The darkest part
 of the scale is at the top where it slides underneath the layer
 above it. The lightest part is at the bottom edge.*

The Dragon
THE DRAGON AND THE CHAMPION

This confrontation happens again and again from one tale to the next, with each knight wishing to prove his worth by slaying the creature that embodies terror, destruction and primal forces. He comes riding forth, confident despite his miniature stature in comparison to his foe. The knight's strength lies not in size. A deep growl rumbles in the cavernous chest of the dragon, and a glint of humor flashes in the slitted eyes as the creature rises up and stretches his wings, eager to meet his challenger.

MATERIALS LIST

Watercolors ~ Alizarin Crimson, Burnt Sienna, Burnt Umber, Lemon Yellow, Naples Yellow, Payne's Gray, Sap Green, Ultramarine Violet, Viridian Green, Yellow Ochre

Brushes ~ 1 inch (25m) flat, nos. 0, 1, 2 and 6 rounds

Other ~ Rubbing alcohol, salt

Preparing the Composition

The diminutive size of the knight by comparison to the dragon is emphasized by the dragon's tail passing in the foreground in front of the knight. Compositionally, this brings the viewer's eye from the dragon's impressive figure, down along the rippling tail and to the knight. The direction of the knight's gaze then brings the viewer back toward the dragon, making the composition self-contained.

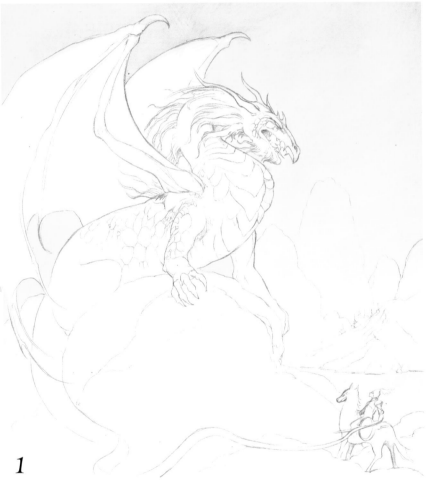

1

1 **Finish the Sketch and Lay In Background Color**
When sketching the dragon, don't define all the scales and minute details with your pencil. Filling everything out at this point will just muddy the watercolors when you begin painting. Rather, just work in details on those areas that are the primary focus of the composition, like the head and upper body.

Using a 1-inch (25mm) flat, lay a graded wash of Naples Yellow in the background. Let the color fade as the wash goes over the background hills to the right. To get into the tighter corners (like under the dragon's chin and the negative space under the wing on the left side) use smaller round brushes.

2

2 Color In the Background Hills
With a no. 6 round and Yellow Ochre, paint the background hills, fading to the white of the paper as you get close to the bottom. Sprinkle salt into the hills while the paint is still wet.

3 Add Texture and Details to the Background Hills
Using a no. 2 round, wet and scrub along the upper edges of the hills to blend them into the background softly. With a no. 0 round, paint in some fine details on the contours of the hills using a mixture of Yellow Ochre and Payne's Gray. Use the irregularities created by the salt as the basis for creating the shadows and highlights of the crenulations on the hillsides.

4 Enhance the Details on the Background Hills
Mix Yellow Ochre and Payne's Gray, and using a no. 0 round, paint more details on the hills.

5 Apply Basecoat to the Foreground Hills
Using a no. 1 round and a mixture of Sap Green and Yellow Ochre, paint in the foreground hills. Keep the edges soft by blending each new layer of color into the background.

6 Refine Details on the Foreground Hills
Mix Sap Green with a little bit of Payne's Gray to mute the brightness of the green. Then, using a no. 0 round, paint in the distant trees and shadows on the foreground hills. Lift some highlights from the ridges on the hills using a no. 1 round loaded with clean water.

Paint a base of Sap Green mixed with Yellow Ochre for the water. While this is still wet, paint some wet-into-wet reflections with horizontal brush ripples using the mixture of Payne's Gray and Sap Green.

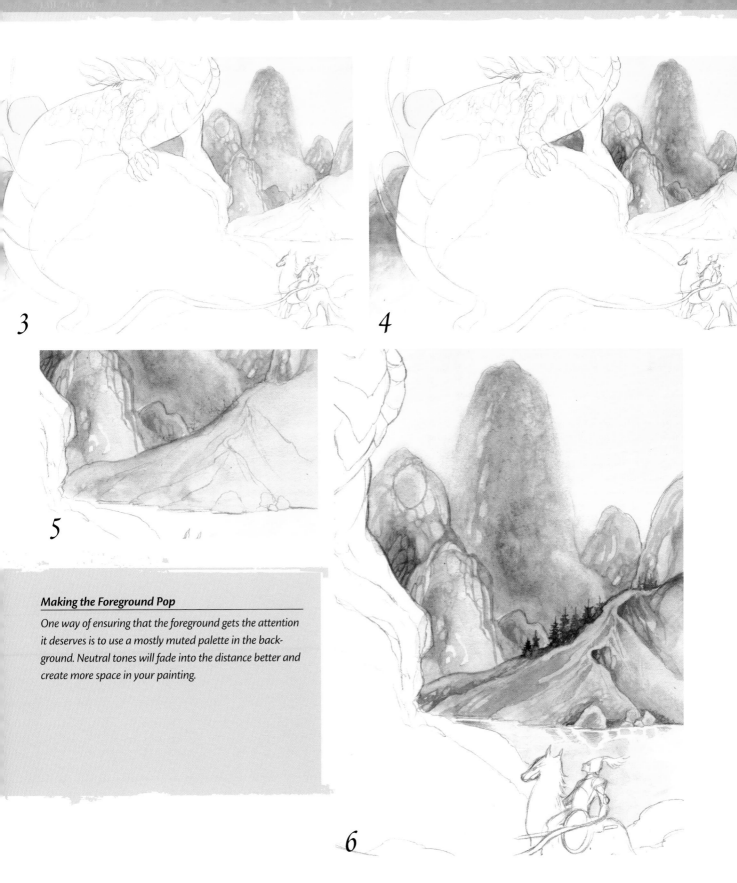

3

4

5

Making the Foreground Pop

One way of ensuring that the foreground gets the attention it deserves is to use a mostly muted palette in the background. Neutral tones will fade into the distance better and create more space in your painting.

6

7 Add Basecoat to the Foreground Rock

Using a no. 6 round and a mixture of Viridian Green and Payne's Gray, paint in the base layer of the rock in the foreground. Let your brush skip a bit to allow the white of the paper to show through. While this layer is still wet, sprinkle with salt (coarse sea salt for larger texture) and rubbing alcohol. Brush off the salt once the paint has dried.

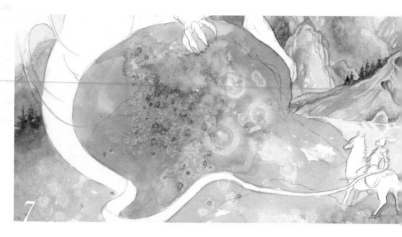

8 Create Shadows on the Rock

Using a no. 6 round and Ultramarine Violet, lay in washes to suggest the shadows. Do this wet-into-wet so the color spreads across the rock's surface. Again, let your brush skip over the paper toward the edges to create added texture. Sprinkle more salt and rubbing alcohol to add an extra layer of texture, brushing off the salt crystals once the paint has dried.

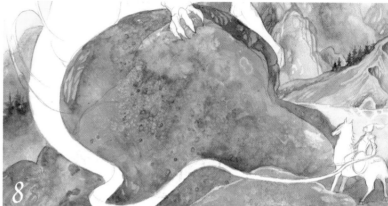

9 Pick Out Rock Details

Using several different round brushes and various mixtures of Payne's Gray, Viridian Green and Ultramarine Violet, go back in to emphasize the random textures that the salt and alcohol have created. Add Sap Green to the swatch of ground in the lower right.

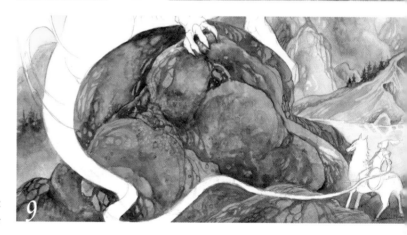

10 Suggest the Highlights and Cracks

Using nos. 0 to 2 rounds and clean water, lift out highlights on the rock. Darken the deepest shadows with a no. 1 round and Payne's Gray.

11 Lay In Shadows on the Dragon

With nos. 0 to 2 rounds and Ultramarine Violet, paint the base shadows on the dragon. Mix in a bit of Burnt Umber in the darkest crevices. Make sure to paint shadows on the scaled plates of his chest as well.

12 Apply Base Color to the Dragon

Using a no. 6 round and Lemon Yellow, brush a glaze over the dragon's body. Leave white along the edges of the tail, chest, and back of the haunches.

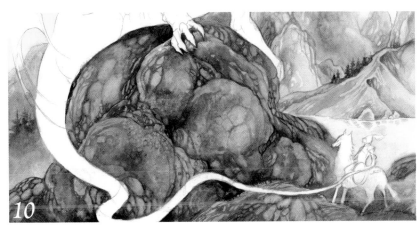

10

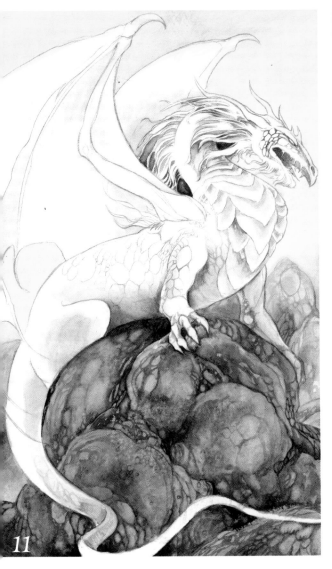

11

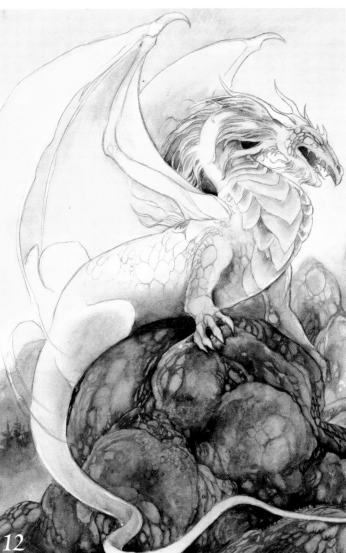

12

141

13 Outline the Scales

Mix Naples Yellow and Burnt Sienna, and with a no. 1 round, glaze more shadows on the dragon's body. Then using a no. 0 round and Burnt Sienna, paint the outlines of the smaller scales, using a combination of squished together ovals and crosshatching.

14 Add More Color to the Center of the Scales

In the deepest shadows on the chest, darken the upper edges of the scales (as they slide under the layer above) using a no. 0 round and Payne's Gray.

For scales along the tail and body, use a no. 1 round and various mixtures of Sap Green (along the belly), Naples Yellow and Burnt Sienna to darken the centers. Blend the edges with clean water.

For the belly, wing, and underside of the arm use a no. 0 round to lift out highlights from the center of the scales. This softens the crosshatch pattern a bit so that it looks more organic.

15 Soften the Scales and Apply Basecoat to the Wings

With a no. 6 round and a mixture of Lemon Yellow and Naples Yellow (let the tones vary across the figure) lay a glaze over the scales. Keep the brushstrokes minimal; the point is to soften the edges of the scales without lifting the color completely. Leave white highlights at the edges, particularly at the silhouette of the chest and the edges of the limbs.

For the wings, use sweeping strokes that flow along the vertical length of the wing spines. Paint Naples Yellow on the inner shadowed areas and Lemon Yellow on the outside. Let some of the brushstrokes show.

16 Place Wing Shadows and Details

Enhance the striations created in the last step by darkening the shadows further with Naples Yellow on the outside and a mixture of Burnt Sienna and Ultramarine Violet on the inside. Let the mixture darken with more Ultramarine Violet in the deepest corners.

Using a no. 1 round, paint a mixture of Burnt Umber and Payne's Gray along the wing talons and the horns. On the back wing, use more Burnt Umber so that it fades into the background.

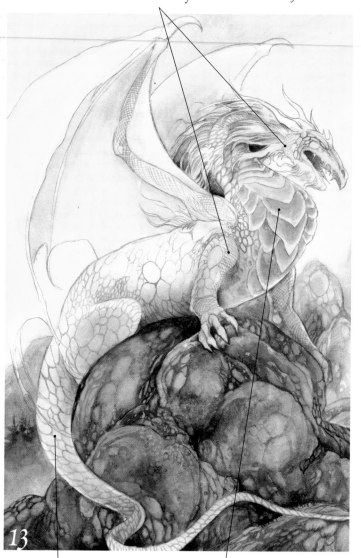

Crosshatched, fine-textured scales along the insides of the arm and around the jaw

13

Smaller, blobby shapes around the joints and flexible tail

Thicker, heavy protective plates across the chest

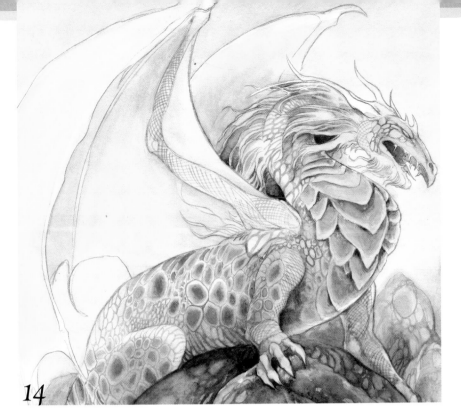

14

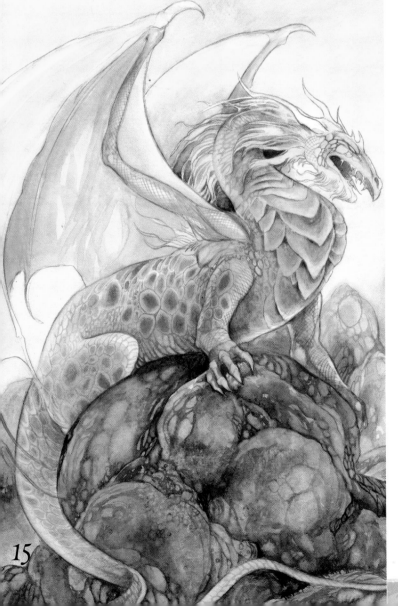

15

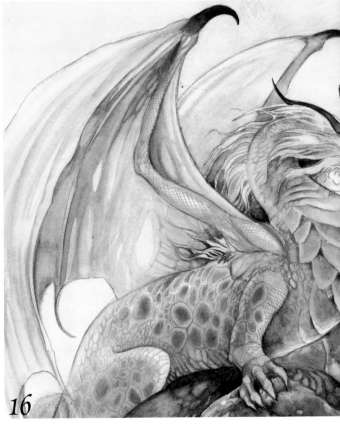

16

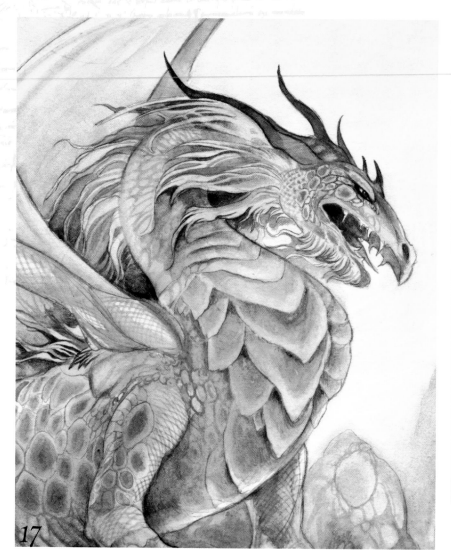

17 Add Face Details

Using a no. 0 round and Alizarin Crimson, paint the inside of the mouth. Add a concentrated dot of the same color to indicate the eye. Use Payne's Gray for the details around the eye, nostril and shadows in the hair. Darken some strands of hair, and add contours and scales around the face with Naples Yellow.

18 Color In the Knight

With a no. 0 round, paint the knight with a light layer of Payne's Gray. Mix in Burnt Umber to paint the horse. Let the colors blend together a bit, wet-into-wet. You want the knight to be mostly neutral colored, so as not to detract focus from the dragon. He will be noticed by the viewer eventually because of the way the dragon's tail curls around to him. Leave the whites at the edges of the horse.

19 Place Finishing Touches

Still using the no. 0 round, add more Payne's Gray and Burnt Umber to finish off the details on the knight and horse. Push the shadows back farther by layering on top. Soften the highlights by lifting out from the dry paint. Give his features a very slight flush with a diluted bit of mixed Alizarin Crimson and Naples Yellow, and a spot of color to his plume with Alizarin Crimson.

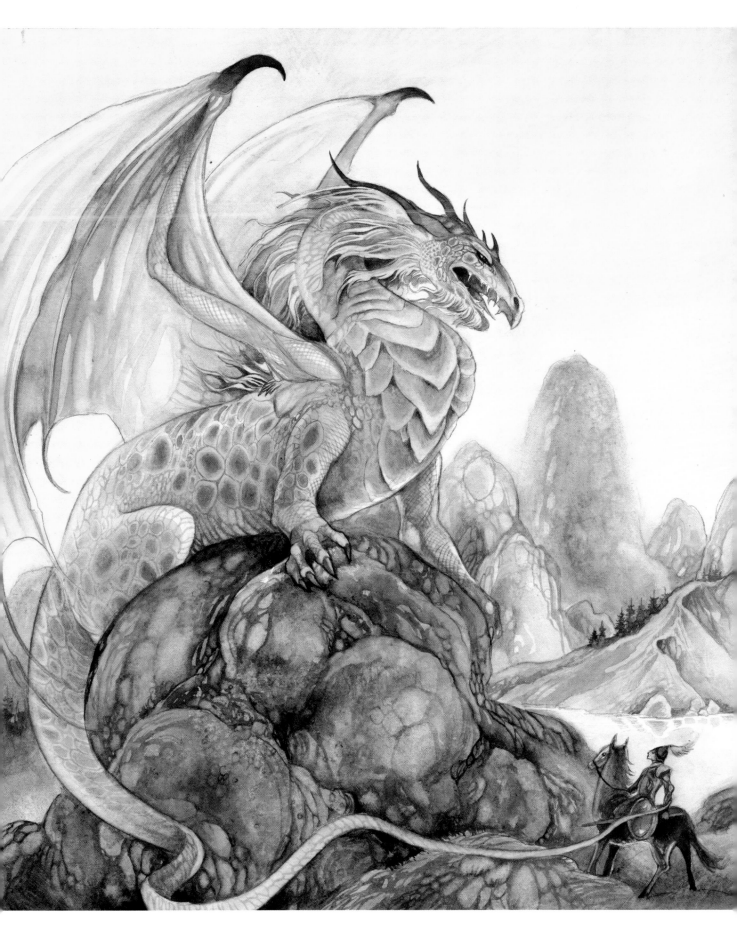

145

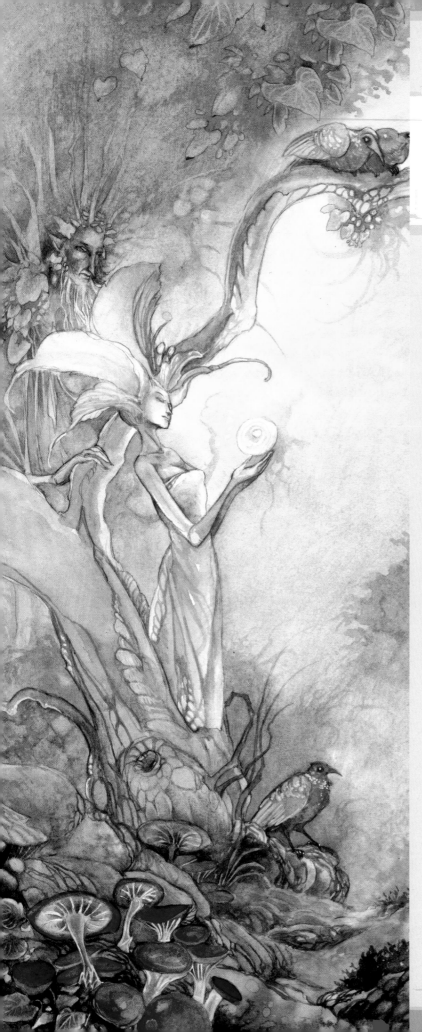

the TREE SPIRIT

FROM THE PINES OF THE BLACK FOREST TO THE massive sequoias of California, and the oaks of Sherwood to the apple trees of Glastonbury, trees mark the passage of time by a slow and stately measure. They are ancient beyond any human lifespan, witnessing a wealth of events in the woods around them. As such, they often have been attributed with having guardian souls.

When coming across an ancient tree surrounded by the soft susurrus of sighing leaves, the crack of falling branches, and the breathless hush of the wild, it is easy to see these hidden watchers cloaked in verdant shadows. Faery eyes gleam from behind shifting leaves, while otherworldly hands push aside twigs and curtains of greenery, peering out in curiosity.

In many stories, the spirit and the tree are so inextricably entwined that they actually share a physical form. That is, the tree is an animate incarnation of the spirit itself. Such is the case with the hamadryads of ancient Greek myths. Hamadryads are integrally linked to their trees. Their blood is the sap of the tree, and their skin the bark. They stretch their arms toward the sky to bathe in the sunlight, and bury their toes deep in the earth to drink the waters of its underground wells. When the tree dies, so too does the dryad.

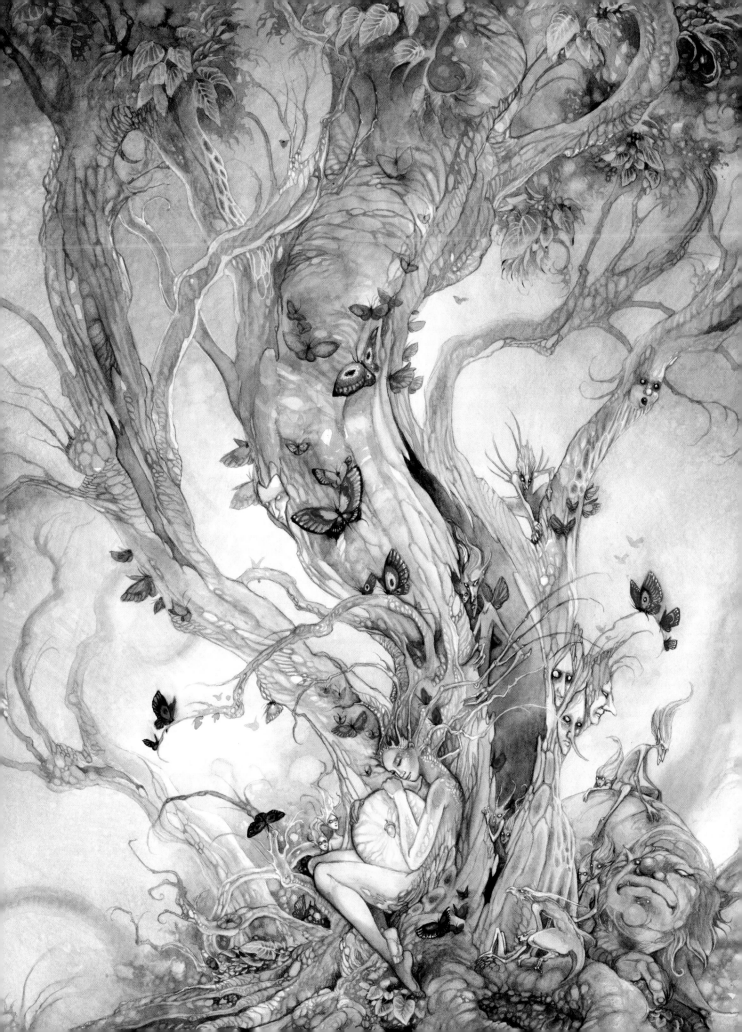

Suggesting Tree Bark

BARK GIVES A TREE SPIRIT ITS CLOTHING AND CHARACTER.

A trunk whose bark is too smooth will have a plastic-like appearance whereas crags, cracks and hollows of most tree bark can suggest the venerable woodland spirit that inhabits it.

The Story of Daphne

In Greek mythology, Daphne was a nymph who was so beautiful that Apollo was stricken with love for her. She did not want his attentions, however, so she prayed that the gods would rescue her. The gods heard her prayers and turned Daphne into a laurel tree. For love of her, Apollo is occasionally depicted wearing a laurel crown.

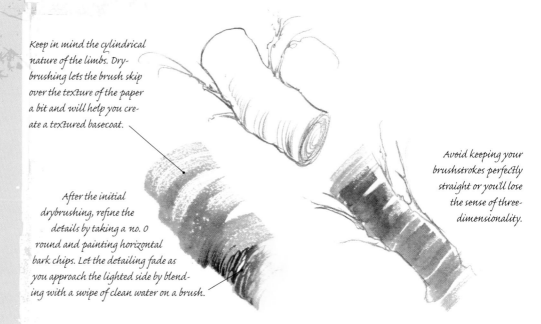

Keep in mind the cylindrical nature of the limbs. Drybrushing lets the brush skip over the texture of the paper a bit and will help you create a textured basecoat.

After the initial drybrushing, refine the details by taking a no. 0 round and painting horizontal bark chips. Let the detailing fade as you approach the lighted side by blending with a swipe of clean water on a brush.

Avoid keeping your brushstrokes perfectly straight or you'll lose the sense of three-dimensionality.

Fruit Tree Bark

Trees that yield fruit, such as apple trees, cherry trees and plum trees, have horizontal striations of bark. Use a small flat brush to make short curved strokes along the circumference, as if you were painting around the limb.

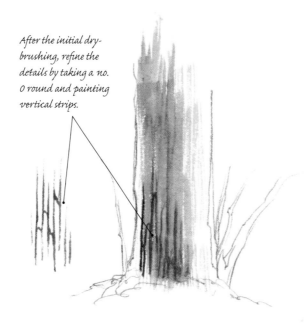

After the initial drybrushing, refine the details by taking a no. 0 round and painting vertical strips.

Redwood Bark

Pine trees have more vertical strips of bark along their trunks. Use a flat brush to apply paint vertically along the length of the limbs using the drybrush technique.

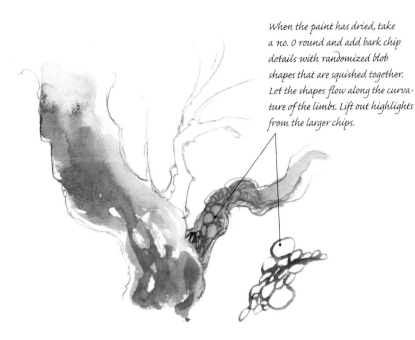

When the paint has dried, take a no. 0 round and add bark chip details with randomized blob shapes that are squished together. Let the shapes flow along the curvature of the limbs. Lift out highlights from the larger chips.

Oak Bark

Some trees have a craggy nature that can't be depicted with a horizontal or vertical pattern, thus requiring you to utilize a slightly unstructured approach. Such is the case with oak trees.

To get started, use a medium-sized round brush to generally fill in the area. Add some wet-into-wet shadows with darker colors, blue or green or purple depending on the colors of the rest of the painting. Let highlights of white paper peek through.

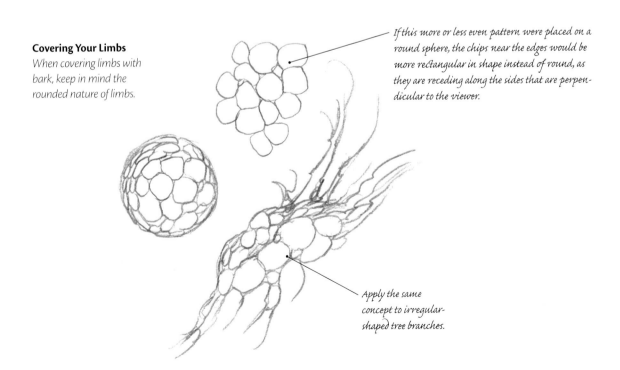

Covering Your Limbs

When covering limbs with bark, keep in mind the rounded nature of limbs.

If this more or less even pattern were placed on a round sphere, the chips near the edges would be more rectangular in shape instead of round, as they are receding along the sides that are perpendicular to the viewer.

Apply the same concept to irregular-shaped tree branches.

Painting Leaves

PAINTING REALISTIC FOLIAGE IS ANOTHER IMPORTANT feature of dryads. Keep in mind that rendering foliage doesn't necessarily mean painting each leaf. Instead, detail the foreground leaves and merely hint at the rest. In this way you'll be able to keep the focus on the important aspects of your composition rather than overwhelming them with detail.

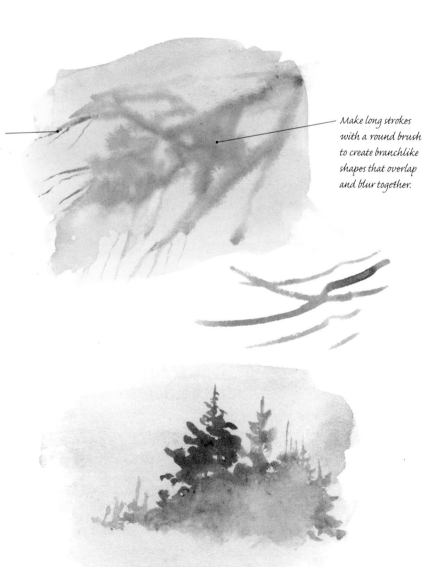

Trail out the ends of branches into delicate thin twigs by pulling the wet paint down with a no. 0 round.

Make long strokes with a round brush to create branchlike shapes that overlap and blur together.

Shadowy Branches in the Distance

Using a slightly darker color than the base, paint wet-into-wet silhouettes of shadowy branches and leaves. Let the strokes bleed outward to give a nice unfocused look that really lets the strokes recede into the background.

Foliage

With a round brush, make overlapping, dabbing strokes, saving bits of white to suggest the light shining through the foliage. Painting wet-on-dry brings a sharper edge to the leaves and doesn't push them as far to the back or out of focus. Various sized rounds can be used to create contrast in the details.

Dab the paint in overlapping blobs.

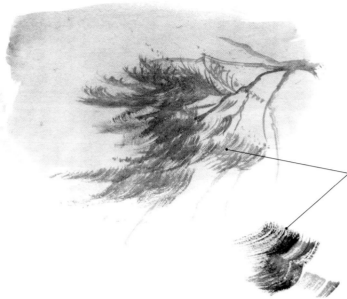

Feathery Leaves

Using the dry-brush technique, lay in short, curved strokes that overlap and trail out toward the end of the branches.

Use the width of a flat brush, and let the strokes flow loosely with a slight curve.

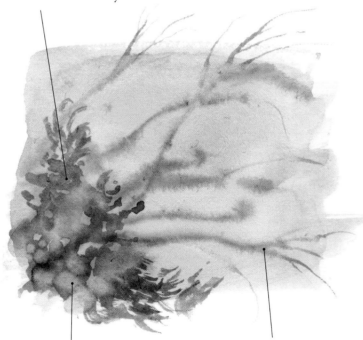

Here, various wet-on-dry and dry-brush strokes were used to fill in leaves.

Lift some lighter blobs with a no. 2 round to suggest highlights of light peeking through.

These nebulous branches receding into the background were painted using the wet-into-wet technique.

The World Tree

Though not exactly a single tree spirit, one could say that Yggdrasil in Norse mythology contains the spirit of all. The world tree is an enormous ash tree whose branches span the heavens to cover the world. The Norse gods would convene at Yggdrasil for their daily court. The roots of this tree pierce down below all the earth to be fed by magical springs, among them the Well of Mimir whose waters are an elixir of wisdom. In this way, Yggdrasil is truly a tree of life.

Combining Techniques

Don't let yourself be limited to any one method. They should all be combined to attain the look that you need.

&Melding Flesh and Wood

It's no surprise that oak trees are often attributed with having guardian spirits. The shadows of their sinuous curves and boles are very humanlike in shape, after all. So much so, in fact, that one has to wonder: How can something so grand *not* possess a spirit all its own?

Here, I've chosen to illustrate two representations of tree spirits—the dryad and the grizzled guardian. Regardless of which you choose to bring to life in your paintings, getting started is as easy as taking a walk through a forested area. Simply find a tree that speaks to you and let your imagination do the rest.

The Dryad—Finding the Perfect Tree
To glean inspiration, go outside and look for a tree that has some character to its shape—the more curves, shadows and boles the better. Isolate an interesting section of the tree to focus on. It doesn't have to be the main trunk; if a particular branch catches your fancy, use that.

Lay In a Rough Sketch
Do a rough sketch of the segment that interests you. It doesn't need to be exact—details can be added later.

Search for the Dryad
Look for the figure that is hidden in the branches. You don't have to adhere to human proportions. Perhaps the limbs are stretched out and the body elongated. Find how a shape fits into the tree. If the current branch is not working for your imagination, look to a different segment.

Use Your Imagination
Don't be limited by the initial tree form you sketched. Let your imagination pull out details. Add tendril twigs and remove sections that don't fit your dryad. But be careful not to get rid of too much—the awkward curves of the tree are really what define this tree spirit.

152

The Grizzled Guardian—Finding the Perfect Tree
A fat trunk with lots of knots and moss-covered branches serves as the perfect inspiration for bringing your grizzled guardian to life.

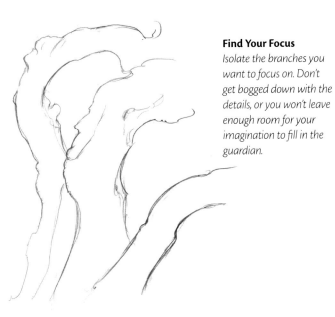

Find Your Focus
Isolate the branches you want to focus on. Don't get bogged down with the details, or you won't leave enough room for your imagination to fill in the guardian.

Pull Out the Figures
Use the tree's bumps and knots to define the features of the guardian. A swirl of bark looks like eyes. A moss covered bump is a gnarled nose and bulbous lips.

Add Your Own Creative Touches
Add a twig and leaf beard to the guardian. Frame the face with mossy bark. The key here is to use the tree reference as a point of inspiration. Use what you see, but don't let that limit your drawing. You want to retain enough of the wild and random factors that nature creates, while at the same time crafting it to suit the expression in your drawing. Have fun with it!

153

The Tree Spirit
PAINTING A TREE SPIRIT

When designing the inhabitant or protector of a tree, keep in mind the physical attributes of the tree itself and reflect these in the spirit. For this guardian of apple trees, incorporate the curling twig tendrils for his hair and beard. Also reflect the stretched out, gangly feel of the trunk in his torso and limbs.

MATERIALS LIST

Watercolors ～ Alizarin Crimson, Burnt Umber, Cadmium Yellow, Indigo, Lemon Yellow, Naples Yellow, Sap Green, Ultramarine Violet, Viridian Green

Brushes ～ ¼-inch (6mm) and ½-inch (12mm) flats, old brush (approximately no. 2) for masking fluid, nos. 0 and 4 rounds

Other ～ Masking fluid

1 Finish Sketch and Lay In the Background
Sketch the Apple Tree Man, then paint masking fluid on the apples. Use an old brush to do this (to avoid damaging a good brush), washing with warm water immediately afterward.

When the masking fluid has dried, paint a graded wash from the top of the page using a ½-inch (12mm) flat and a mixture of Burnt Umber and Ultramarine Violet. Paint the wash directly over the tree and figure. While this is still wet, dot wet-into-wet Viridian Green into the lower areas with a no. 4 round, letting the color spread, but trying your best to keep the green from covering the tree and the figure.

2 Add Greenery Around the Tree and Lay Basecoat for the Trunk
Using a no. 4 round, paint Sap Green strokes along the ground in short overlapping arcs, leaving gaps of the Viridian Green layer showing through. Dot in some foliage around the tree. As you move upward, mix Viridian Green in, letting it fade out around the edges of the upper branches and the figure's head. Drybrush horizontal strokes of Burnt Umber along the tree trunk and the Apple Tree Man's body for some base texture, using the side of your brush to deposit the paint. Mix Burnt Umber with Indigo for the shadows beneath the ground apples.

3 Add Bark Details
Remove the masking fluid.

Using a no. 0 round and a mixture of Alizarin Crimson and Burnt Umber, paint bark details on the Apple Tree Man. Using the same brush and a mixture of Indigo and Burnt Umber, add bark details and shadows on the tree.

4 Finish the Bark
Mix Naples Yellow with a tiny bit of Indigo. Using a ¼-inch (6mm) flat, paint the horizontal curve of the tree up the main trunk, and on the figure's body. Take smaller-sized rounds to work the color into the smaller branches. Leave an edge of highlight along the edge of the trunk and the figure's leg. Add in touches of Burnt Umber at the top.

5 Color In the Apples
Mix Lemon Yellow with Cadmium Yellow and paint in the apples with a no. 0 round. Working wet-into-wet, apply Alizarin Crimson dots to give the apples a red tint. Make sure to leave some of the white edge showing around the edge for highlights. Use a mixture of Naples Yellow with a tiny bit of Sap Green to suggest more background apples.

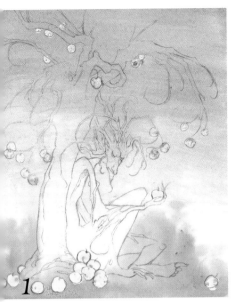

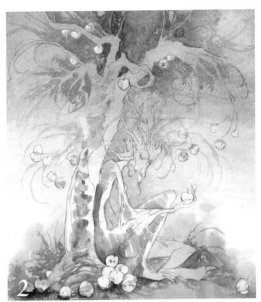

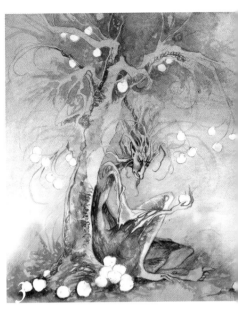

1

2

3

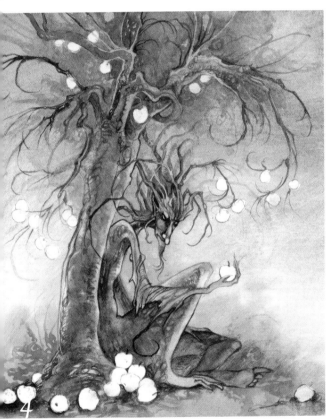

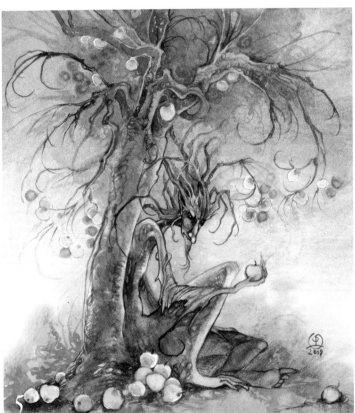

4

5

The Apple Tree Man

To the ancient Celts, apple trees were revered. At harvest time,
the last apple was left on the oldest tree in an orchard for the
Apple Tree Man, so that he would ward off evil spirits and
ensure a good harvest for the next year. In the depths of winter,
the people would come to pour sweet cider at the tree's roots
and sing to the tree's spirit.

155

The Tree Spirit
THE DRYAD

With its massive spread of branches arcing out overhead, and mysterious hollow at its center, the Major Oak in Sherwood Forest doesn't possess a named spirit. Nevertheless, it has obtained legendary status by virtue of its place in the folktales of Robin Hood.

It was said that this mighty oak hid Robin Hood from his enemies in the hollow of its trunk. It has stood for 1,000 years as the dwelling place for the spirits of greenwood, imbued with the power of the encounters it has witnessed.

Younger oaks may not claim such a grand place in legend, but it is hard to deny that they possess a spirit all their own when one takes notice of their sinuous trunks and arcing branches. The dryads hide beneath the veneer of bark and pith, beckoning to those who walk the trails beneath their boughs, inviting the passerby to come press an ear to their trunks and hear the pulse at the heart of the wood.

MATERIALS LIST

Watercolors — Brown Madder, Burnt Umber, Cerulean Blue, Indigo, Lemon Yellow, Naples Yellow, Payne's Gray, Raw Umber, Sap Green, Ultramarine Violet, Viridian Green

Brushes — ¼-inch (6mm) flat, nos. 0, 1, 2, 4 and 6 rounds

Other — Rubbing alcohol, salt

1 Finish Sketch and Color In the Background Sky
Once your sketch is complete, take a no. 4 round and a mixture of Cerulean Blue and Sap Green to paint in the background, wet-into-wet. Avoid the main trunk area, though it's okay to paint over leaves up top. Let the color fade to white at the edges and blend softly.

2 Paint the Distant Leaves
With a no. 4 round and Indigo, paint background leaves in the upper half of the painting, wet-into-wet. Sprinkle salt into the wet paint to add texture. In the lower half, mix Indigo and Sap Green and lightly glaze in shadowy branches. Blend outward into the background. Pick out twigs from the edges of the foliage using a no. 1 round.

3 Add Further Definition
Using a no. 2 round and a mixture of Viridian Green and Indigo, paint in darker areas at the top to suggest closer foliage. Add bits of Sap Green for variation in color. Let parts of the randomized salted texture remain untouched. Lift out circular bits of highlights to indicate the sun specks peeking through the distant foliage.

1

2

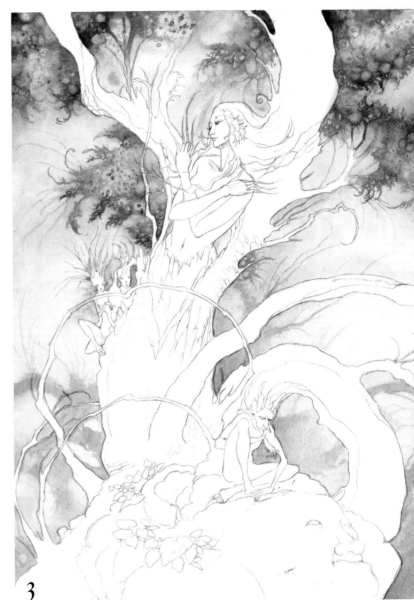

3

157

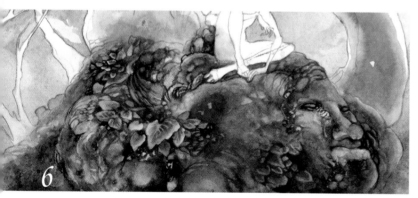

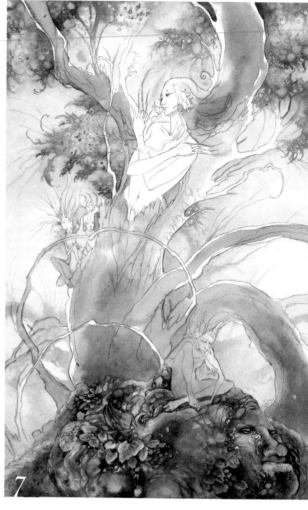

4 Lay Basecoat on the Ground

With a ¼-inch (6mm) flat, add broad strokes to lay in a mixture of Indigo and Payne's Gray at the rocky base, painting wet-into-wet. Add dark splotches to begin hinting at shadows, further defining the shape of the base. If you have trouble getting into the areas below the sprite or around the leaves, switch to a no. 2 round and blend the wet paint into those areas. While the paint is still wet, sprinkle it with salt and rubbing alcohol to create texture.

5 Indicate the Shadows

Using a no. 2 round and a mixture of Burnt Umber and Payne's Gray, further define the shadows around the leaves, molding the shadows and highlights of the rock. To suggest the darkest shadows, use a no. 0 round and concentrated Payne's Gray, filling in the smaller crevices.

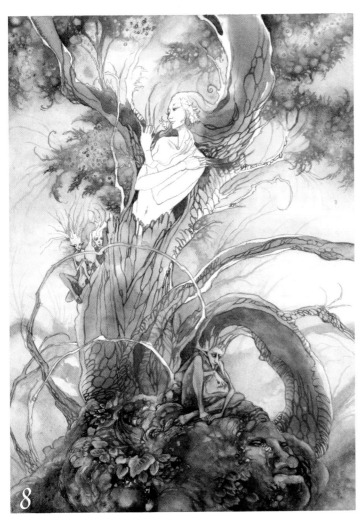

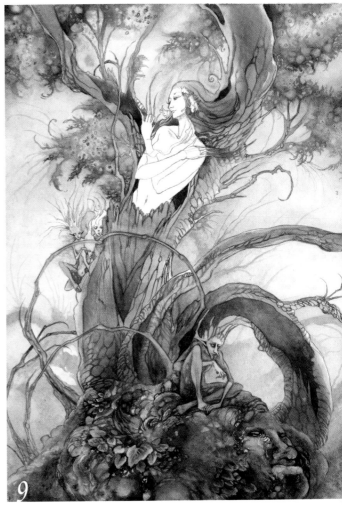

6 Paint the Foreground Leaves

Mix Naples Yellow and Indigo, and with a no. 1 round, blend outward from the stem of each foreground leaf. Add some Viridian Green to the mixture for variation in some of the darker shadowed areas. Retain a highlighted lip of white around the outer edges of the leaves.

With a no. 6 round, glaze a layer of Naples Yellow mixed with Sap Green into the lower right and left corners to soften and blend the edges. Let the rounded edges of the rock recede a bit into the distance by losing their sharp focus.

7 Apply Base Layer to the Tree

With a no. 6 round, use variations of Raw Umber and Burnt Umber to paint a wet-into-wet base layer on the tree and the sprites. Add in some Indigo wet-into-wet at the base in the shadowed core and along the upper branches.

8 Suggest Bark Texture

Using nos. 0 and 1 rounds and Burnt Umber, paint shadows and striations on the bark to suggest texture.

9 Add Ambient Shadows

Add a touch of Payne's Gray to Sap Green to dull the brightness a little, then using a no. 4 round, paint in areas of ambient shadows that reflect the surroundings. This also helps soften the hard edges of the texture from the last step, creating a more natural appearance.

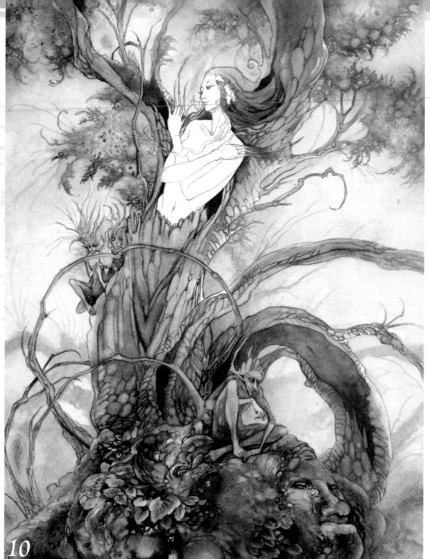

10 Place Highlights

With a no. 1 round and clean water, lift out highlights from the center of the bark chips.

Using the same brush, glaze a layer of Naples Yellow to create the shadows on the sprites clinging to the trunk and the base. Switch to a no. 0 round to get the small twiggy details.

For the sprites on the left and the sprite at the bottom, glaze over the shadows of their bodies, using a no. 0 round to pull out twigs for hair.

With a ¼-inch (6mm) flat, paint a diluted glaze of Naples Yellow across the upper edges of the branches as they flow off the page. This softens the edges, forcing the branches to recede into the distance a bit, and integrates the color with the surrounding foliage.

11 Create Shadows on the Dryad

Using a no. 2 round, paint an underlayer of shadows to the dryad's body with a mixture of Viridian Green and Ultramarine Violet.

12 Indicate Flesh Tones

With a no. 2 round and a diluted mixture of Lemon Yellow, Naples Yellow and a touch of Brown Madder, glaze a light layer over the dryad's body. Her skin tones will still have a very distinct green tint from the underlayer and from the sparse amount of red tones used.

13 Add Finishing Touches

Using a no. 0 round and a mixture of Payne's Gray and Burnt Umber, paint in the deepest shadows on the dryad and define her eyelashes, nostrils and lips. Use a mixture of Naples Yellow and Sap Green to finish off the details of the leaves that frame her face and the tendril branches of hair.

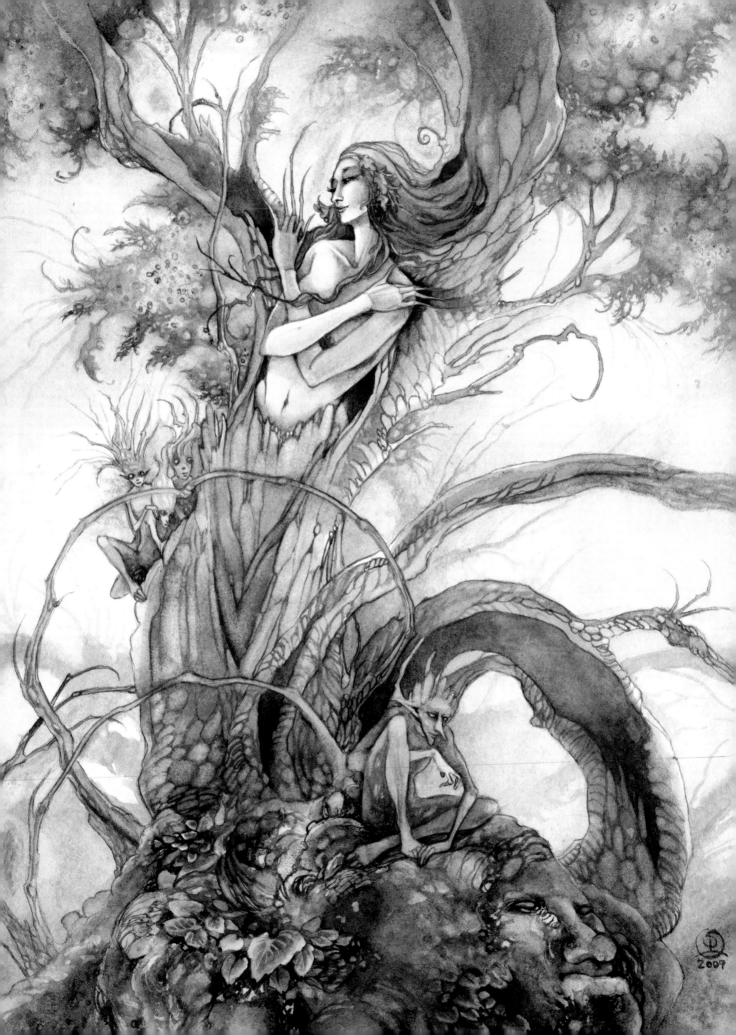

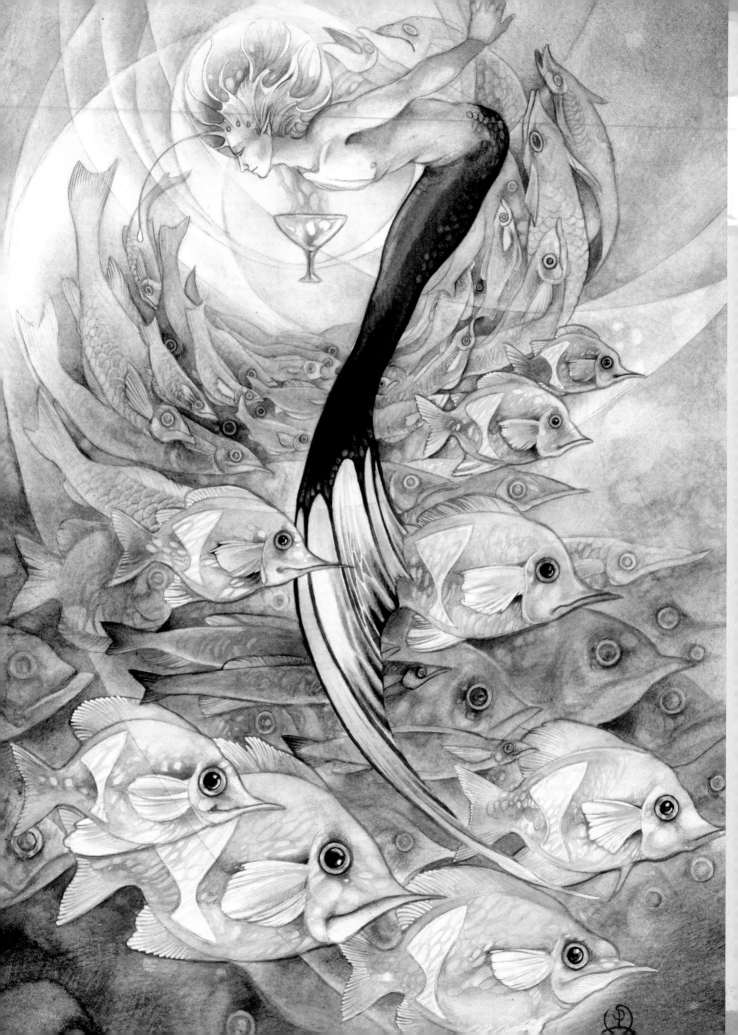

the SIREN

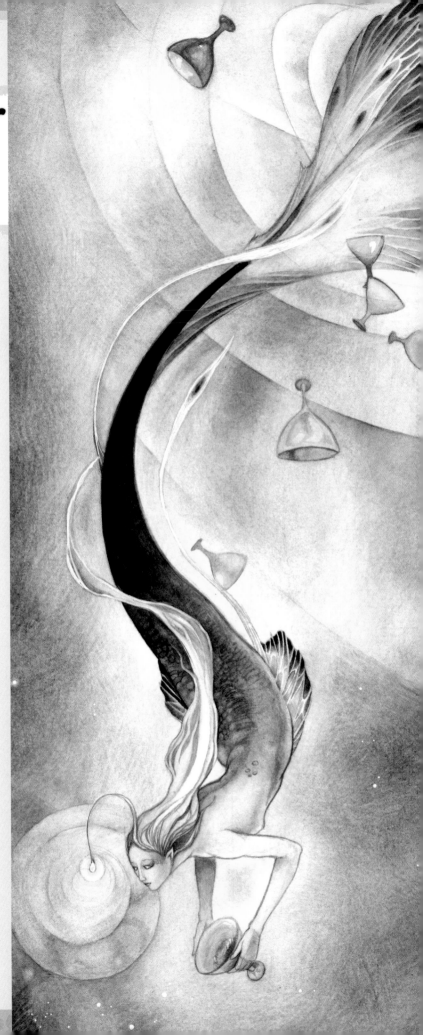

THE OCEAN'S DEPTHS ARE A MYSTERIOUS PLACE, filled with beautiful and sometimes alien denizens. Its cerulean swells have entranced many men, held spellbound by the striking maidens that dwell therein. Mermaids, sirens and selkies—all half-human half-aquatic myth, sinuous and graceful in form—have been known to entrance many a man as they sweetly sing with the voice of the tides.

Homer's *Odyssey* tells us of one such man, a sailor named Odysseus. On a long voyage home, Odysseus and his men must sail past the rocky isle of the Sirens. Odysseus beseeches his men to plug their ears with beeswax so they can row past the deadly isle without hearing the seductive voices of the mystical maidens. However, he himself wishes to hear the lovely song of the Sirens. He asks his men to bind him to the mast to keep him safe from harm. As they sailed near the isle, the Sirens began to sing enticing promises of wealth and wisdom. Enchanted beyond reason by the sweet voices, Odysseus strained to break free and dive headlong into the churning waves, not caring that he would be dashed to death on the jagged cliffs below. At last, his men sailed the ship beyond the isle and out of range of the songs of the Sirens. Odysseus was safe.

rawing Selkies

SEA DWELLERS ARE NOT LIMITED TO MERFOLK and sirens. Selkies are found in the myths of Orkney, a series of islands near northern Scotland. These creatures of the sea wear the form of a seal when swimming in the waters. When they come on dry land, however, they can shed their seal skin and take on human form.

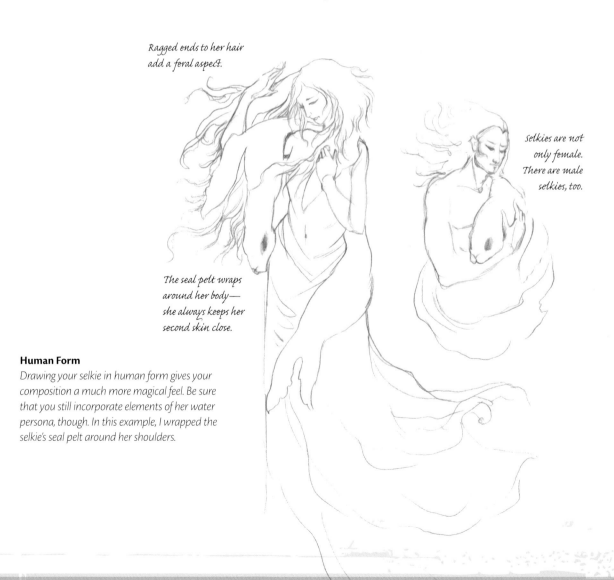

Seal Form

When sketching ideas for your painting, you could start with a seal. However, this might not convey a strong enough sense of fantasy. Thus, consider finding ways to simultaneously illustrate the spirit of the selkie and her human form.

Ragged ends to her hair add a feral aspect.

Selkies are not only female. There are male selkies, too.

The seal pelt wraps around her body— she always keeps her second skin close.

Human Form

Drawing your selkie in human form gives your composition a much more magical feel. Be sure that you still incorporate elements of her water persona, though. In this example, I wrapped the selkie's seal pelt around her shoulders.

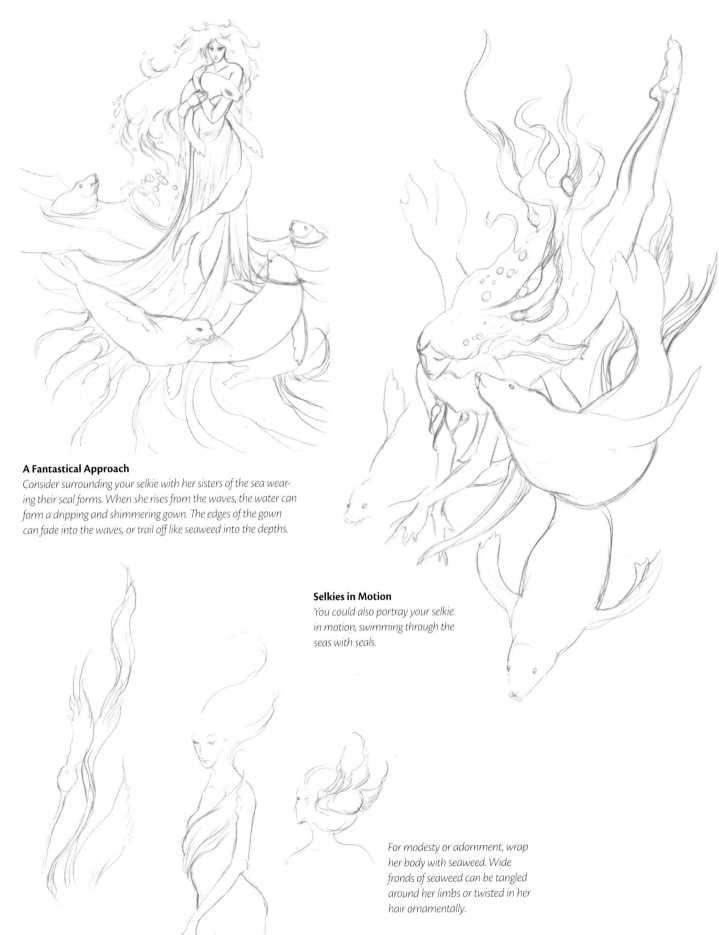

A Fantastical Approach

Consider surrounding your selkie with her sisters of the sea wearing their seal forms. When she rises from the waves, the water can form a dripping and shimmering gown. The edges of the gown can fade into the waves, or trail off like seaweed into the depths.

Selkies in Motion

You could also portray your selkie in motion, swimming through the seas with seals.

For modesty or adornment, wrap her body with seaweed. Wide fronds of seaweed can be tangled around her limbs or twisted in her hair ornamentally.

Determining the Lighting

IT'S IMPERATIVE TO DETERMINE THE LIGHTING you will use for an underwater piece *before* you begin painting. Knowing how to lay out the values of the various elements in your painting, as well as understanding where the light source comes from—and, hence, where the shadows and highlights should be—will keep your composition from looking flat or two-dimensional.

As you begin sketching your underwater scene, remember that your light source (the sun) will not be in view. Rather, it is somewhere off the page and up to the left. Bearing this in mind will help you properly place the necessary shadows and highlights.

Picturing a Light Source
Remember, the sun itself is not in the view of an underwater painting, but somewhere off the page and up to the left. The water diffuses the light, so shadows and highlights are not quite as sharp as they would otherwise be. Likewise, elements in the distance quickly fade to shadowy silhouettes.

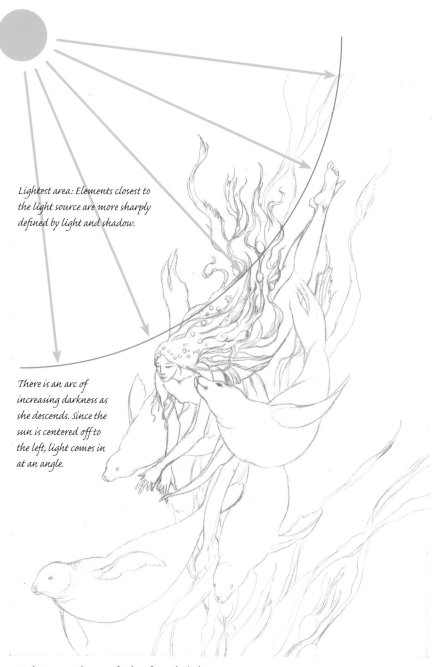

Lightest area: Elements closest to the light source are more sharply defined by light and shadow.

There is an arc of increasing darkness as she descends. Since the sun is centered off to the left, light comes in at an angle.

Darkest areas: Elements farthest from the light source quickly fade out into the shadowy blue surroundings of the ocean.

The Siren
THE SELKIE

One day, a fisherman came across a selkie bathing near the shore. When he spotted her seal pelt lying on a rock, he stole it. While in possession of the pelt, he had power over her, and so she married him and bore him children. But she was sad, and her heart constantly yearned for the open waters. Splashing in the shallow pools were a poor substitute for the freedom of the sea. One day, one of her children found the pelt, and innocently asked her what it was. Without a moment's hesitation, she snatched the pelt from the startled little fingers, and dove into the ocean as a seal, leaving the fisherman and her family.

This tale is a common refrain among the stories of selkies. Tied to the dry earth against their will, they toil under the sun and bear children. Still, they do not hesitate to return to the sea when the opportunity arises, discarding home, hearth and family for the wild song that never stilled in their hearts.

MATERIALS LIST

Watercolors — Alizarin Crimson, Burnt Umber, Lemon Yellow, Naples Yellow, Payne's Gray, Prussian Blue, Sap Green, Ultramarine Blue, Ultramarine Violet, Yellow Ochre

Brushes — ½-inch (12mm) flat, nos. 0,1, 2 and 4 rounds

Other — Rubbing alcohol

1 Lay In Base Washes

Once you've finished your sketch, lay a graded wash in the upper and lower corners of the page with a ½-inch (12mm) flat. Use Naples Yellow on the top left portion of the page, and use Ultramarine Violet along the bottom of the page. It's okay to paint over the seaweed in the background; doing so will help you build up deeper shadows later.

Laying in pale yellow along the top left side will help suggest the warm gleam of sun streaming into the water, while the deep violet along the bottom will indicate the lower, shadowy depths of the sea.

1

2

2 Apply Background Color

Using a ½-inch (12mm) flat, paint a wash of Prussian Blue in the background. Let the color fade and dilute to clear as you near the top yellow corner. Switch to a no. 4 round to get into the tighter spaces in her hair and seaweed at the top. Splatter the wet paint with rubbing alcohol to create texture.

3 Define Shadowy Seaweed

Using a no. 4 round, paint the shadowy seaweed in the background with a mixture of Ultramarine Blue, Ultramarine Violet and Payne's Gray. Accentuate the irregularities in the previous wash and alcohol splatter, letting the seaweed flow around the splotches naturally. For softer-edged long strands, wet a patch of the background area and draw the paint out, wet-into-wet, pulling upward toward the edges of the page.

4 Fill In the Foreground Seaweed

With a no. 2 round, paint a glaze of Yellow Ochre over the foreground fronds of seaweed.

5 Indicate Seaweed Texture

Using a no. 0 round and a mixture of Prussian Blue and Yellow Ochre, paint lengthwise strokes along the fronds of the seaweed for texture. For darker bits of shadow, mix in a bit of Burnt Umber.

6 Add Shadows and Highlights

Using a no. 0 round and a mixture of Prussian Blue and Burnt Umber, soften the texture of the seaweed by adding shadows.

Using the same brush loaded with clean water, lift out some highlights by scrubbing gently at the edges of the fronds.

3

4

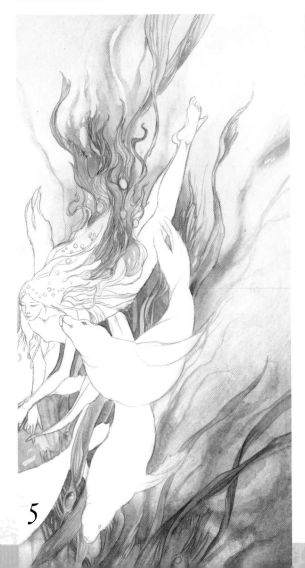

5

6

169

7 Lay Base Shadows on the Skin
Paint a base of shadows on the selkie's skin with a no. 1 round and Ultramarine Blue. Blue shadows will help tie her to the aquatic surroundings.

8 Color In the Skin
Using a no. 2 round and a mixture of Alizarin Crimson, Naples Yellow and a touch of Ultramarine Blue, glaze a diluted layer across her body to suggest the main skin tones. Keep the glaze very light so that the blue undertones still show through.

9 Refine Details
Using a no. 0 round and a mixture of Burnt Umber and Prussian Blue, work in the corners and deep shadows under her arms, on her forehead, and along her back and legs. Finish off the details of her face—her eyes, lips and nostrils—with Burnt Umber.

7

10 Paint the Selkie's Hair
Using a no. 2 round and Naples Yellow, color in the selkie's hair. Let the color blend into the lighter bits of seaweed so that it all tangles into a single mass of strands.

11 Add Shadows and Definition
Use a no. 0 round loaded with Burnt Umber to define the shadows and strands of her hair.

12 Finish the Hair
Using a no. 0 round and Sap Green, paint shadows around the pearls in her hair, dotting some of the same color into the larger pearls to indicate reflected shadows.

Using a no. 1 round and Prussian Blue, glaze over the strands of hair and seaweed that wrap around her torso.

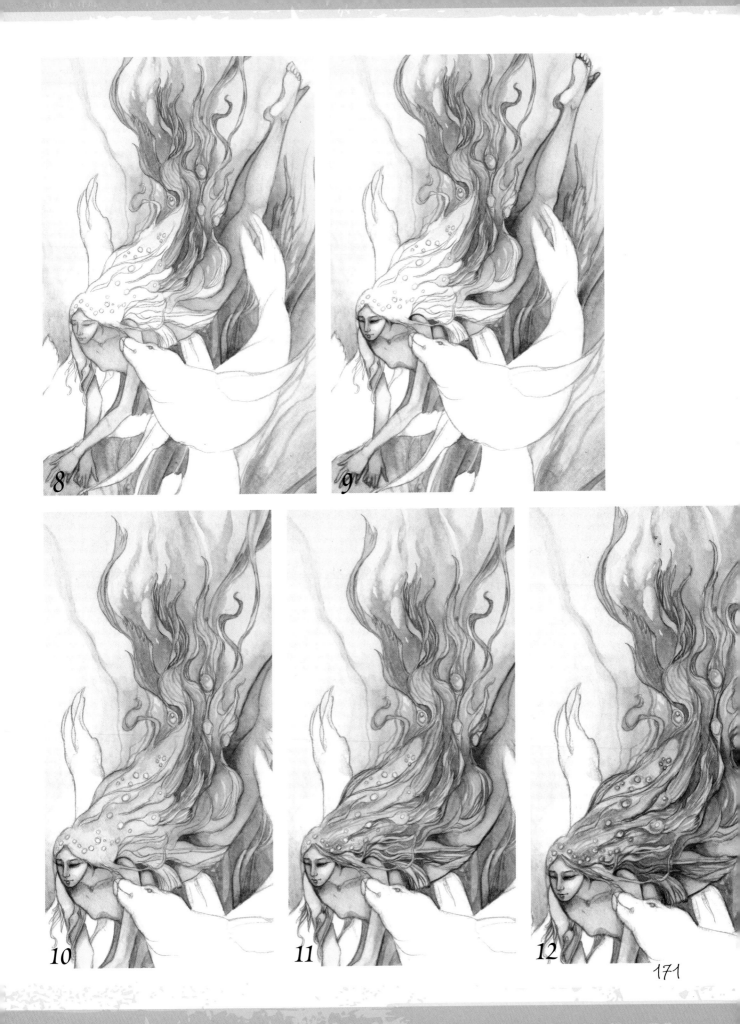

8

9

10

11

12

13

14

13 Paint the Seals
Using a no. 4 round and a mixture of Ultramarine Violet and Burnt Umber, paint the seals' backs. Let the color fade out toward their bellies, leaving their undersides white. Mix in a bit of Ultramarine Blue to glaze over the seals farther in the background.

14 Color the Undersides
With a no. 4 round and Lemon Yellow, paint the undersides of the seals, fading up into the darker shades.

15 Create Sunlight Reflections
Mix Ultramarine Violet and Burnt Umber and paint a dappled sunlight texture on the backs of the seals using a no. 2 round. Think of the wavering quality of light seen through water. Finish off the eyes and whiskers with a no. 0 round and Payne's Gray.

15

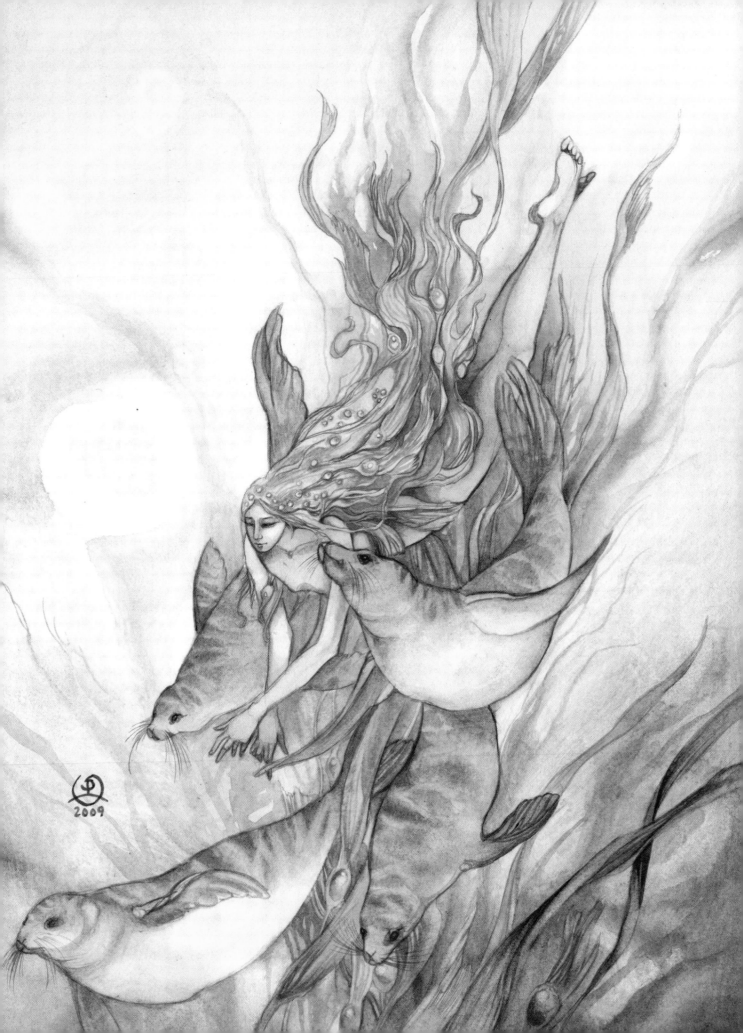

Index

\mathscr{C}reate fantasy worlds with *IMPACT*!

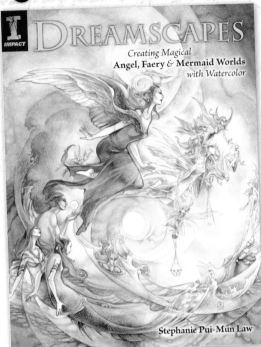

Dreamscapes is a unique guide to painting beautiful watercolor angels, fairies and mermaids in their own worlds (celestial, woodland, garden, sea and castle scenes) step by step. Begin by learning about essential materials, including brushes, paints and paper, then move on to important techniques such as planning and sketching; figure proportions; specific characteristics of angels, faeries and mermaids (including clothing); developing backgrounds; and finishing techniques that add an air of magic.

ISBN-13: 978-1-58180-964-0 • ISBN-10: 1-58180-964-6
paperback; 176 pages, #Z0688

These and other fine **IMPACT** products are available at your local art & craft retailer, bookstore or online supplier.

Capture the wonder and whimsy of woodland elves, gnomes, sprites and dwarfs in colorful, natural surroundings. You'll find everything you need to know including the secrets behind magical watercolor effects, advice for painting authentic attire, intricate wings and more. Add beautiful butterflies, autumn leaves, tree bark and other natural textures to make your paintings come to life.

ISBN-13: 978-1-60061-307-4
ISBN-10: 1-60061-307-1
paperback; 128 pages, #Z2909

Let your imagination take flight as you paint enchanting fairy dreamscapes filled with wonder and delight. Using nature as a starting point, 23 step-by-step painting demonstrations show you how to portray beautiful fairies in magical settings. Enhance your fairy scenes with natural settings and elements such as butterflies, birds, flowers, mushrooms, clouds and rainbows.

ISBN-13: 978-1-60061-089-9
ISBN-10: 1-60061-089-7
paperback; 128 pages, #Z1978

IMPACT-Books.com

- Connect with other artists
- Get the latest in comic, fantasy, and sci-fi art
- Special deals on your favorite artists